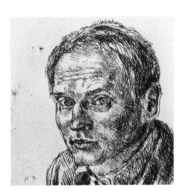

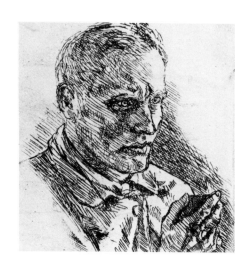

the prints
of REGINALD MARSH

an essay
and
definitive
catalog
of his
linoleum cuts,
etchings,
engravings, and
lithographs

Norman Sasowsky

Clarkson N. Potter, Inc./Publisher NEW YORK
DISTRIBUTED BY CROWN PUBLISHERS, INC.

For Felicia, and for Mary, Ira, and Peter

Design by Ladislav Svatos/Graphicon Ltd.

Library of Congress Cataloging in Publication Data

Marsh, Reginald, 1898–1954.
 The prints of Reginald Marsh.

 Bibliography: p.
 Includes index.
 1. Marsh, Reginald, 1898–1954. I. Sasowsky,
Norman. II. Title.
NE539.M27S28 769'.92'4 75-45374
ISBN 0-517-52493-7

Contents

Preface

Marsh visited my studio frequently during the last two years of his life; it was on the floor below, almost directly beneath his. I remember one occasion when he knew I had had no luck in purchasing a book on Ryder's paintings that interested me greatly. He came in early one morning—I think it was Sunday—and presented me with his copy of the book which had been autographed by the author.

I worked on two paintings just before Marsh died, both in egg tempera. He painted a few strokes on one of the paintings to feel the quality of the tempera I was using. He did not touch the other painting then in progress, which I had done in relation to his work. Rather than a girl striding toward him, as Marsh almost always painted, this painting was of a girl striding away—she was leaving, or had left, and was glancing back.

I welcomed the opportunity to catalog Marsh's prints. He must have sensed that this job would be done one day. He knew that his work would have greater appreciation and meaning in the future, and he sometimes commented on this. In studying his notes, I had the distinct feeling that Marsh had prepared these for the future.

The present book is more than a record. Although a large part of the book consists of factual data, this is of less importance than the single images and the whole body of images that Marsh produced and left to us. These could scarcely be grasped in total by the artist as they were experienced and produced. They now stand as a body of work—a vision—that is for us to understand and from which to draw meaning and sustenance.

I have no recollection of ever talking to Marsh about his prints, although we talked a great deal about other aspects of work in which he was involved. I never had the pleasure of meeting his wife, Felicia Meyer Marsh, during his lifetime. Our first meeting occurred in 1954, shortly after her husband's death. Since that time, Mrs.

Marsh has become a friend, and I have shared with her an intense interest in Marsh's art. Without her interest, devotion, and support, the necessary work could never have been done.

The late William Benton—a devoted admirer of Marsh, one of the first to realize that he was special when they were students at Yale University—greatly facilitated my study. I did not know him prior to Marsh's death. In the years since that time, he proved an invaluable friend, overseeing my efforts at a distance and always "appearing" at the moment his presence was needed.

Lloyd Goodrich, former Director of the Whitney Museum of American Art, and Marsh's oldest friend, has helped me in many ways. From the very beginning, he gave me the basic tools I needed to do the research and has always stood by to provide the advice and judgment necessary to the advancement of the work. I am greatly indebted to him for much of the information and ideas I have developed. Similarly, Edward Laning's writings have been instrumental in providing important insights into Marsh's work.

My former colleague Michael Miller, an excellent printmaker, now teaching at the Art Institute, Chicago, helped in examining Marsh's plates and in the arduous job of identifying states. I greatly appreciate his contribution.

I also wish to thank the staffs of the following institutions for their help with information and for supplying photographs: The Cleveland Museum of Art, The Los Angeles County Museum, The Boston Public Library, The New York Public Library, The Yale University Art Gallery, Rehn Gallery, Kennedy Gallery, The Metropolitan Museum of Art, The Library of Congress, The Philadelphia Museum of Art, and, most importantly, The Whitney Museum of American Art, for its assistance over the years in helping me to build this record.

I include here a special note of appreciation to William Benton's family for permission to use their collection of prints and for helping bring this project to completion.

My close association with Marsh stands as a possible handicap to studying his work—the ties are still very close—yet, it is through love and feeling that works of art are known, appreciated, and, ultimately, function. What I have attempted to do is bring Marsh's work to light by both reproduction and data so that others might look into the images he made. No doubt, new insights will be drawn from his prints; if this is accomplished, then I am satisfied that I have done the job I was meant to do.

N.S.

Introduction

by Lloyd Goodrich

Reginald Marsh's art was a rare combination of realism and design. It was based on firsthand observation of contemporary life, on mastery of the human figure, on a strong sense of plastic form and movement, and on deep devotion to the living tradition of Western art. As Marsh once said: "Art is derived from two sources: art and nature. All art is a mixture of the two. The greater the degree of each, the greater the art."

He was almost literally born an artist. His father, Fred Dana Marsh, was one of the first American painters to picture modern industry; his mother, Alice Randall, was a painter of miniatures. The young couple were living in Paris when their second son, Reginald, was born on March 14, 1898, in an apartment over the Café du Dôme. When the boy was two the family returned to America and settled in the New York suburb of Nutley, New Jersey. It was there that I first knew Reg; we were only a few months apart in age, and we became close friends, then and thereafter.

Curiously enough, Reg had little art training. He learned by the artistic environment of his father's home and studio, and by his own constant drawing from childhood on. Since his grandfather Marsh was well-to-do the boy was given a conventional education at Lawrenceville School and Yale. The Yale Art School of those days was an academic stronghold, and he was never allowed to enter the life class. Better experience came from drawing for *The Yale Record,* whose star illustrator he became. Something else Yale gave him was extracurricular college life: parties, girls, nightclubs, the world of privilege and pleasure, of which he remained a somewhat misfit member but which furnished material for his later satiric bent.

After graduating in 1920 he came to New York and became a free-lance illustrator for newspapers and slick-paper magazines. For three years, from 1922 to 1925, he was on the staff of the New York *Daily News,* drawing city subjects and vaudeville shows. "It took the place of an art school," he later said. When *The New*

Yorker was launched in 1925 he was an early member of its staff, contributing
for seven years. Through succeeding years he also drew for *Esquire, Fortune, Life,*
and other magazines, and illustrated many books.

In the beginning Marsh thought of himself as an illustrator, not a painter.
"Painting seemed to me then a laborious way to make a bad drawing," he wrote later.
In the early 1920s he studied sporadically and for brief periods at the Art Students
League under John Sloan, George Bridgeman, George Luks, and Kenneth Hayes
Miller. In 1923—a rather late date—he began to paint seriously, and next year
the Whitney Studio Club gave him his first one-man show.

Then in 1925 he went abroad for the first time since infancy, and in the
Louvre his eyes were finally opened to the art of the old masters. After his return
to America this revelation was continued by Kenneth Hayes Miller, with whom he
studied again, and formed a friendship that lasted all the older man's life. One of the
most illuminating minds among American artists, Miller helped Marsh to discern
the qualities of form and design in the art of the past, and to use them in picturing
the raw material of the present.

In his early thirties, about 1930, Marsh began to express himself fully
in painting, in a series of powerful temperas picturing city life. Thenceforth his art
was built almost entirely out of the world he knew best—New York. No painter knew
the city more completely. He walked its streets continually, he frequented every
kind of neighborhood, he observed the city in all its aspects: the streets with their
crowds and characters; the subway and el; movie theatres and burlesque houses;
night clubs and dance halls; Harlem, the Bowery, Coney Island; the waterfront,
the harbor, the skyline, the great bridges. Recalling his emotions on first returning
from Europe, he wrote: "I felt fortunate indeed to be a citizen of New York,
the greatest and most magnificent of all cities in a new and vital country whose
history had scarcely been recorded in art."

For twenty-five years his studios were always on or near Fourteenth Street;
for the last two decades, he had a little eyrie overlooking Union Square, whose busy
life he could study with high-powered binoculars. Summers, when other artists
took to the country, he stayed on in New York—summers, when the city, emptied of
the fashionable classes and left to the democratic masses, was most itself, when
the hot days and nights brought physical freedom, when the girls wore least on the
streets, and Coney Island was jammed.

In Marsh's panorama of New York, humanity was the center. He liked
crowds, movement, the vitality and variety of popular life. Wherever the crowds were

thickest, he found his subjects. A dominant theme was the public's pursuit of pleasure in its many forms: dime-a-dance joints, Harlem dance halls, burlesque theatres. Early in his career he fell in love with Coney Island, and became the first painter to fully exploit its flamboyant wonders: merry-go-rounds, roller coasters, revolving bowls, swinging chairs, freaks, barkers, lurid signs, the mad world of Luna Park, the surging holiday crowds—a wealth of fantastic imagery that gave him lifelong subjects.

Sex as publicly displayed fascinated Marsh. A constant motif in his work was the magnetic power of the female body, that immemorial theme that has produced some of the world's greatest art—and some of the worst. To him the human figure was the most vital subject in painting, as it had been to many of the old masters. The academic studio nude was not for him; it had to be the figure as seen in the real world, from the shopgirl on the street to the burlesque stripper. Burlesque had no more devoted student. "The whole thing is extremely pictorial," he explained. "You get a woman in the spotlight, the gilt architecture of the place, plenty of humanity. Everything is nice and intimate."

The greatest opportunity to observe the human body was on the beach at Coney Island: "... crowds of people in all directions, in all positions, without clothing, moving—like the great compositions of Michelangelo and Rubens. I failed to find anything like it in Europe." Here was a whole universe of bodies: robust men and women, athletic show-offs doing stunts, loving couples, the handsome and the ugly, the fat and the skinny—the human body in all its vitality, beauty, and grotesqueness.

Marsh's crowds were not faceless robots; they were individuals, sharply characterized. His eye was not gentle; he made the most of the vulgar lushness of the girls, the coarseness of the men, the downright ugliness of a large part of the human race. But his people, ugly or handsome, were alive. It is true that he did not have the penetrating character sense of a Rembrandt; he was a realist in the tradition of Hogarth and Rowlandson, relishing the rich variety of physical characteristics in *Homo sapiens*. Satire was one element in his attitude toward mankind, but it was combined with enjoyment of the life of the body, of health and energy, of sexual attraction. Fundamentally his art was more affirmative than negative.

His social range was wide: Fifth Avenue, Fourteenth Street, the Bowery. Toward the upper class his attitude was that of one who was of it but not with it. There was no glamour in his picturing of high life. His portrayals of the Metropolitan

Opera with its dowagers, old beaus, and fatigued beauties, or the Stork Club with its aged male merrymakers and their bored young mistresses, called forth his most overt satire.

At the other end of the social scale, the Bowery and its people interested him from his early days as an illustrator. Then with the 1930s came the depression, whose effects he saw firsthand: breadlines, crowded missions, "jungles" where the homeless unemployed lived. Even after the worst was over, there remained the unchanging wreckage of the social order—the permanent bums. They and their special world continued to fascinate him for the rest of his life. For him this submerged world had human and pictorial values far greater than respectable society. Here was an extreme of city life that few artists had pictured, and fewer still with such uncompromising, unsentimental truth. But his attitude remained objective: he expressed no social protest, pictured no idealized proletariat, offered no creed and no solutions. Although his personal politics were somewhat left of center, his art was completely apolitical; he was never part of the social school that dominated the New York art world in the 1930s as the abstract school did in the 1950s. Hence, Marxist artists and critics attacked him as a bourgeois, a Yale man in bum's clothing.

While focusing on the human actors in the drama of city life, Marsh also gave full attention to their setting, the city itself, its buildings, shop windows, el structures, lampposts, traffic signals, and the babel of reading matter in signs, billboards, posters, theatre marquees—the whole jungle of insistent words and images and objects in which city-dwellers exist. Where that other portrayer of New York, Edward Hopper, simplified the city to its massive essentials, Marsh delighted in its lawless profusion. Such multiform urban phenomena played leading parts in his compositions, pictured with precise authenticity, down to the exact typography in the headlines of a newspaper lying discarded in the street.

A born draftsman, Marsh had a natural gift for recording essential forms and actions, swiftly, unhesitatingly, and accurately. Never without a sketchbook and fountain pen, he drew unceasingly; among his many works are several hundred pocket sketchbooks filled with notes of all kinds of things seen on the street, the subway, everywhere he went. At parties he would sit and draw most of the evening, joining in the talk but always looking and drawing. Almost every day he drew from the nude. Few models, especially women, came to his studio looking for work without immediately getting it. And he made them work, taking every imaginable pose. His drawings of the nude, numbering hundreds, perhaps thousands, reveal a mastery of the human body that is rare in our day.

Anatomy was a major interest; he knew it not only from books but from dissecting in New York medical colleges. These studies resulted in his own book, *Anatomy for Artists,* published in 1945—not the usual textbook, but based largely on old master drawings and paintings, redrawn by him. His knowledge of the body was much more than academic correctness; it was a passion, both intellectual and sensual, for bodily forms and motions. His figures are centers of energy and movement. Even when they are clothed one feels the body beneath the clothes.

Marsh's starting point was realism; but it was creative realism, not academic naturalism. His earliest style had been more or less straight realism, but as he studied other art and thought things out, he arrived at a more mature conception of the nature of pictorial art. In his developed thinking, the work of art, while based on the real world, was not a mere copy of reality but the re-creation of reality in form, line, and color, and their design—physical elements that speak directly to the senses, like sounds in music. To him painting was the design of round forms in three-dimensional pictorial space, always within the range of projection and recession established by the picture plane. This was the Renaissance and Baroque concept rather than that of contemporary academic naturalism. He saw no necessary conflict between representation and plastic creation, between the forms of nature and those of art.

The forms in Marsh's pictures were in strong relief, and alive with movement—not only realistic action (though he had an unerring eye for this) but movement of the forms themselves, plastic movement. His compositions were crowded, right up to their edges; they were more baroque than classic. The style of his earliest paintings tended to be overdetailed and episodic, but as his art evolved, design became more conscious and controlled, details were subordinated, forms were larger, and every element played its part in a coordinated whole.

Marsh was a prodigious worker and a constant experimenter, and through the years he practiced an extraordinary variety of mediums. The basis of all his techniques was the essential graphic character of his art. Beginning as a draftsman in black and white, in the 1920s he went on to watercolor, which he took to naturally, and oil, which gave him trouble. Then in 1929 he discovered the egg tempera medium, basically like watercolor but with more body and depth—a medium perfectly suited to his graphic style, and in which for the first time he attained full expression. After a decade he switched to large-scale watercolors, as complex and strong as his temperas. In 1940 he began to use the Maroger medium, an unfortunate detour until, after about five years, he commenced to master it. At the same time he embarked

on still another medium, Chinese ink with a brush on paper, which he practiced
the rest of his life, producing big grisaille compositions that were among his most
original works.

All these years, from the middle 1920s on, he was a prolific printmaker,
first working in etching and lithography, then concentrating on etching, and from
the early 1940s on, the ancient art of engraving. In essential form and design his
prints were among his most fully realized works in any medium, as can be seen in the
present book, in which his student and friend Norman Sasowsky has assembled
complete information, based on years of research, about this major field of Marsh's
artistic creation.

Marsh's style and content fitted him exceptionally for mural painting, which
was being revived in the 1930s by the government art projects. When the Treasury
Department Art Program was launched, he was one of the first twelve painters
chosen to decorate new buildings in Washington, and in 1935 he produced two frescoes
for the Post Office Building. This led to a much more ambitious project, for one of
New York's chief federal buildings, the Custom House: a huge oval rotunda offering
eight large and eight smaller spaces. The theme Marsh evolved was eight successive
stages in the arrival of an ocean liner in the port of New York, from passing
Ambrose Lightship to the final discharge of cargo—a contemporary saga, both actual
and epic. No artist was better qualified to picture it, by his love of New York's
great harbor and his years of painting it. The style of the murals was strong, vigorous
realism, less exuberantly crowded than his city paintings, with more simplification
and more sense of space. The forms throughout were constructed with a solidity
and power that made academic mural painting seem anemic. Marsh had achieved
something parallel to Renaissance mural painting; he had embodied living content
in monumental form. The Custom House murals remain not only an outstanding
success of the federal art projects but one of the most impressive achievements in the
history of American mural art.

While always at home in New York, Marsh traveled extensively; between
1925 and 1953 he made seven long visits to Europe, spent mostly in museums,
once as far as Moscow and Leningrad. It was his boast that "I have made some kind
of copy in pen and ink of almost every great picture in the European cities I visited."
All his life he was a learner, which made it inevitable that he should become a
teacher. Beginning in 1935 he taught at the Art Students League every year except
one, at first in summer, then from 1942 in both summers and winters, becoming
one of the league's most popular instructors. His teaching was founded on drawing,

study of the nude, and study of the old masters and of their technical processes, so much more complex than most modern methods.

From the middle 1940s Marsh's art exhibited interesting new developments. His subjects remained the same, but subject matter now acted as a springboard for pictorial invention. Often it seemed no longer directly connected with reality; the greater reality was the work of art. Naturalistic truth ceased to be important. Inanimate things received less attention; the entire concentration now was on the figures, whose essential forms and actions were the leading motifs. Even his Coney Island beach scenes had a visionary quality: dreamlike figures running, leaping, balancing—embodiments of energy and movement. They were more and more fantastically characterized: elongated thin figures, bulging obese ones, Bowery bums with skeleton bodies and desperate faces. The sense of the grotesque that had always been present in his work was now given free rein; his Chinese ink drawings especially revealed a wild humor that made earlier works seem staid.

His style displayed increasing freedom. Forms were linked in fluid rhythms running through the design. Line was broken up, interrupted, crosshatched, producing a vibrating continuum throughout the picture. His art was tending toward more abstract qualities; it could no longer be called primarily realistic, it now had a stronger element of the baroque. His handling showed increasing skill. Unexpectedly, refinement had replaced his earlier exuberance. There was a new delicacy; the technique was more translucent, the touch more deft, the color the most subtle he had achieved. Though not as large or complex as his pictures of the 1930s, those of the 1950s marked a major advance in intrinsic quality. In these last works, he was revealing the results of his long study and experimentation. His untimely death from a heart attack, on July 3, 1954, at the age of fifty-six, was a major loss to the art of our country.

Essay on Marsh's prints

part I

Nineteen twenty-nine, the year of the Great Depression, was a shattering year for many; for Reginald Marsh it was a beginning.

The skyline was a remarkable feature of New York in 1929, equaling, if not surpassing, the splendors of the great cities of earlier times. Broadway was the greatest light show in the world, a brilliant constellation compared to the dimness it was to experience in the 1940s and the faded, jaded afterglow it was to become. During the twenties the United States as a whole, and New York in particular, was self-confident in its economic well-being with little inkling of what would befall it at the end of the decade.

Reginald Marsh came to New York in the early 1920s, recently graduated from Yale, and in his early twenties himself. Behind him were an excellent education at The Lawrenceville School and a pleasant life in Nutley, New Jersey. His family had its birthright secure in American soil, and his economically successful grandfather had provided substantial security for his family, thus making it possible for Marsh's father to pursue an interest in the arts.

There were many opportunities for Marsh in New York City. New York as a factory was the place one came to make a livelihood, where even if one had little or nothing, by striving, working, conniving, a living or a fortune could be made. If one succeeded, living in the factory was abandoned in favor of suburbia, in the tradition of all the factory workers who had gone to the city to find and make their way. Unlike the immigrants who came to New York because this was their sole "choice," New York was truly Marsh's choice.

The city had its charms; it was lively and colorful and offered numerous amusements and diversions. It also provided its peculiar brand of humanism, a

live-and-let-live attitude, privacy amid close quarters, opportunities, and exposure to a multitude of ideas and styles. Graciously, New York made a place for Marsh, giving him sustenance by recognizing his background and ability. His work was soon commissioned by two new publications, *The Daily News* and the aptly titled weekly magazine, *The New Yorker*. Marsh was well suited for this work. At Yale, he had developed a quick graphic style in his drawings and cartoons for the *Record*. It was here that he met his lifelong friend and patron, William Benton, then the *Record*'s editor. In interviews, Marsh often credited Frank Crowninshield, editor of *Vanity Fair*, as having directed him to those locations which he was to make famous in his prints and paintings. However, there is evidence that the Yale undergraduate was aware of the world which was to attract and hold his later attention—New Yorkers in Coney Island, on the Bowery, and in the burlesque houses.

Marsh's work as a newspaper artist left him time for other pursuits. In the fall of 1922 he studied for one month with each of the following: George Luks, George Bridgeman, and Kenneth Hayes Miller. He also attended Sloan's night drawing class for four months during that same year. The road must have seemed fairly clear to him. New York received him well. He was talented and had chosen to develop his talents in an area in which he was successful. He had a good start and a willingness to work.

In 1925 Marsh made a trip to Europe and was inspired by the paintings in the Louvre to study art more seriously. However, his decision in 1927 to study with Kenneth Hayes Miller had a more lasting effect. Marsh could have continued on to a successful but limited career as an illustrator. It is to his credit that he chose to explore his full potential rather than rest on easily won laurels.

The 1920s were a period of great activity in the visual arts. Many new museums were founded during this time. The earlier strong influence of European abstraction was to loosen its hold on such distinguished American artists as O'Keeffe, Hartley, Weber, Macdonald-Wright, Dasburg, and Thomas Hart Benton.

Marsh inherited a situation already clarified in American painting. The period of the twenties was to harbor an antimodernist tradition, or, put in a more positive light, a turning inward, a look at one's immediate surroundings, to discover America, American ideals, and an American art.

According to Matthew Baigell, Thomas Hart Benton created his "first strictly Regionalist painting *The Lord is my Shepherd* in 1926."[1] Edward Hopper had developed his outlook as early as 1913, although it was not until the early 1920s that his style was fully realized. Charles Burchfield had evolved his style in the 1920s

and had achieved recognition by 1924. By the mid-twenties, the questions posed by the Armory Show were no longer pressing for many artists. The strong influence that the Armory Show had on many American artists was not felt by Marsh. By 1929, Hopper and Burchfield were considered leaders.

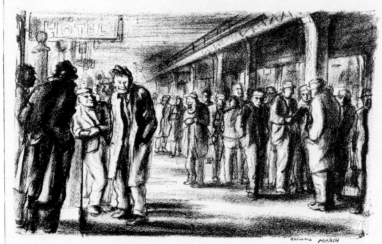

The New Yorker
October 20, 1928
Collection of
the Library of Congress

"Oh, Al Smith's all right, but I'm for leaving prosperity alone."

Marsh was never attracted to the modern movement. It is not at all difficult to trace the artistic heritage that Marsh accepted as his birthright. The seeds of a tradition in American art had been sown by Winslow Homer, Albert Pinkham Ryder, and Thomas Eakins. Though it was wholly based on the European tradition, the work of these artists possessed qualities that were thought to be uniquely American. This American tradition was continued by the group of artists called the "Eight"—Robert Henri, John Sloan, William Glackens, George Luks, Everett Shinn, Ernest Lawson, Arthur B. Davies, and Maurice Prendergast—particularly Sloan, Luks, and Shinn, and one should include George Bellows and Guy Pène du Bois although they were not members of the "Eight." Of course, Marsh was not content to look only at his immediate predecessors; he also returned to the European masters of the Renaissance and Baroque periods.

Marsh greatly admired the work of such artists and printmakers as Thomas Rowlandson (see illustration), Hogarth, Blake, Henry Fuseli, Daumier, Goya, Piranesi, and Rembrandt. There is a strong relationship between the tradition of painter-printmaker in Marsh's work and the work of some of the above-mentioned artists. The relationship to Marsh's contemporaries and predecessors in printmaking in America is closer and more obvious.

Marsh's prints are most directly related to the work of Sloan, Hopper, and Bellows, all of whom were already well established in printmaking in the mid-twenties. There are some interesting parallels between the prints of these men and Marsh's work.

John Sloan, considered the "dean of American etchers," started his career as a newspaper illustrator, as Homer had done before him and as Marsh was to do after him. In 1904, Sloan moved to New York and began an epic series of etchings of city life. He would often find subjects by looking out of his Twenty-third Street studio window, a practice Marsh followed years later in his studio at 1 Union Square.

Sloan's etchings were very influential. Guy Pène du Bois considered him foremost among etchers who used figures in their natural environment. In the autumn of 1905, Sloan substituted for Robert Henri at the Chase School where George Bellows was a Henri student. Sloan's etchings were well known at this time, having received praise from liberal critics. Bellows also had a great appreciation of Sloan's etchings; in addressing the annual meeting of the National Arts Club, he said: "... for the price of a theater ticket or so, one can buy the proof of an etching by John Sloan who, in my humble opinion, is the greatest living etcher and a very great artist."[2]

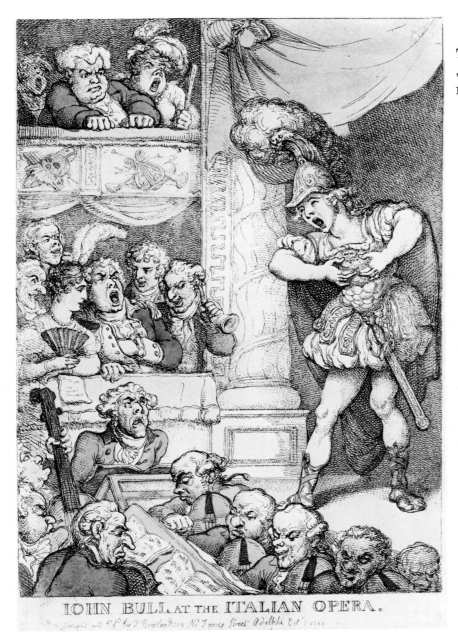

Thomas Rowlandson
John Bull at the Italian Opera
Harvard Theatre Collection

IOHN BULL AT THE ITALIAN OPERA.

Sloan was a very skillful technician. His etchings are nicely bitten with a
wide range of tones, created by carefully developed cross-hatching. The drawing in his
prints is often very beautiful, with a sense of correctness and a professional quality.

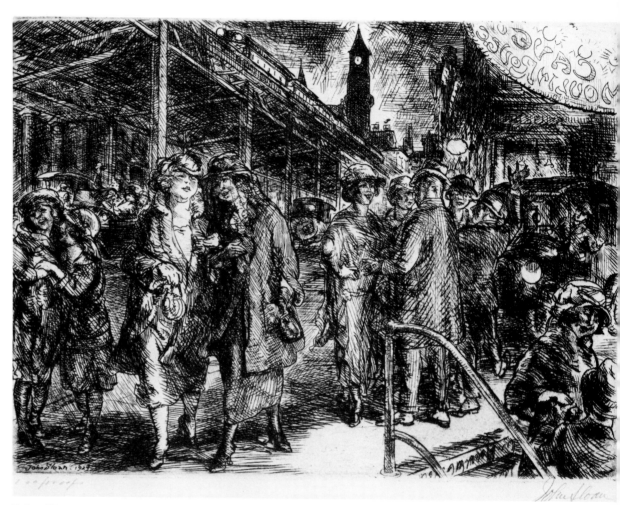

John Sloan
Sixth Avenue, Greenwich Village
Collection of the Library of Congress

He placed great emphasis on characterization and movement, and his work has
marked topical interest. His *Jewelry Store Window,* a 1906 etching, has as its subject
a couple under the elevated trains looking into a storefront window. Illumination
of the scene is emphasized as are the gestures and facial expressions of the
couple. *Sixth Avenue Greenwich Village,* done by Sloan in 1923, is another scene

of life under the elevated trains; two girls stroll arm in arm. While similar themes and moods were used by Marsh, the forms in his prints are more compressed, that is, perspective lines tend to be de-emphasized.

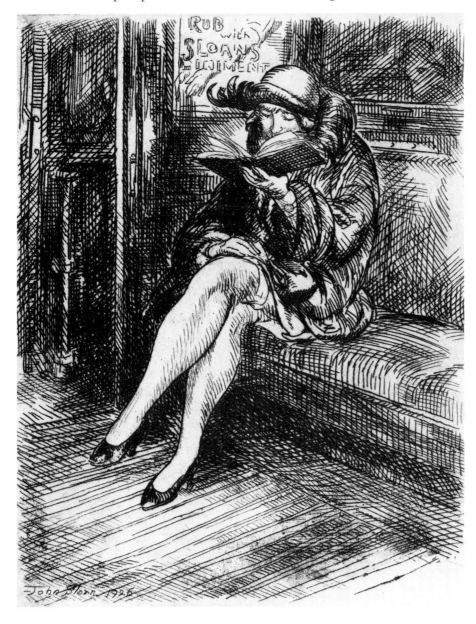

John Sloan
Reading in the Subway
Collection of the Library of Congress

Sloan's lithograph, *Sixth Avenue and Thirtieth Street,* 1908, and the etchings *Girl and Beggar,* 1910, and *Reading in the Subway,* 1926, are other examples of subjects related to those Marsh was to develop during his career. (See Marsh prints #59 and #61.) *Reading in the Subway* was reproduced in *Vanity Fair* (August 26, 1926), a magazine to which Marsh also contributed.

Sloan abandoned the genre aspect of his work around 1929 and started a series of etchings of nude models. His interest had definitely turned away from the topical, as if he were consciously trying to eliminate illustrative incident in his work in order to concentrate on form. (Mrs. Marsh still has one of the best etchings of this series, *Nude on the Floor,* which Sloan did in 1934.)

Edward Hopper
House Tops
Philadelphia Museum of Art

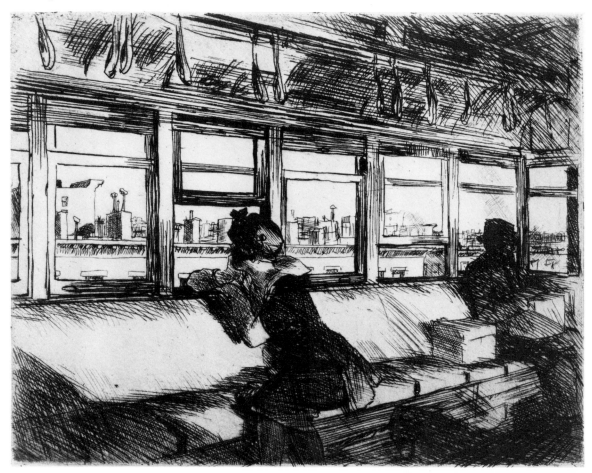

Sloan had provided a model upon which Marsh could build. Hopper provides another in that tradition, although, unlike Sloan, mood and space, strong dark and light pattern, and stark illumination dominate the best of his work. Marsh was to develop a keen interest in movement and to minimize any interest in highly contrasted light.

Between 1919 and 1923, Hopper made thirty prints. Hopper was extremely persevering; from the early twenties until his death in 1967, he rode out the storms and tribulations of art movements with a slow, continuous progression from a vision established early in his development.

Hopper studied at the Chase School from 1900 to 1905, under Robert Henri and Kenneth Hayes Miller (Bellows and du Bois were fellow students). Prints such as *The Evening Wind,* 1921, and *East Side Interior,* 1922, are excellent examples of Hopper's treatment of interior domestic scenes. There is a great range of tones including very fine lines. Blacks are extremely intense. The feeling of space and atmosphere is strong.

In prints like *The Catboat,* 1922, *Night in the Park,* 1921, and *Night Shadows,* 1921, dramatic foreshortening is used to penetrate space. In the latter two prints, there is a strong light and dark pattern that is strengthened by leaving much ink on the plate in the dark areas and wiping the plate clean in the light areas. *House Tops,* 1921, is more akin to Marsh in subject. Marsh also shared with Hopper an interest in locomotives. An example is Hopper's 1922 etching, *The Railroad,* in which the forms penetrate the space creating a sense of quiet or ominous waiting. Converging lines seem to be a characteristic of many of Hopper's etchings. (One might note that the diagonal is extremely important in Hopper's work.) In his print *Train and Bathers,* 1920, the locomotive and nude female figure are united in one composition. Marsh used both themes in his work, but never together. Hopper's etching is very weak in some respects. The figures are poorly realized and the locomotive looks more like a trolley than the majestic locomotives and figures that appear in other Hopper prints. Hopper had a range of interests not exclusively attached to city subjects. However, he provides an interesting precursor for Marsh's work. In 1927 (February 14 to March 5), Hopper exhibited a group of etchings at the Rehn Gallery. Hopper never pursued his career as a printmaker. Before Marsh had started making prints, Hopper had left the field and concentrated his efforts in painting.

Commenting on Hopper and Burchfield, Baigell states that perhaps unconsciously they kept alive the intellectual disillusionment of the 1920s.[3] They

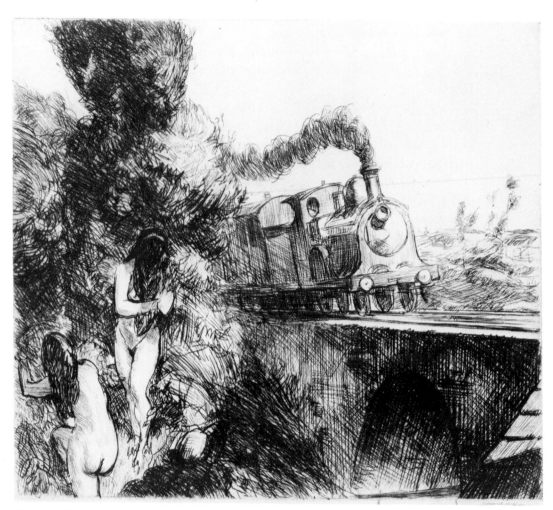

Edward Hopper
Train and Bathers
Philadelphia Museum of Art

lacked optimism; they indicted America. Joy and love of life do not exist in their work
as they did in the work of the "Eight." Even before the depression they painted
an America that was tired and drained of spirit. In reviewing Marsh's 1930 exhibition
of paintings at the Rehn Gallery, a critic said that Marsh received the mantle of
John Sloan and George Bellows.

George Bellows
The Street
Collection of the Library of Congress

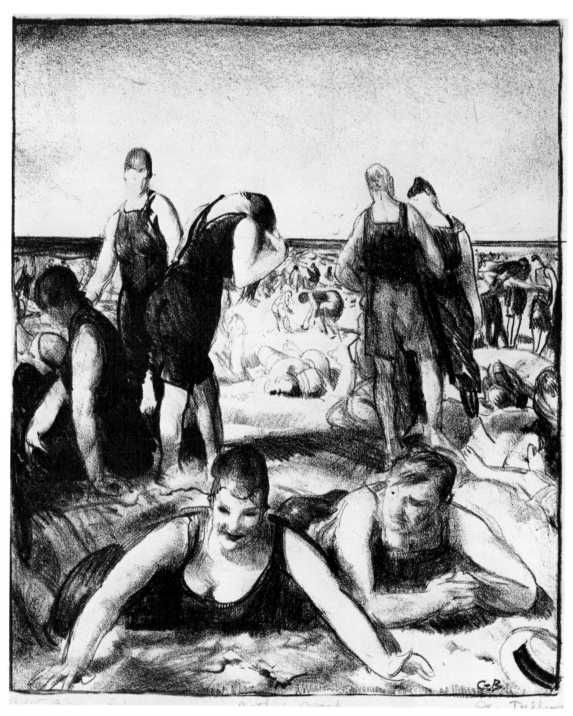

George Bellows
Bathing Beach
Collection of the Library of Congress

Bellows continued in a tradition that Sloan had started. Bellows had come to New York City in 1904 and studied with Robert Henri, Kenneth Hayes Miller, and H. G. Maratta. As part of Henri's inner circle, he was in close contact with Luks, Sloan, Shinn, and William Glackens, fertile soil in which his talent could mature.

Charles H. Morgan reports that in the fall of 1918, Bellows received unexpected fame for his war lithographs shown at Keppel's.[4] Ultimately, Bellows was to receive greatest acclaim for his lithograph *Stag at Sharkey's* and other lithographs of boxing subjects. Bellows's sale of lithographs in 1921 and 1922 brought more than $1,000. In five years he had made lithography profitable.[5] Printmaking as a source of income and fame for the artist was an established possibility; Marsh, starting out as a cub illustrator for the New York newspapers, must have been aware of Bellows's work and his success.

Bellows's lithographs were reproduced in a book published in 1928[6] and may have stimulated Marsh's interests. *The Street,* 1917, and *Two Girls,* 1917,[7] are precursors of Marsh's work—especially the latter, which recalls Marsh's 1928 lithograph, *Two Models on Bed.* Bellows's *The Street* includes two girls promenading amidst the street crowd under the elevated train. The girls have the manner of Marsh's girls, but for Marsh the girl was almost always alone. Bellows made the crowd most important; the structure of the elevated is subordinated, creating a sense of space and air on the street. Marsh tended to crowd similar scenes and he was as interested in the elevated structure as in the crowd. Moreover, in Marsh's print *Tattoo-Shave-Haircut,* there is no sense of air, space, or escape; it is a self-contained world.

Bellows used other subjects that Marsh was to immortalize. Bellows's 1921 litho, *Bathing Beach,*[8] composed of people on the beach, is somewhat static and open compared to Marsh's treatment of similar subjects. The 1924 *River Front*[9] is in the same category except that in this print Bellows creates a feeling of density by the play of light and dark patterns. Peyton Boswell quotes Bellows as stating that the prize ring was "the only instance in everyday life where the nude figure is displayed." Years later, Marsh described the beach as a place "where a million near-naked bodies could be seen at once, a phenomenon unparalleled in history."[10]

Sometimes Bellows made drawings and prints for a particular idea before treating it in a painting, as in the case of the Dempsey-Firpo fight.[11] At other times, the procedure was reversed. This interchangeability of method was used also by Marsh.

It is difficult to speculate on what Bellows would have continued to do as a

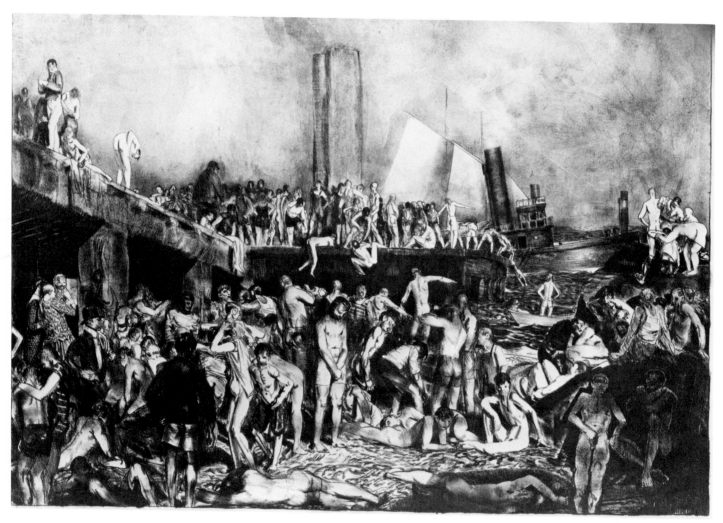

George Bellows
River Front
University Art Museum, The University of Mexico

printmaker had he not died in 1925. Marsh's first etching was done in 1926 and his first lithograph in 1928, though he had executed some linoleum cuts in the early twenties. Late in 1925, as noted earlier, Marsh went to Europe and was inspired by the paintings in the Louvre. He returned to New York and studied with Kenneth

Hayes Miller for four months in 1927–28. Miller was of course familiar with the "realist" tradition, but he had ideas of his own beyond that tradition. While there is not a strong link between Marsh's prints and those of Kenneth Hayes Miller, there is a definite relationship. Miller did use New York subjects, such as in the etching *Three Girls Meeting,* 1918. The subjects were of secondary importance in his work; he was much more concerned with form. Marsh derived part of his approach from Miller in that they both minimized illumination and strove to create a relieflike form compressed in a relatively shallow space. Miller often brought his subject close to the front picture plane, whereas Marsh kept some foreground free and placed his forms in the middleground. Overall "color" is similar in both men's prints, tending toward a "blond coloration" rather than an emphasis on illumination or strong dark and light patterns.

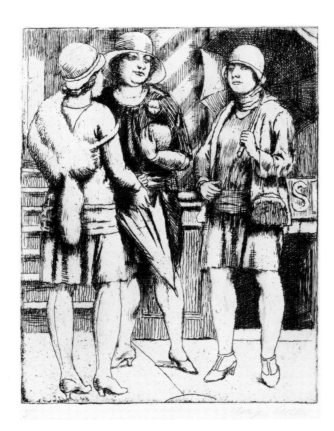

Kenneth Hayes Miller
Three Girls Meeting
The Metropolitan Museum of Art

Bellows's, Sloan's, and Hopper's work can be seen as part of an historical development of printmaking prior to the 1930s. Marsh continued that tradition and made a unique contribution. Besides using New York as a subject for their prints, Bellows and Sloan also used the Southwest and Hopper used New England. Marsh alone used New York City, its structures and signs exclusively as the focus of his work. Many of Marsh's contemporaries also looked to the city as a vital subject for their work. However, Marsh chose to explore certain aspects of the city not explored by the others and he made them his symbol. He hated to leave the city as much as Miller did, since his art was totally intertwined with the city. It should also be clear that Marsh did not choose his subject matter as a reaction to the Great Depression. He made his choice because the city and its people held a great attraction for him.

Marsh had time to explore his interests and abilities in the twenties. When the world went asunder in 1929, Marsh found himself. In 1929 he became an established intaglio printmaker, producing twenty-seven etchings, and surpassing this in 1931 when he produced twenty-eight. Perhaps it was the disastrous situation of those years that gave Marsh the impetus to devote himself to printmaking. (Surely, he sensed and experienced the fallen glory of New York in the thirties and its further decline until his death in 1954. As the city changed, so did Marsh's interest in printmaking abate.) A twelve year period, from 1928 through 1940, marks his most productive years, although there were notable high points in later years.

part 2

Marsh explored and mastered traditional etching techniques; he was for the most part self-taught. He kept careful records regarding many of his etchings, noting the temperature of the room, the age of the bath, its composition, and the length of time the plate was bitten (etched). When printing, he recorded how long the paper had been soaked, the heating of the plate, the nature of the ink used, and preparation of the plate for printing (the sequence of heating, inking, and wiping of the plate). Marsh enjoyed trying new methods within the confines of traditional intaglio plate making. Experimentation expanded his techniques and added another dimension to the experience of working. For example, various grounds were used: Rhinds liquid, Nankwill liquid, and Sands wax. The methods were also varied for applying the ground to the etching plate: rolled, dabbed, poured, or painted. Both Dutch (mordant) and nitric acid etching baths were used, the former being noted for its slower action, which produces fine, well-bitten lines. Later on he made use of a faster-biting Dutch bath. In 1939, he experimented briefly with Russell mordant. Acetic acid was often employed to start biting the plate. There are many references to ''spit biting'' in Marsh's notes; small areas are bitten by mixing saliva and acid and applying this with a brush.

When Marsh drew on the ground, he also enjoyed experimenting with different drawing tools. Sometimes he drew directly on the plate while it was in the bath being etched. His self-portrait (S.46) is an example of this practice. On several occasions, Marsh noted the use of a mirror while drawing from nature directly on the plate. Daylight made it easier to see the drawing on the plate without having to darken it with smoke.

When Marsh began working primarily in engraving, he tried many different sizes and shapes of engraving tools. His notes indicate the use of a Grofé lozenge and a variety of both Muller's and Sellers's tools. Isabel Bishop reports that when both she and Marsh were in Stanley William Hayter's class at the New School, one of the great challenges was to learn the proper way to sharpen one's tools. Hayter's emphasis was on a free use of the burin so that one could draw in the copper; the tool had to be expertly sharpened to make this a possibility. Marsh used fine, hand-hammered copper for his engravings and rarely worked on zinc plates.

His notebooks are filled with minute data regarding the etching of many of the plates. A code was employed to indicate how the plate was prepared for printing. Thus, when a notation such as ''HIRHW'' appears in his notes, it suggests

that the plate in question was heated, inked, rag- and hand-wiped. In this way, he was able to determine the method that best suited his needs. Marsh did not vary the inks and papers very much. Kimber French and Frankfort black printing inks seem to have been his favorites; a little boiled oil was used to thin the ink. At the beginning of his career, he used Umbria Italia and BFK Rives papers; gradually, he used more Whatman. At times he also used random antique papers that he obtained from old books. The lithographs have, for the most part, been printed on "papier collé," a thin sheet of paper printed and mounted simultaneously on a larger, heavier backing sheet. The thin India paper used in this process is excellent for printing but too weak as a self-sufficient support.

It did not appear that Marsh was interested in more experimental techniques or in the utilization of nonlinear approaches, such as aquatint. While the technical possibilities of printmaking were not the focus of his interest, one cannot help but note the aesthetic qualities created by Marsh's etching and engraving techniques.

Marsh first began adding touches of engraving to his etchings in the early 1930s. Gradually, he taught himself the art of copper engraving. In the fall of 1940 he studied with the noted British engraver Stanley William Hayter. Marsh's records also indicate that he studied with a commercial engraver, Michael Hoppé, as early as 1942. Edward Laning describes an account of what must have been Marsh's introduction to Hoppé:

> I remember going to his (Marsh's) studio one day and being introduced by him to a stranger. They were poring over bits of calligraphy—and dollar bills! Reg had found the man on Fourteenth Street, selling examples of penmanship (for a quarter he would write the purchaser's name in fine italic script on a card). Reg had watched for a while and then said to him "Where did you learn to use your pen like that?" The man replied "I used to be an engraver at the mint in Washington." Reg invited him to come up to his studio and immediately began to pay him for lessons in engraving.[12]

The influence of Hoppé is very apparent in Marsh's brilliant 1943 engraving *Merry-Go-Round* (S.222). This plate was done in "bank-note" style engraving, a decidedly more cursive style than Marsh had ever before used.

Throughout his career, Marsh was in the habit of studying the visual world around him. He had a need to observe and make notations of what he saw. To record his observations he carried a small pocket sketchbook and drew whenever he had the opportunity. He also photographed many of the locations used in his

prints, drew the nude model regularly, and made "on-the-spot" watercolor studies. Each of these activities helped him to see more vividly, to gain knowledge of the forms that interested him, and to remember these forms. Rarely did he use these "exercises" as the direct basis for a print; they served rather as background experience upon which he could call. Marsh preferred to work, as he said, "from my imagination," that is, creating his forms from his general experience.

It is not clear how Marsh initially composed his prints, though it is thought that at least one careful drawing was done beforehand in which all the compositional problems had been resolved. He would transfer his drawings—sometimes done on tracing paper—by reversing the drawing, red-chalking the underside of the paper, and then making the transfer directly onto the ground.

In making his etchings, Marsh's method was to draw the complete design on the etching ground. Usually this was done in outline with some building-up of the forms; he retained this basic approach for many years. (The first state of the 1938 engraving *Merry-Go-Round* (S.179) has an etched outline drawing which he used as a guide for a subsequent engraving.) He would proceed to build up his forms by adding parallel diagonal and crosshatched lines to various areas (mostly in the dark areas) until he had achieved the desired effect of large forms and details. Rarely were the basic forms or the overall relationship among the forms changed. Marsh sought to create a relieflike space: a feeling of three-dimensional form compressed on a two-dimensional surface. Often the first state was bitten in three stages, thus differentiating between lightly and more deeply bitten lines. The biting of the plate frequently took many hours when Marsh used a Dutch bath (mordant). Toward the end of his career, he used the more common nitric bath in order to produce quicker results. His decision to make copper engravings eliminated the process of biting the plate, thus allowing him to work more directly and to see the results rapidly.

Prints offer a fascinating area for study because state proofs are often available. State proofs provide evidence of the thought and work processes of the artist. Fortunately, Marsh kept most of his state proofs. It is good to keep in mind how indirect the method of printmaking is. While the artist's design is conceived in one way, it must be reversed in order to appear as originally conceived in the final print. Furthermore, in the case of etching, the drawing is a light drawing against a dark ground. Thus, printmaking involves a very indirect approach, requiring the artist to make trial proofs in order to see what he has really created.

In writing the descriptions of the various states for the catalog, an attempt has been made to provide the reader with an idea of how Marsh developed individual

plates. Some plates were developed rather quickly, others required as many as ten states to bring the print to completion. Generally, it was a technical problem, such as foul biting, which might necessitate the careful removal of the foul bite over a number of states. *Coney Island Beach, 1934* (S.153) required correction because part of the ceiling had fallen on the plate.

In a few instances, Marsh was dissatisfied with the drawing of a face, and this required major work on the plate to correct the fault. For example, the final state of the 1930 etching *Merry-Go-Round* (S.99) contains a very different head on the main female figure than do the early states. The original head was not a pretty 1930s type; he effaced the head and replaced it with one that was more acceptable. Similarly, the figure immediately to the left of the main figure was changed. The prints *Smokehounds* (S.158) and *Grand Tier at the Met* (S.190) required more major changes. Marsh was not reluctant to undertake such revision when he felt there was a real need, even though it required extensive ''hammering up'' of the plate in order to provide new copper on which to make corrections. Changes such as these are not common in Marsh's work. The state proof descriptions offer the reader information about the way in which Marsh's prints were developed. They also offer a description of particular states, although the catalog descriptions fall far short of what actual illustrations of individual states would provide.

What cannot be illustrated is the way in which Marsh etched the states. As noted earlier, he generally bit each state, especially early ones, in three stages. He would draw on the ground that had been rolled, dabbed, or poured on the plate and had been darkened with smoke. The plate would then be etched for a time, removed from the bath, and certain parts of the drawing ''stopped out,'' that is, coated with an acid-resistant substance so that those lines would no longer be bitten. After a second time in the bath the plate was removed, more lines stopped out, and the plate returned for a final biting. In this way three different values of lines were created, the darkest lines being those that had not been stopped out at all. Typically, he then removed the ground and made two trial proofs to see the progress of his work.

Another ground was then laid and the process of drawing and biting the plate was continued. However, in some states, he was more likely to add drawing to the plate between each successive biting of the plate; this had the effect of adding lighter lines as the plate was bitten. The method describd here is the way Marsh worked in the early part of his career. Later he began to simplify his method by adding touches of engraving to develop the plate, thus making it possible to avoid laying a ground and etching the plate.

In the early 1920s Marsh produced linoleum cuts that seem to be illustrative in intent. Some of the subjects are biblical, others are derived from secular literature, and there is enough evidence to surmise that a number were illustrations for magazines. Several reproductions of different linoleum block subjects have been located (J, K, L, S, EE). Since few contemporary impressions exist, one could conjecture that the linoleum block prints were not made with the idea of printing an edition, but rather to create an illustration using the special technique of linoleum block cutting. The few subjects that were greeting cards were probably printed and distributed as such. To support the idea that the blocks were never intended strictly as print mediums, it should be noted that many of them have holes drilled in the corners. These holes were used to mount the blocks on a wall or door of Marsh's father's home in Woodstock, New York. The linoleum prints offer some insight into Marsh's approach to printmaking at this early date.

The fact that he did not continue making linocuts is in itself significant, for Marsh did not prefer to work directly with light and dark areas, which are characteristic of the linocut method, but chose to build forms with lines. His early interest in lithography suffered the same fate. Marsh began making lithographs and etchings in the second half of the 1920s. Although he had bursts of activity in 1928 and 1932, he subsequently produced only a few lithographs. The greatest bulk of his work is in etching and copper engraving. While Marsh preferred etching and engraving, he was quite capable of doing excellent work in nonlinear mediums. One might indeed feel that in the few instances where he treated the same design in etching and lithography, the lithograph is superior (S.20 and S.99, S.29 and S.85).

Marsh's earliest prints were conceived as drawings and then transferred to a printmaking medium. Two trips to Paris (1928, 1932) made possible the completion of two groups of lithographs. These lithographs are, for the most part, drawn in a style similar to his work for *The Daily News* and *The New Yorker*. In fact, we expect to find in a few of them a ''one-liner'' beneath the drawing. These early works are related in approach to Daumier's lithographs, which often were published with a ''one-liner'' and certainly rank high in the history of graphic art.

In addition to Parisian subjects in the two groups of early lithographs, Marsh also brought to Paris sketches and/or ideas about New York. These ideas were realized in *Huber's Museum, Irving Place Burlesque, The Bowery,* and *Erie R.R. Yards. The Bowery* (S.16) is one of the outstanding prints in the 1928 group. It has better drawing, design, mood, use of medium, and characterizations than the other prints. The forms of the figures are gnarled masses. Light and dark pattern

plays an important role in serving to define individual forms within the larger mass. The figures seem to support the train tracks; the background, by contrast, is placid. The diagonal thrust is important in this print; space is penetrated, creating a deep space. If this was drawn in Paris, Marsh retained a strong memory of the Bowery. However, the drawing may have been done in New York and brought to Paris for transfer and printing; this was not an uncommon practice.

Two lithographs were completed in 1929 and 1931, *Penn Station* (S.19) and *Merry-Go-Round* (S.20). Marsh was not happy with the latter. An impression has been located in which the face of the main figure has been redrawn on the proof. Inscribed in the margin is a note in Marsh's hand attesting to the fact that he made the corrections. Marsh commented to the owner of the proof that he was not satisfied with this print. It seems that the problem of the main figure's face was to plague him in both the etching and lithograph of this particular subject. Also, note the ''second thought'' regarding the placement of the arm near the top of the print.

On the whole, the six lithographs made in 1932 are weak in comparison to Marsh's earlier prints and perhaps mark the loss of his interest in lithography for an extended period.

The 1948 lithograph *Switch Engines, Erie Yards, Jersey City* (S.30) is strong and well realized. Marsh completed drawings on three stones before a final stone was selected. He also made an engraving (S.232) and a watercolor study in preparation for the print that had been commissioned by the Print Club of Cleveland. Marsh had a tendency to emphasize strong illumination in working with a tonal medium, and this print is an excellent illustration of his ability to master this approach.

The subject of Marsh's earliest etching (1926) is two tramps by the Seine (S.32). Probably this print was created from sketches he brought home from a European trip. By 1929 he had committed himself to line etching after some work in drypoint. At first he would employ drypoint additions to the plates when he wanted to add some final touches. However, he soon abandoned drypoint in favor of the more distinctive additions of the engraver's burin. Gradually, engraving became the preferred medium, probably because Marsh could realize his images more directly than he was able to do in the more elaborate, time-consuming medium of etching.

A parallel idea supporting the contention that Marsh was more drawn to working with line is the fact that he stopped oil painting and chose to use egg tempera during the 1930s. He used tempera as a drawing medium, transparently, with reliance on a linear framework as opposed to painting masses. Mass was added to a linear structure much as was done in his etchings and engravings.

The 1928 drypoint *Paris Tramp* (S.53) provides a good comparison between Marsh's lithographs of that date and his emerging interest in intaglio printmaking. It would seem that the artist was better able to realize his great potential as a draftsman in this print. The drawing has great sensitivity, which is given an opportunity to emerge, in part, by the nature of the medium.

Where Marsh has treated the same design in mediums other than printmaking, this is indicated in the catalog. In some cases, he made the print first; in others the painting preceded, or they were created at the same time. Often the print seems finer in design or details. It is difficult to compare them since scale, color, and value are so different. It would be shortsighted to think of these prints as mere reproductions of his paintings, because he did consider his ideas in terms of the print medium.

Toward the end of his career, Marsh was making prints that were not directly related to his paintings. He used the characteristics particular to engraving, that is, he thought more in engraving terms. In this sense, his work as a printmaker became more pure. However, for a long time, Marsh found it important to use the same designs in two different mediums. Perhaps it is unfair to ask how important an addition to Marsh's œuvre are his prints, or if his reputation would suffer without considering them. Would it be more correct to ask how much his paintings add to his stature as a graphic artist? Surely, both facets of the man are very important, and the omission of either would be a great loss.

The highest award given to Marsh was the Gold Medal for Graphic Arts awarded by the American Academy and the National Institute for Arts and Letters shortly before his death.

In a sense, Marsh was a chronicler—the person to record certain aspects of life in New York City from the early 1920s to his death in 1954. Laning has said in comparing Marsh's work to Sloan's that "Marsh convinces us that its [city life] meaning is no longer so easy to grasp and that an element of the fantastic is necessary to suggest it."[13]

It is possible to view Marsh's work from two vantage points. From one view we see that many of his prints were based on his observations; these are rather factual in that they represent particular people and places. This is not to say that he sought to reproduce nature in this group of prints, for indeed the artist's hand and eye are the intermediaries, and one still gets *Marsh*'s interpretation of observed data. What is lacking in them is the larger stage or setting for the presentation

of Marsh's ideas. The greater portion of his work is concerned with forms of his own creation. Although these prints are also composed of observed data, they represent observed, remembered, and imagined forms in new combinations.

Some people and places are symbolic of what many of us are experiencing or are about to experience. One can agree with Goodrich in saying that Marsh identified with New York and certain groups in the city. However, Marsh was neither one of those who pay to be seen, or who pay to see, but was rather in an intermediary position, somewhat outside the situation, aware of his inextricable association with it. A tragic mood and a quality of fantasy underlie much of his work.

What and whom did Marsh choose to chronicle? Places. Many, in and around New York, occasionally a landscape. The landscapes were done mostly as a defense for having been removed from his natural habitat, the city. Clearly, his subject was the city and people in relation to it, and this was established by the late 1920s.

Certain aspects of the city seemed to interest Marsh more than others; they received a more intense treatment and development and interest his audience more. They remain in our minds because strong responses are evoked. The burlesque show is such a recurring theme as are the locomotives in the railroad yards, the Bowery, girls on the merry-go-round, and occasionally high life at the opera. It is clear that Marsh had a strong interaction with certain facets of the city; they provided him with the stimulus and forms that he could use to express his ideas. But beyond the places he chose, a central concern was—people. Generally large groups of people, occasionally solitary girls, and the people in his personal life.

In his etchings and engravings, Marsh returned to the subjects to which he had first been introduced as an illustrator. Now he approached these subjects in an entirely new way. He had traveled to Europe on several occasions, not to see the moderns, but to study the old masters. Renaissance artists and baroque artists like Rubens were of great interest to him. He was attracted to their art, the kind of form they had developed, and the way they drew. The burlesque and Coney Island prints have more in common with Renaissance and baroque painting than with Marsh's previous work as an illustrator. He was able to go beyond a highly developed style as an illustrator, even though it is difficult to eliminate the mannerisms of line and caricature once these are established. Occasionally, the prints show these earlier stylistic marks.

Marsh included different types of people in his prints. These people are distinguished by what they are doing. Sometimes the subject is a laborer, stripper, or subway rider; their clothing, a costume or uniform, and their placement or location

help to define them. In fact, Marsh's work is a good source for the clothing styles of the period. Individuals are usually part of a larger tableau and are rarely singled out for greater in-depth study. The people in Marsh's prints are on stage, posing for the artist—captured in an attitude, a telling moment.

When Marsh chose to concentrate on an individual, as in his portraits, he exhibits greater character analysis. Two excellent examples of his ability in this area are depicted in the prints *Llewelyn Powys* (S.98), the noted British writer, and *Walter Broe* (S.165), a destitute man the artist had befriended. Other such examples are the elegant portrait of Marsh's wife, *Felicia* (S.173), a beautiful later small engraving *Felicia* (S.181), and the portrait of *Kenneth Hayes Miller* (S.189), which appears as if it had been carved in granite.

Marsh was interested in the impact of the aggregate. The people in his earlier prints sometimes seem stereotyped or caricatured, though, by 1934, this is not the case. By that time the forms of the faces are highly developed and one has the impression that they are people we might encounter in a real-life situation. The faces of his friends appear in some of Marsh's work. Lloyd Goodrich appears in at least one etching (S.101). In S.153, Kenneth Hayes Miller can be seen standing on the boardwalk wearing a straw hat. There probably are others, with whom the author is not acquainted. Small self-portraits were also included, for example, as a decoration on a merry-go-round horse's gear (S.99, S.222), or as a reflection in a subway-car window (S.59). The artist is along for the ride and we feel his presence.

Marsh retained a boyhood interest in locomotives and industrial subjects, the latter no doubt attributable to his father's interests. The locomotives are phallic in form and appear in Marsh's work almost as a leitmotif throughout his career. They are rendered with great knowledge, affection, and dignity. Machines are stately, powerful, and detailed; men are secondary in these prints—the ''masculine'' presence is the locomotive, men are minuscule, mere functionaries for the machine. City buildings and elevated trains are other kinds of machines that seem to have dominated Marsh's men. In *Tenth Ave. at 27th Street* (S.128), men are huddled together, hands in their pockets, passive in the shadow of overpowering buildings.

By 1932, Marsh had produced some of his most important prints, including *Tattoo-Shave-Haircut* (S.140). In this print a crowd of men, a girl, and the Bowery with the elevated are totally integrated. It is a fantastic setting, albeit the situation seems realistic. Perhaps it is Marsh's meshing and condensation of the various elements that give the print its great power. In *Star Burlesque,* 1933 (S.142), the men are still the same types as those found in earlier prints, trapped

by a beautiful baroque machine—an elegant one at that—very much dominated by the surroundings. Only the girl—the striptease artist— can compete with the environment. She stands in a victorious pose while the men seem to cringe in her presence. *The Jungle* (S.154), *Smokehounds* (S.158), and *Steeplechase Swings* (S.160) all follow in 1934. In the first two prints, men are again trapped, the factory is impervious in the background, neat, trim, operating, while the down-and-out men perform their small rituals of daily living. In the third print the people surrender to the machine and literally take off from mundane everyday cares.

The Merry-Go-Round prints, completed in 1930 (S.99), 1936 (S.171), 1938 (S.179), 1940 (S.210), and 1943 (S.222) provide us with an exemplar of Marsh's development. By 1943 the girl on the merry-go-round horse no longer has to compete with the environment. She retains her "charger" but she has become, as a student once remarked to the author, more horselike. Indeed, she is twisted and machinelike, even though she is rendered with great technical skill and facility with a strong emphasis on anatomical detail. The horse seems half-crazed. Marsh's self-portrait appears beneath the horse's gaping mouth. The development of this subject is a chronicle of the changes undergone by Marsh, the city, and its inhabitants.

As Marsh's career developed, he gradually began to abandon the use of background material (he did this to some degree as early as 1930, see S.133) and concentrate on the figures themselves. The setting disappears; the machine or the backdrop falls away—only the people remain, but they are now isolated; something has happened to them and to the artist. Compare Marsh's *Coney Island Beach* (S.153) done in 1934 to the same subject (S.191) in 1939. The beach is hardly evident in the later etching, even though both compositions are crowded with typical summer throngs. The 1939 print reminds one of Michelangelo's *Last Judgment*.

The people in Marsh's prints communicate via their body actions and forms. The men are usually defeated and passive, although those on the beach display an interest in physical form and athletics. The women are symbols, modern-day (1930s) madonnas, an ideal. They are desirable but unattainable—a last vestige of romance. Marsh was gradually able to sift out the intense interest he had in what is perhaps his major theme: woman and his feelings toward this form.

One can summarize Marsh's subjects by stating that they were often animated; they included locomotives, tugboats, skylines, and industrial subjects in which people play a minuscule part. They also encompassed life on the Bowery or under the elevated, where derelicts wander aimlessly; Coney Island, the amusement area and the beach, where figures are seen in mass in a fantasylike world;

and the burlesque house in which men—like passive locomotives—sit locked in the audience viewing the girl or girls from whom they are effectively separated by art—stage art. Marsh was able to weave a very fine, delicate web of lines in which to capture New York and its people. And this is exactly what Marsh had to do, because he needed to grasp the real world, to fix it clearly in his mind and then on paper, in order to have some power and control over these forms. Art served the artist as a form of magic. The city and its people were magical, fantastic works of art.

It would be wrong to consider as important only the subjects of Marsh's work. He used these as many artists have done in the past, that is, continuing a tradition of subject matter. This can be readily seen as indicated earlier by noting the work of Hopper, Sloan, and Bellows. It is Marsh's development of certain subjects that really allows us to come in contact with his work, his topic. Although his subject matter is an important structural component, the manner in which he developed and extended subject matter is more important.

One of the major purposes of this book is to make Marsh's work available to a wider audience. By being able to see his entire output in prints, by observing the work, new insights and understanding may emerge. In accord with this idea, one should note the qualities to be found in Marsh's work.

Laning has accurately noted that Marsh's line was, essentially, nervous and jittery compared to Sloan's. There is a very restless quality in Marsh's multidirectional lines. Most of his lines are short and suggest quick movements. It is important to remember that in making etchings, Marsh had to draw in reverse with a light line (cutting through the darkened ground to expose the lighter colored copper). Also, variations do not occur within the etching line which is of even thickness, but rather with the directions of the lines. Although Marsh did not vary the thickness of his drawn lines, he could bite the plate for various lengths of time, thus producing lines of different thickness and darkness. By variations in biting time and by grouping lines, he built up the needed gradations of tone. The directions of the lines also aided in defining the three-dimensional aspects of his forms; curved surfaces were treated with curved lines, flat surfaces with straight lines.

In his first attempts with engravings, Marsh used the same concept of line that he used in etching. He engraved three different-sized lines, as if he were still restricted to biting the plate in three stages. The only difference was that the engraved lines had some taper at their beginnings and endings. The lines still function without any explicit tonal quality; they do not, in themselves, suggest light

or dark values as a means for developing forms. Marsh also used parallel lines with little space between them to suggest the three-dimensionality of his forms. Lines also created textural qualities that are often slightly bristly or hairy. One might note the similarity of this texture to dark hairs. Although Marsh tended to minimize local color, lines were occasionally used to darken (local color) certain elements.

The outlines of solid bodies are often darkened by the addition of drypoint or engraving. This helped to separate forms from each other and to enhance the three-dimensional development of the forms. An outline of the shapes Marsh has enclosed is rarely made of a single, continuous line; it consists of many lines and the viewer tends to select the one that helps to define the limits of the form.

Marsh had a definite preference for ovoid enclosures or forms. *Merry-Go-Round* (S.99) abounds in such enclosures, having both large and small ovoid forms that join to create a bubbly surface. Often he placed ovoid forms in contrast to rectangular enclosures representing man-made architectural elements. The "rule" he used was: human forms are curved, swollen; man-made forms, angular, flat. In the burlesque theatre, the architecture is loaded with baroque embellishments, thus making the whole environment more "organic."

There are many small, highly modeled forms in Marsh's work, with strong dark and light patterns being developed among the forms. This multitude of forms produces a restless quality closely related to the kind of line he employed.

Erie R.R. and Factories (S.90) provides an excellent and beautiful example of contrasted forms. In the lower portion of the print there are cubelike rocks on a flat surface that rise to a molded, undulating surface of the siding. Above this are the cylindrical forms of the trains, rectangular solid buildings, and soft, bubbly smoke formations. A great deal of attention has been paid to the various textures of these forms, which are all set against a still, flat sky area.

When Marsh dealt with architectural forms, there seems to be a much greater serenity in his treatment; these forms are clearly stated and the lines are more controlled, as in *Tombs Prison* (S.65).

In the early prints, around 1929, forms are very restless and collide with one another. One experiences, in looking at Marsh's work, the delight he had in the full realization and development of individual forms. At this time in his career, human figures generally occupy a small part of the entire composition; they derive a great deal of their meaning from the supporting background. During the second half of his career, he concentrated more on human forms, making them the exclusive focus of his attention. Often they exist without any indication of where they might be located in

terms of environment. They live in a space that is known only to art—the picture plane.

Marsh's forms push out toward the spectator. The energy contained in the forms seeks release and "yearns" to go beyond its limit. He had a great attraction to swelled, pressured forms; they move across the space in a chain, carrying one rhythm to the next, each containing smaller, highly energized rhythms that generate the given form. This produces a highly activated overall surface, alive and sensuous.

In the engravings his forms tend to be more discrete and well defined. No doubt this is in part due to the qualities of the medium which tend to produce a colder "color" and more clearly defined forms. A more regular pattern of lines emerges as part of the process of engraving. Although the texture of the engravings is no longer the hairy texture of the etching, it still presents a very agitated surface; if one uses the comparison to hair, it now appears to be neatly combed.

Sometimes Marsh presents his forms to us as if we are looking down on them. Most of the time, however, the subjects are at eye level, appearing to occupy what seems to be a normal position. The space in the prints retains a classic quality. He includes the floor until the later part of his career (when he abandoned it in prints such as *Coney Island Beach #1* (S.191) and *Merry-Go-Round* (S.222)). Even when Marsh uses a strong diagonal form in his work we do not usually experience a great penetration of space; we feel more the side-to-side movement of forms rather than a front-to-back movement. By emphasizing lateral directions within a shallow space and also pushing many small forms toward the viewer, a tension is set up that helps to drive the forms as if they were pushed by a very powerful inner support. Consider the difference between a bas-relief that has as its support a piece of cardboard and one supported by a thick wall. The same forms in the two situations will produce entirely different effects. Even though Marsh uses paper, he seeks and achieves a powerful effect of raised, supported, and pressured forms!

In the end, one must ask what was Marsh's topic, what was his work about? Looking at the engraving *Merry-Go-Round,* 1943 (S.222), one sees his attempt to construct a very fully realized form. We have noted that in his later work he no longer used the environment to support or define his figures. Marsh sought to create solid and durable forms. His topic is human vitality, or an attempt to infuse and sustain what is vital in human beings.

In studying Marsh's prints, a vision of a particular world emerges. Although it is clearly and unmistakably Marsh's, it is a vision shared by many others—full of tremendous energy, vitality, and enduring humanity.

44

Notes to the text

[1] Matthew Baigell, "The Beginnings of 'The American Wave' and the Depression," *Art Journal* 27 (Summer 1968), p. 393.

[2] Charles H. Morgan, *George Bellows, Painter of America* (New York: Reynal, 1965), p. 242.

[3] Baigell, "American Wave," pp. 394–95.

[4] Morgan, *Bellows*, p. 220.

[5] Ibid., p. 260.

[6] Emma S. Bellows, ed. *George Bellows, His Lithographs* (New York: Alfred A. Knopf, 1928).

[7] Bellows, *George Bellows*, plates 9 and 85.

[8] Ibid., plate 18.

[9] Ibid., plate 24.

[10] Lloyd Goodrich, *Reginald Marsh* (New York: Whitney Museum of American Art, 1955), p. 9.

[11] Morgan, *Bellows*, p. 276.

[12] Edward Laning, *The Sketchbooks of Reginald Marsh* (New York: New York Graphic Society Ltd., 1973), pp. 24–25.

[13] Edward Laning, "Reginald Marsh" (Demcourier 13, June 1943), p. 6.

Catalog

Catalog explanation

Shortly after Reginald Marsh's death in 1954, the author was asked to catalog all the work left in his estate. Among the many items in the estate were his prints and related material. Fortunately, the author had access to these items before they were dispersed.

Marsh kept many of the proofs of his prints. He also kept records of his work. He used notebook No. 3 in the late 1920s, and a series of yearly diary books—Red Star Diaries 1929 to 1933—to record work done on a particular day. To trace his work on a particular print, one has to look at many pages and often in diaries for two consecutive years. Notes about work done during the second half of the 1930s were rendered more directly on single pages of another notebook, No. 6. Notebook No. 7 contains a listing of prints, including sizes and prices; No. 8 (pp. 48–67) provides an ordered listing of etchings. Marsh's records are considered primary evidence, unless the author was able to establish an error made evident by observation of other available data.

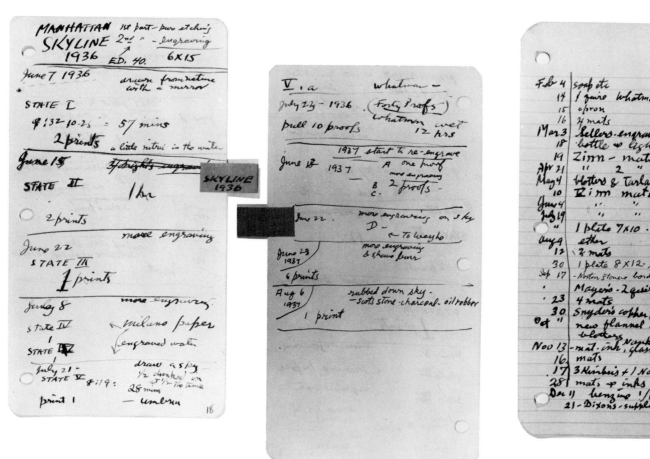

The opportunity to study Marsh's prints and some related material during 1954 to 1956 made it possible for the author to publish a small book, *Reginald Marsh— Etchings, Engravings, Lithographs* (New York: Praeger, 1956). In addition to the research done for that book, a much more extensive study was undertaken in preparation for the present work.

Aside from Marsh's records, which are the property of his widow, there is a master set of Marsh prints acquired by William Benton from Mrs. Marsh. This set contains all known subjects(with three exceptions: FF, 164A, 188A) and many state proofs. The Benton Collection is now located in the William Benton Museum of Art, University of Connecticut, Storrs. A second set of prints was recently presented by Mrs. Marsh to the main branch of the New York Public Library. This set contains many subjects and quite a few state proofs, although it is in no way as complete as The Benton Collection. Another large collection of Marsh prints is owned by the Middendorf Gallery, Washington, D.C. This collection was acquired just prior to publication of this book. Of the public collections, the largest is found in the Library of Congress.

An attempt has been made to include in the catalog the following information for each print:

Catalog number.

Title.

Alternate title.

Date. Source for date other than on plate or stone.

"Signature" on the plate or stone. Location of name and/or date on impression, as it was inserted on plate or stone.

Medium. Size.

State number. Number of proofs: actual or recorded numbering of proofs, location, and condition. Notation if touched. Description of various states.

Printing. Name of the person printing or authorizing printing, number of impressions made, actual numbering, date of printing, and location in public collections.

Edition. Name of authorizing agent, number of impressions, date, location in public collections.

Plate. If plate was recorded as destroyed, this is so noted with the source of information. Facing, if any.

Notes. Related information.

Catalog numbers

The catalog numbers used for the Marsh prints in the author's previous catalog have been retained for consistency. In order to accommodate prints discovered since 1956, intervals between catalog numbers have been extended by using suffix letters. For example, the capital letters A, B, C, . . . , AA, BB, . . . have been used to list the linoleum cuts. It is believed that these were all completed prior to Marsh's first lithographs, etchings, and engravings. Similarly, a print that was located since the earlier catalog was compiled (for example *Kopper Koke,* S.164A) has been inserted in its appropriate place.

In some cases, the chronological listing of plates is out of order; this is due to the incorporation of new information that has required adjusting dates previously attributed to several prints. Since new data affected only a few prints, it has not been felt necessary to change the numbering system to accommodate these prints.

Titles

Marsh assigned titles to most of his prints. These titles appear both in his notebooks and on the envelopes and folders in which he kept his proofs and impressions. Most of the titles were taken from these sources. Occasionally, Marsh used more than one title; in these instances they have been listed in the catalog as alternate titles. In some cases, it has not been possible to find any evidence of a Marsh title, and in these instances a descriptive title has been provided. All the author's titles are followed by an asterisk.

Dates

It was fairly easy to establish an accurate chronological listing of Marsh's prints because he often included the date of the print in the plate or on the stone. This has been used as the primary source for determining dates. When Marsh's records include the actual day he started work on a print, it has been listed in the catalog immediately following the date, in parentheses. Source for dates is also given where possible. The term "estimate" is used when no reliable source has been found for establishing a specific date.

The linoleum cuts are thought to have been executed in 1921, or close to that

time, since one of the blocks includes this date. Stylistically, it would seem that
they were all finished near the same time.

Most of Marsh's lithographs were completed within the span of a few years.
Since the date for his first lithograph was 1927, and most of his lithographs were
done by 1933, there is little difficulty in dating these.

The majority of drypoints, etchings, and engravings posed few problems,
with the exceptions of the early and late years. These two periods include small,
experimental plates, without dates included in the plates or much recorded data. They,
too, are easily identified by style. Moreover, the drypoints were without doubt
Marsh's first ventures into intaglio platemaking. The small engravings occupied
Marsh's later years; it is thought that most were completed after 1940.

Name or initials and/or date on plates or stones

Marsh often signed his plates by etching or engraving his initials or name on
the plate; or, in the case of his lithographs, by drawing on the stone. Sometimes
his initials or name appears in reverse on an impression because he had forgotten to
reverse the material on the plate or stone.

Abbreviations are used to describe the position of Marsh's name, initials,
and/or date on a plate or stone. For example: "u.l." refers to the upper left portion
of the impression. Similarly, "l.l." (lower left), "c." (center), and "u.r."
(upper right) have been used. The position of the name, initials, and/or date on
plates or stones is noted as it appears on the impression, *not* as it is on the plate.

Medium

Marsh worked in various print mediums. His linoleum cuts present
something of a problem because there is little data regarding them. However, it
would seem that printing was intended, since he cut the letters in reverse in order to
ensure correct position. The only proofs known to the author are those printed
by order of Marsh's stepmother long after his death, an impression found in Marsh's
notebook, and several impressions apparently made by him now located in the
Yale University Art Gallery. The linoleum blocks were left in Marsh's father's house
in Woodstock, New York, and were hung as decorations. (The holes in the corners
of many of the blocks provided spaces for insertion of the nails.)

Marsh's early work in intaglio included drypoints and drypoint and/or

engraved additions to etchings. The early etchings have touches of engraving. He continued to increase the use of engraving on his etchings until, toward the end of his career, he was concentrating mainly on pure burin engraving. Almost all his later intaglio work was done on copper—fine, hand-hammered copper—although he still made a few etchings and lithographs during these years. Taking his career as a whole, the greater portion of Marsh's work consisted of intaglio, etching, and copper engraving.

Size

Sizes are given height first, width second, to the closest millimeter, in the case of metric measurement, and to the closest quarter-inch under the United States system of measurement.

When the plate size is given, it is evidence of the plate's existence. If it was not possible to measure a plate, the size listed is a measurement of the platemark of the impression in The Benton Collection's master set of prints. In the case of the lithographs and linoleum cuts, the measurement represents the image area; this is recorded as "picture." Individual impressions may vary depending on the amount of shrinkage of the paper at the time of printing.

State proofs

The term "proof" or "trial proof" is used to denote an impression (a printing of the plate) which was made in order to see the development of the work. "State" refers to a proof of a print showing a conscious change in a plate, thus making it somewhat different from the previous condition of the plate. "Impression" has a more general meaning since it refers to any proof whether it be a trial proof or a final "published" proof. The term "print" is used as a noun rather than a verb; the words "proof" or "impression" are substituted to denote actual printing.

Marsh kept very detailed records of the development of many of his intaglio prints and he also retained many of his state proofs. These two primary sources were used for information about the state proofs.

An attempt has been made to provide all available information on state proofs. Optimum information would include: state number (first state, second state, etc.), a description of the states, state proofs, their location, and proof numbers as they appear on individual impressions. Notations have been made in the catalog to

indicate the location of state proofs in public institutions; see "Abbreviations" for the forms used.

States of individual prints are listed, for example, State I, State II, etc. Following the state number in parentheses is the number of proofs Marsh made of a particular state. Typically, he made one or two proofs of each state. Marsh often recorded a "number" for each of these state proofs (e.g., 1, 2, or A, B). When Marsh recorded a proof number such as "1" in his notebooks, he sometimes labeled the actual proof "A." When there is no listing in the catalog of the number of proofs (proof: D), this indicates that information was not available on the number of proofs of a given state. When a proof number has been confirmed by actual observation, it has been italicized. Proof numbers that have no location or ownership listed immediately following them are in The Benton Collection's master set of prints. If the proof has been touched, drawing added, annotated, damaged, or the like, this has been noted within the parentheses enclosing information about the proofs. In a few instances where Marsh recorded the number of trial proofs and the kind of paper, but not the proof number, only the number of proofs and paper are listed: (three proofs: Rives).

In preparing the 1956 book on Marsh's prints, the author had the good fortune to be assisted by A. Hyatt Mayor, at that time curator of prints for The Metropolitan Museum of Art. After examining the state proofs left in Marsh's estate, we labeled them with an encircled arabic numeral placed in pencil in the lower center section of the proof's margin. The arabic numeral or a "P" number in the lower right corner of the paper indicates an impression cataloged by the author prior to 1956. The "P" numbers were used from 1954 to 1956 for cataloging.

For the present catalog, a description has been written for each state proof based on the author's most recent observation and study of the proofs as well as photographs of the proofs. Reference has also been made to Marsh's notes on the states, thus providing two sources for determining and describing state variations. In some instances, the recent study of the proofs has provided new information on the states, and this has been incorporated in the present text. When Marsh's notes have been relied upon either because study of a particular proof was not possible or because his description was adequate, the initials "(RM)" have been added to indicate a direct quote or paraphrase of Marsh. All the description preceding the "(RM)" is Marsh's; all following, the author's.

Marsh sometimes did not consider slight additions of engraving or major alterations to the plate as a new state. Technically, such fundamental changes

in the plate are new states and have been considered so in this book. In a few instances, one might find a proof labeled "State IV" when it is, in fact, a later state. This has been noted when such a question might arise and create confusion.

Marsh used several forms of notation for his state proofs. He often used letter notations for state proofs and referred to them in his notes as "prints." Sometimes, he actually labeled such proofs "State I only proof." More often he used letters in sequence, that is, proofs of State I might be labeled A, B, State II C, or State I #1, State II #2, #3. On rare occasions, Marsh numbered proofs using capital letters and roman *and* arabic numerals. There are several examples of this in catalog number 158.

The prints illustrated in this book are labeled according to state number on the basis of a study of all available information. In most cases the final state or published state has been reproduced.

Printing

Marsh printed his own linoleum blocks, although it has not been possible to determine the extent of printing. It is known that two posthumous impressions were made of many of Marsh's linoleum blocks; one set is in The Benton Collection, the other is in Yale's collection.

It has not been possible to establish who printed Marsh's lithographs, although it is assumed he did not do them himself. The 1928 lithographs were printed by a professional printer in Paris (Marsh recorded having declared four hundred thirty prints for customs officials in 1928). This was probably the case for the 1932 group of lithographs since Marsh was in Paris again during that year. It is believed his other lithographs were printed in the United States, especially the last few completed toward the end of his career. At least one of these (S.30) was printed by George Miller of New York.

In the case of the drypoints, etchings, and engravings, the situation is different. Marsh owned an excellent press and did most of his own printing. He kept copious notes on printing techniques in order to improve the quality of his prints. When professional printers were used, it has been noted.

From a study of Marsh's records and the remaining impressions in his estate, it has been possible to determine with some accuracy the actual printing of various subjects. For example, it is presumed that lower-numbered impressions were sold before higher numbers, according to custom. Therefore, when impressions

numbered 18/50, 19/50, 20/50, 21/50 remained in Marsh's estate, it was concluded that Marsh actually printed only twenty-one impressions of the proposed edition of fifty. In many cases, it has been possible to estimate printing done by Marsh. However, in those cases where a plate remained in the "trial" state, "printing unknown" is used to indicate lack of information on the extent of printing beyond trial proofs.

Impressions printed by Marsh are listed with the actual number of impressions made and the proof numbers he used. When known, the date Marsh made the impressions was also recorded in parentheses. Also, in some instances the phrase "highest numbered impression located" is used to provide evidence of the extent of final state printing. Immediately following this information, separated by a semicolon, the location of individual impressions is listed in abbreviated form with the impression number, if available. When the print had no impression number, only the location is listed, and if there is more than one impression without numbers, the number of impressions in a particular location is listed in parentheses, e.g., (4) NYPL. The same procedure is used for listing impressions printed by Charles White and Peter Platt.

Often proofs of the final state became part of the final printing; therefore, final state proofs are sometimes included in the listing of Printing.

Editions

While Marsh made more than two hundred and fifty prints in his lifetime, relatively few of these were printed or published as editions. Presumably this was due to the limited demand for prints. Some of his impressions do indicate intended editions of fifty, seventy-five, or one hundred, but in almost every instance they were not printed in full. Several exceptions are noted where editions were commissioned and presumably were issued in full.

Marsh's records and the impressions left as part of his estate provided information about how many impressions he made of each print. In most cases these impressions do not constitute an "edition" in the sense that a specific number were issued for sale to the public. This information does indicate actual printing of impressions by Marsh and, in a few instances, by other printers. Therefore, as previously indicated, this has been listed under the catalog item Printing.

In Thomas Craven's *Treasury of American Prints* (New York: Simon & Schuster, 1939), plate 22, Marsh is quoted as saying, in response to a question about

the size of his editions: ''Probably a dozen.'' Then he was asked how many of that edition were still available and he answered, ''Probably a dozen.'' He went on to explain: ''Since I do practically all my own printing, I do not limit the edition. The buyer limits the edition—he rarely buys, I rarely print. I usually print fifteen or twenty and sell one or two in the next five years—so why limit the edition?''

Editions were printed of Marsh's lithographs. When Marsh's records have been used to determine the size of an edition, the source of this information is included in the catalog. Source for the size of lithograph editions is entered prior to the edition size.

Marsh's attitude was characterized by his wish for the widest distribution of his work. He was an excellent craftsman and used good materials. As a result, Marsh's plates have yielded—and have the potential for yielding—many excellent impressions. With these thoughts in mind, Mrs. Marsh has authorized posthumous editions. The first posthumous edition was made by Alfred Jones in 1956, under the author's direction. The 1956 ''edition'' is so noted with the number of impressions made, e.g., Jones, twelve impressions (1956). These were signed ''Reginald Marsh (F.M.)'' by Mrs. Marsh.

A special edition of one hundred impressions of print number S.175 was issued with the limited edition of *Reginald Marsh, Etchings, Engravings, Lithographs* (Sasowsky). These were numbered by Mrs. Marsh, impression number over the edition number (1/100, etc.), and were also signed ''Reginald Marsh (F.M.)'' by her.

Another posthumous edition was authorized in 1969 when the plates were given to the Whitney Museum. This edition was printed by Anderson and Lamb, with Una Johnson acting as consultant to the Whitney Museum. The Whitney Museum also authorized a second edition of four more Marsh plates in 1971. The 1969 and 1971 editions consist of one hundred impressions plus fourteen ''artist's proofs'' and have the stamp of the Whitney Museum in the place generally used for the artist's signature.

Blocks, stones, and plates

Thirty-one linoleum blocks are in The Yale University Art Gallery; the only other known blocks are in The Benton Collection.

The stones used for making the lithographs are presumed long since reused as is the general practice with lithographic stones.

Most of the drypoint, etching, and copper-engraving plates are owned by

the Whitney Museum. None of these plates has been canceled. All the plates are copper, with the few exceptions noted in the catalog. Some of the plates have recently been steel-faced to strengthen the surface for printing; this was done for the Whitney editions. Where Marsh has recorded the destruction of a plate, ''Plate destroyed'' has been entered in the catalog followed by the source of this information. Also, notable existing conditions of individual plates are recorded.

A great number of Marsh's plates have not been located; these are listed as ''Plate not found.'' Recently, information about a large number of these plates has been discovered. Apparently Marsh left many of his plates, mostly executed from 1927 to 1932, at 138–52 Elder Ave., Flushing, New York. This was the house of his father-in-law Bryson Burroughs, curator at The Metropolitan Museum of Art. Marsh lived there with his first wife until their divorce in 1933. Subsequently, the house was sold in the 1930s to Mr. Coley Taylor, and then again in 1955.

Marsh had left many paintings and plates in Flushing. During restoration of the house, a fire destroyed much of this work. The plates were temporarily spared since they were not located in the main house but in the barn that served as a studio. Unfortunately, the new owner of the house was not aware of the artistic value of the copper plates. A recent conversation between the author and the last owner of the house revealed that most of the plates were lost or destroyed. The few remaining plates (most of which are no longer suitable for printing) were acquired by William Benton and given to the Whitney Museum.

This unfortunate story does help to account for a large body of Marsh's plates and makes one wonder why he never claimed them. It is perhaps correct to surmise that there was little need to claim the plates when demand for the prints was so small at that time.

A small plate was found among Marsh's plates at the Whitney Museum. The subject is a landscape, farm scene, etching, 61 x 102 mm (2⅜ x 4″); it has not been determined that this is a work by Marsh and is not included in the catalog.

Notes

Often Marsh made a painting that was closely related to a given print; this information is recorded with present location or ownership. Also, sketches or drawings related to the print are recorded in the same manner. Marsh's estate included some sketches of details and compositional studies for particular prints. Some of these are now owned by The Fogg Museum of Art, Mrs. Reginald Marsh, and the author.

No attempt has been made to include all the paintings or drawings that are closely related to Marsh's prints. In his early years as a printmaker, it was Marsh's common practice to etch and paint the same designs. In later years, he continued to use the same subjects and motifs for both prints and paintings, although, during this period, the differences between the two mediums are decidedly more distinct. These later examples are not illustrated in the catalog.

Other miscellaneous information is included, such as notable relationships to other Marsh prints, work done on the reverse side of the plate, or reproduction or illustration of the print.

Attributions

A combination of Marsh's records and the many plates, stones, and linoleum blocks that have been signed in the ''plate'' made attributions fairly easy. Marsh's full name, initials, or date in his handwriting is considered primary evidence of Marsh's authorship. Where this evidence is not available, Marsh's records have been used to identify plates. Thus, there is no question about the authenticity of the prints included in this catalog.

Photographs

The photographic reproductions or illustrations used in the book are from The Benton Collection unless otherwise noted. In some instances various states of a particular print and the paintings and drawings or sketches relating to the print have been included to provide additional visual references.

It was not possible to obtain photographs for three subjects: 31A, 164A, and 195. In each case, there is evidence for the existence of the print at some time; however, impressions could not be located for photographing. All available information about the prints is included in the catalog, and it is hoped that the publication of this book will bring extant impressions to the author's attention.

Sale of prints

While Marsh's prints never sold extensively, they were regularly consigned to several dealers. Among these dealers were Weyhe, Rehn, McDonald, Associated American Artists, Kennedy, Kleeman, and Kraushaar. Also, especially in the

1930s, when Marsh had one-man exhibitions of paintings, he often included a selection of prints.

Marsh's records indicate limited sales during his lifetime. In fact, sales seem to have fallen off toward the latter part of his career. However, after Marsh's death many of his prints were offered for sale through Albert Reese of the Kennedy Galleries, and all the remaining prints were quickly purchased.

Signatures

No attempt has been made to provide an analysis of Marsh's signatures since this is beyond the author's capabilities. A sample of Marsh's signature and examples of typical Marsh notations have been included for the reader's information.

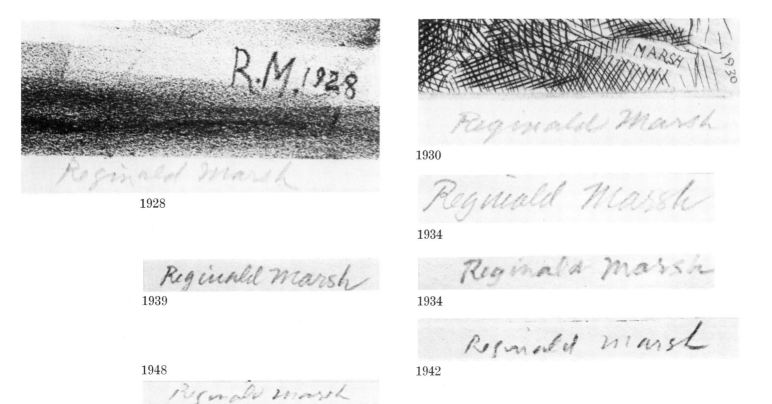

1928

1930

1939

1934

1948

1934

1942

Abbreviations

ACH	Achenbach Foundation for Graphic Arts, California Palace of the Legion of Honor, San Francisco
AD	Addison Gallery of American Art, Phillips Academy, Andover
ADW	Andrew Dickson White Museum of Art, Cornell University, Ithaca
ART	Art Institute of Chicago
BMA	Baltimore Museum of Art
BOW	Bowdoin College Museum of Art, Brunswick, Maine
BPL	Boston Public Library
CAR	Carnegie Institute, Pittsburgh
CGA	Corcoran Gallery of Art, Washington
CIN	Cincinnati Art Museum
CL	Cleveland Museum of Art
DAL	Dallas Museum of Fine Arts
DIA	Detroit Institute of Arts
FM	Mrs. Reginald Marsh, New York City
FOGG	Fogg Art Museum, Harvard University, Cambridge
KIA	Kalamazoo Institute of Arts, Kalamazoo, Michigan
LC	Library of Congress, Washington
LOS	Los Angeles County Museum of Art
MFA	Museum of Fine Arts, Boston
MINN	Minneapolis Institute of Arts
MMA	Metropolitan Museum of Art, New York City
MOMA	Museum of Modern Art, New York City
MWPI	Munson-Williams-Proctor Institute, Utica, New York
NAT	National Collection of Fine Arts, Washington
NGA	National Gallery of Art, Washington
NS	Norman Sasowsky, Newark, Delaware
NYPL	New York Public Library, Central Branch, New York City
P	The Art Museum, Princeton University, Princeton
PLNNJ	The Public Library of Newark, New Jersey
PMA	Philadelphia Museum of Art
POR	Portland Art Museum, Portland, Oregon
RM	Reginald Marsh

SI Smithsonian Institution, Division of Graphic Arts,
 Washington
UMO University of Maine at Orono
WMAA Whitney Museum of American Art, New York City
WB The Benton Collection
Y Yale University, New Haven
Z The Middendorf Gallery, Washington

Linoleum cuts

A. *Greetings—Reginald Marsh**
1921.
u.l.; 1921.
Linocut; 152 mm. x 102 mm.
 (6″ x 4″) picture.
Only state.
Printing: Marsh, one impression; Y.
 One posthumous impression.

Photograph: Only state.

B. *Christmas Greetings From F. D.,
 A. R. Jr., R and D. Marsh**
1921. Estimate.
Linocut; 165 mm. x 133 mm.
 (6½″ x 5¼″) picture.
Only state.
Printing: One posthumous impression.

Photograph: Only state.

C. *Greetings from Justin & Raymond**
 1921. Estimate.
 Linocut; 146 mm. x 108 mm.
 (5¾″ x 4¼″) picture.
 Only state.
 Printing: Marsh, one impression; Y.
 One posthumous impression.

 Photograph: Only state.

D. *Stuart Rose**
 1921. Estimate.
 Linocut; 108 mm. x 82 mm.
 (4¼″ x 3¼″) picture.
 Only state.
 Printing: One posthumous impression.

 Photograph: Only state.

E. *Bowling Green**
 1921. Estimate.
 Linocut; 146 mm. x 127 mm.
 (5¾″ x 5″) picture.
 Only state.
 Printing: One posthumous impression.

 Photograph: Only state.

F. *Dinner**
 1921. Estimate.
 Linocut; 114 mm. x 114 mm.
 (4½″ x 4½″) picture.
 Only state.
 Printing: Marsh, one impression; Y.
 One posthumous impression.

 Photograph: Only state.

*G. Scene from "The Cabinet of Dr.
 Caligari"**
 1921. Estimate.
 Linocut; 127 mm. x 114 mm.
 (5″ x 4½″) picture.
 Only state.
 Printing: Marsh, one impression; Y.
 One posthumous impression.
 Note: Yale impression does not have
 "hole" marks in corners, which
 suggests that this impression may
 have been made by Marsh; the
 impression in The Benton Collection
 is definitely a posthumous impression.
 Impression at Yale has Marsh
 inscription l.l.: Scene from the
 "cabinet of Dr. Caligari."

 Photograph: Only state.
 Courtesy Yale University Art
 Gallery, bequest of Mabel Van
 Alstyne Marsh.

*H. Woman Reading Book**
 1921. Estimate.
 Linocut; 127 mm. x 108 mm.
 (5″ x 4¼″) picture.
 Only state.
 Printing: Marsh, one impression; Y.
 One posthumous impression.

 Photograph: Only state.

*I. Two Couples**
 1921. Estimate.
 Linocut; 171 mm. x 146 mm.
 (6¾″ x 5¾″) picture.
 Only state.
 Printing: One posthumous impression.

 Photograph: Only state.

*J. Three Women**
 1921. Estimate.
 Linocut; 127 mm. x 127 mm.
 (5″ x 5″) picture.
 Only state.
 Printing: Marsh, one impression; Y.
 One posthumous impression.
 Note: Illustrated in the *Liberator*,
 vol. 4 (September 1921), p. 29.

 Photograph: Only state.

*K. Bootblack**
1921. Estimate.
Linocut; 120 mm. x 108 mm.
 (4¾″ x 4¼″) picture.
Only state.
Printing: Marsh, one impression; Y.
 One posthumous impression.
Note: Illustrated in the *Liberator*,
 vol. 5, no. 8 (August 1922), p. 17.

Photograph: Only state.

*L. Gossips**
1921. Estimate.
Linocut; 127 mm. x 114 mm.
 (5″ x 4½″) picture.
Only state.
Printing: Marsh, one impression; Y.
 One posthumous impression.
Note: Small reproduction of this print
 located in Notebook No. 13, p. 13;
 includes the following caption:
 "Back to Nature." Yale impression
 inscribed l.r.; illustrated in the
 Liberator, vol. 5, #7 (July 1922),
 p. 25.

Photograph: Only state.

*M. Crucifixion**
 1921. Estimate.
 Linocut; 152 mm. x 127 mm.
 (6″ x 5″) picture.
 Only state.
 Printing : Marsh, one impression ; Y.
 One posthumous impression.

 Photograph : Only state.

*N. Reclining Nude in Boat**
 1921. Estimate.
 Linocut; 165 mm. x 108 mm.
 (6½″ x 4¼″) picture.
 Only state.
 Printing : One posthumous impression.

 Photograph : Only state.

O. *Standing Female Nude**
1921. Estimate.
Linocut; 146 mm. x 127 mm.
 (5¾″ x 5″) picture.
Only state.
Printing: Marsh, one impression; Y.
 One posthumous impression.

Photograph: Only state.

P. *Resurrection**
1921. Estimate.
Linocut; 127 mm. x 120 mm.
 (5″ x 4¾″) picture.
Only state.
Printing: Marsh, one impression; Y.
 One posthumous impression.

Photograph: Only state.

Q. *Subway Car**
1921. Estimate.
Linocut; 133 mm. x 120 mm.
 (5¼″ x 4¾″) picture.
Only state.
Printing: Marsh, one impression; Y.
 One posthumous impression.

Photograph: Only state.

R. *Cowboy Shooting Pistols**
1921. Estimate.
Linocut; 184 mm. x 127 mm.
 (7¼″ x 5″) picture.
Only state.
Printing: One posthumous impression.
Block in The Benton Collection.

Photograph: Only state.

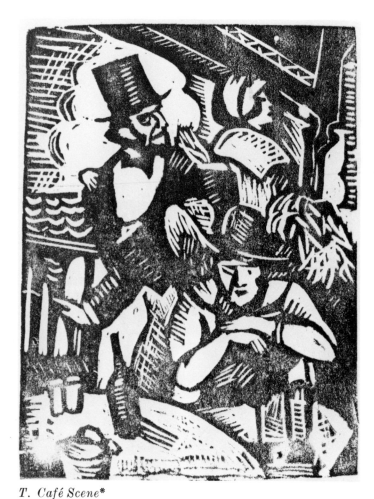

S. The Wooly West
1921. Estimate.
Linocut; 184 mm. x 127 mm.
　(7¼″ x 5″) picture.
Only state.
Printing: Marsh, one impression; Y.
　One posthumous impression.
Block in The Benton Collection.
Note: Illustrated in *The Bookman LVI,*
　No. 2 (1922), p. 149. Holes used
　for nailing to wall not in evidence
　on reproduction, which suggests a
　printing by Marsh.

Photograph: Only state.

T. Café Scene *
1921. Estimate.
Linocut; 152 mm. x 108 mm.
　(6″ x 4¼″) picture.
Only state.
Printing: Marsh, one impression; Y.
　One posthumous impression.

Photograph: Only state.

U. *Two Men—One on Horse**
 1921. Estimate.
 Linocut; 89 mm. x 114 mm.
 (3½″ x 4½″ [?]) picture.
 Difficult to determine actual size of
 block.
 Only state.
 Printing: Two posthumous
 impressions; Y.

 Photograph: Only state.

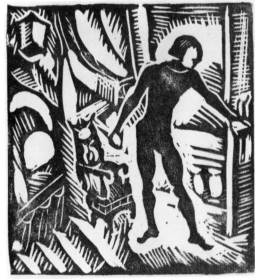

V. *Hamlet**
 1921. Estimate.
 Linocut; 127 mm. x 127 mm.
 (5″ x 5″) picture.
 Only state.
 Printing: One posthumous impression.

 Photograph: Only state.

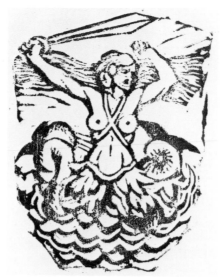

W. *Woman With Sword**
 La Belle France
 1921. Estimate.
 Linocut; 127 mm. x 102 mm.
 (5″ x 4″) picture.
 Only state.
 Printing: Marsh, two impressions; Y.
 One posthumous impression.

 Photograph: Only state.

X. *The Garden of Eden**
 1921. Estimate.
 Linocut; 127 mm. x 102 mm.
 (5″ x 4″) picture.
 Only state.
 Printing: Marsh, one impression; Y.
 One posthumous impression.

 Photograph: Only state.

Y. *Adam and Eve**
 1921. Estimate.
 Linocut ; 127 mm. x 102 mm.
 (5″ x 4″) picture.
 Only state.
 Printing : Marsh, one impression ; Y.
 One posthumous impression.

 Photograph : Only state.

Z. *Cain and Abel**
 1921. Estimate.
 Linocut ; 152 mm. x 127 mm.
 (6″ x 5″) picture.
 Only state.
 Printing : One posthumous impression.

 Photograph : Only state.

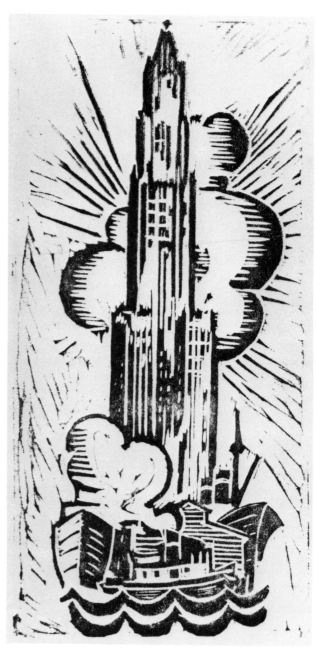

*AA. Woolworth Tower #1**
1921. Estimate.
Linocut; 228 mm. x 108 mm.
 (9″ x 4¼″) picture. Edges of the
 impression not distinct, therefore,
 it is difficult to determine the size
 of the picture.
Only state.
Printing: One posthumous impression.

Photograph: Only state.

*BB. Woolworth Tower #2**
1921. Estimate.
Linocut; 228 mm. x 114 mm.
 (9″ x 4½″) picture.
Only state.
Printing: One posthumous impression.

Photograph: Only state.

CC. *Skyline**
 1921. Estimate.
 Linocut; 140 mm. x 127 mm.
 (5½″ x 5″) picture.
 Only state.
 Printing: One posthumous impression.

 Photograph: Only state.

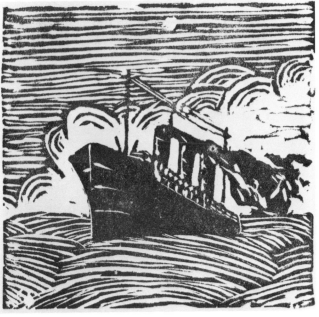

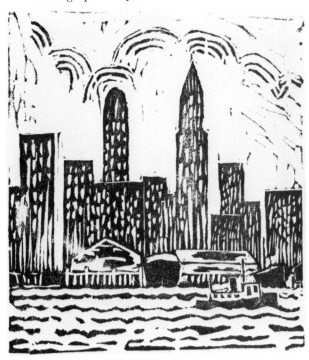

DD. *Ocean Liner**
 1921. Estimate.
 Linocut; 102 mm. x 108 mm.
 (4″ x 4¼″) picture.
 Only state.
 Printing: One posthumous impression.

 Photograph: Only state.

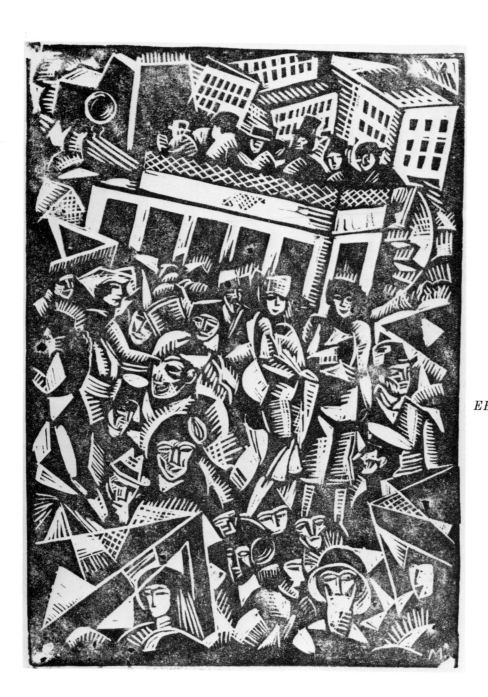

*EE. Cityscape**
 1921. Estimate.
 l.l.; R (partially effaced). l.r.; M.
 Linocut; 260 mm. x 184 mm.
 (10¼″ x 7¼″) picture.
 Only state.
 Printing: Marsh, two impressions,
 one located in Notebook No. 13,
 p. 14; printed on rice paper, Y.
 One posthumous impression.
 Note: Reproduced in *Vanity Fair,* 18,
 no. 3 (May 1922), p. 56.
 Titled: "The Fifth Ave Bus A
 Very Modern Lady, in a Cubistic
 Limousine, Views the Pageant of the
 Avenue." Credited as a drawing by
 Reginald Marsh although it is
 identical with the linocut.
 (Scrapbook #3, p. 24.)

 Photograph: Only state.

GG. *Ye Goode Ship Prima Donna**
 1921. Estimate.
 Linoleum block; size not known.
 Only state.
 Printing: Unknown.
 Note: A reproduction was found
 among Marsh's papers, indicating
 the existence of this print.

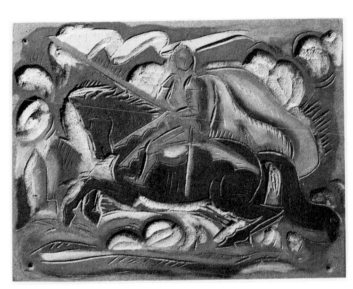

FF. *Joan of Arc**
 1921. Estimate.
 Linoleum block; 127 mm. x 178 mm.
 (5″ x 7″).
 Only state.
 Printing: Unknown.
 Block owned by Yale University
 Art Gallery.
 Note: No impressions have been
 located. It is thought that the block
 was printed. The surface has several
 colors of inks remaining on it,
 which suggests a multicolored
 printing. Also, the holes in the
 corners of the block indicate that
 it was mounted for display.

 Photograph: Only state.
 Courtesy Yale University Art
 Gallery, bequest of Mabel Van
 Alstyne Marsh.

Lithographs

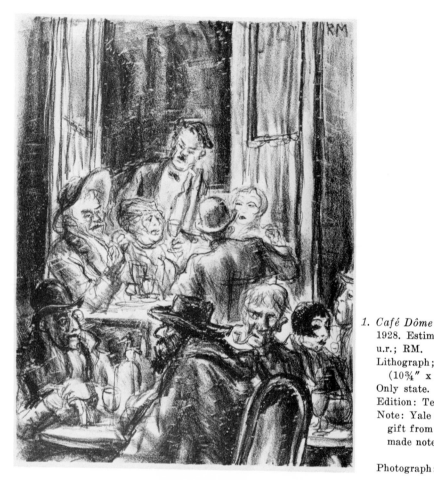

1. *Café Dôme*
 1928. Estimate.
 u.r.; RM.
 Lithograph; 273 mm. x 210 mm.
 (10¾" x 8¼") picture.
 Only state.
 Edition: Ten impressions; NYPL, Y.
 Note: Yale received its impression as a
 gift from Marsh in 1929. First litho
 made noted in Notebook No. 8.

 Photograph: Only state.

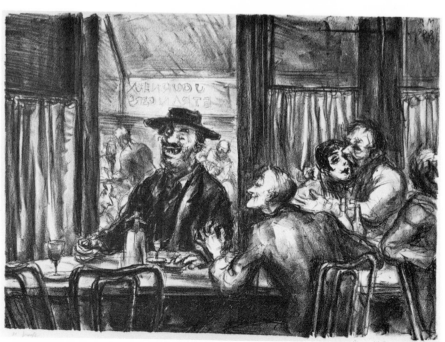

2. *Café du Dôme (Homer Bevans Is
 Central Figure)*
 1928.
 u.l.; RM
 1928
 Lithograph; 215 mm. x 305 mm.
 (8½" x 12") picture.
 Only state.
 Edition: Notebook No. 1, p. 5. Thirty-one
 impressions; NYPL, Y.

 Photograph: Only state.

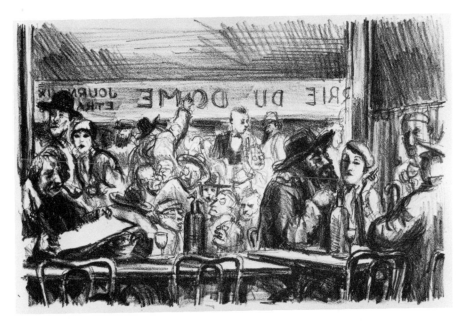

3. *du Dôme**
 1928. Estimate.
 Lithograph; 165 mm. x 260 mm.
 (6½″ x 10¼″) picture.
 Only state.
 Printing: Unknown.

 Photograph: Only state.

4. *Rue Bonaparte*
 Priests—Lovers
 1928. Estimate.
 l.r.; RM
 Lithograph; 215 mm. x 330 mm.
 (8½″ x 13″) picture.
 Only state.
 Edition: Notebook No. 1, p. 5.
 Twenty-six impressions; NYPL.

 Photograph: Only state.

5. *Rue St. Jacques*
1928.
l.l.; MARSH '28
Lithograph; 317 mm. x 215 mm.
 (12½" x 8½") picture.
Only state.
Edition: Notebook No. 1, p. 5. Thirty-six
 impressions; ART, BPL, NYPL, Y.

Photograph: Only state.

6. *Old Paris*
Night Street with Two Girls
1928.
l.c.; MARSH 1928
Lithograph; 330 mm. x 228 mm.
 (13" x 9") picture.
Only state.
Edition: Notebook No. 1, p. 5. Thirty-one
 impressions; BPL, NYPL, Y.

Photograph: Only state.

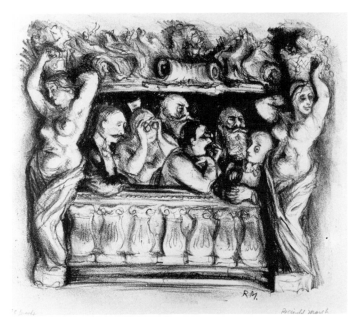

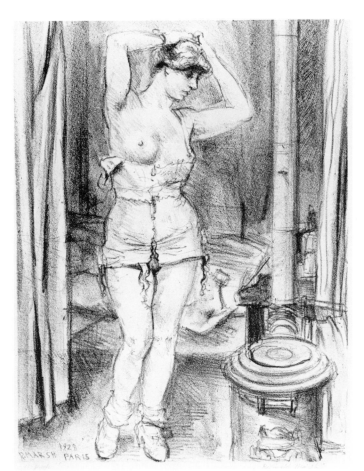

7. *Théâtre Palais Royal*
 1928. Estimate.
 l.r.; RM
 Lithograph; 190 mm. x 235 mm.
 (7½″ x 9½″) picture.
 Only state.
 Edition: Notebook No. 1, p. 5. Thirty-one
 impressions; 13/30 LC, NYPL, Y.

 Photograph: Only state.

8. *Model*
 1928.
 l.l.; R. MARSH $^{1928}_{\text{PARIS}}$
 Lithograph; 286 mm. x 215 mm.
 (11¼″ x 8½″) picture.
 Only state.
 Edition: Notebook No. 1, p. 5. Fifteen
 impressions; BPL, NYPL, Y.

 Photograph: Only state.

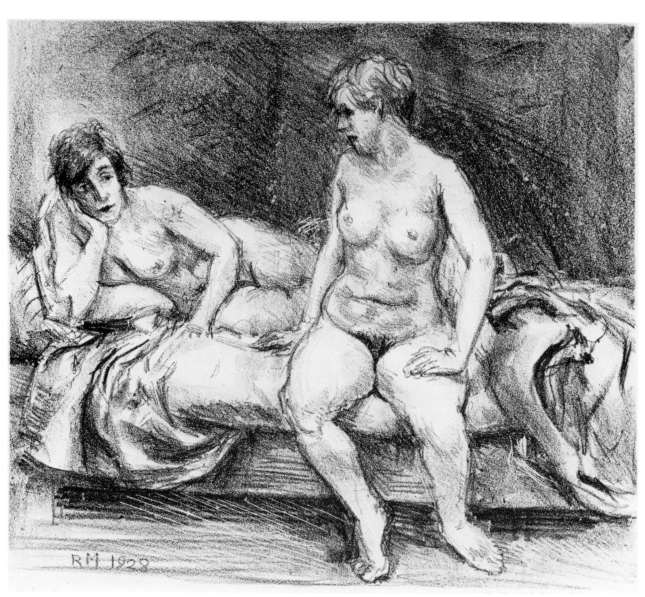

9. *Two Models on Bed*
 1928.
 l.l.; RM 1928
 Lithograph; 228 mm. x 266 mm.
 (9″ x 10½″) picture.
 Only state.
 Edition: Notebook No. 1, p. 5. Fifteen
 impressions; BPL, NYPL, Y, Z.

 Photograph: Only state.

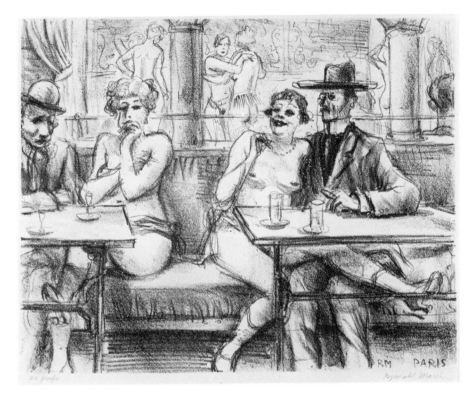

10. *Rue Blondel #1*
 1928. Estimate.
 l.r.; RM PARIS
 Lithograph; 203 mm. x 266 mm.
 (8″ x 10½″) picture.
 Only state.
 Edition: Notebook No. 1, p. 5. Twenty
 impressions; NYPL, Y, Z.

 Photograph: Only state.

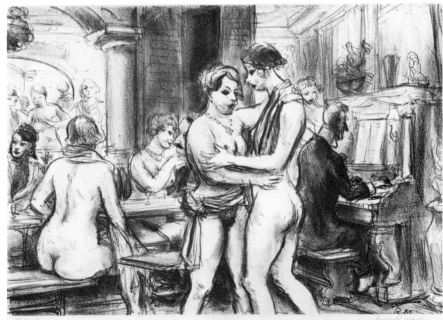

11. *Rue Blondel #2*
 1928. Estimate.
 l.r.; RM
 Lithograph; 210 mm. x 305 mm.
 (8¼″ x 12″) picture.
 Only state.
 Edition: Notebook No. 1, p. 5. Twenty-six
 impressions; NYPL, Y, Z.

 Photograph: Only state.

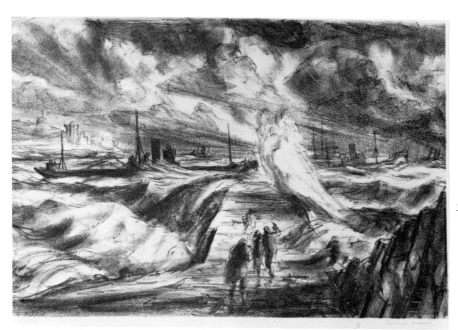

12. *St. Jean de Luz*
 1928. Estimate.
 l.l.; R. MARSH
 Lithograph; 210 mm. x 317 mm.
 (8¼" x 12½") picture.
 Only state.
 Edition: Notebook No. 1, p. 5. Forty-one
 impressions; CL, NYPL, Y, Z.

 Photograph: Only state.

13. *Along the Seine*
 1928.
 PARIS
 l.r.; MARSH 1928
 Lithograph; 190 mm. x 279 mm.
 (7½" x 11") picture.
 Only state.
 Edition: Notebook No. 1, p. 5. Forty-one
 impressions; NYPL.

 Photograph: Only state.

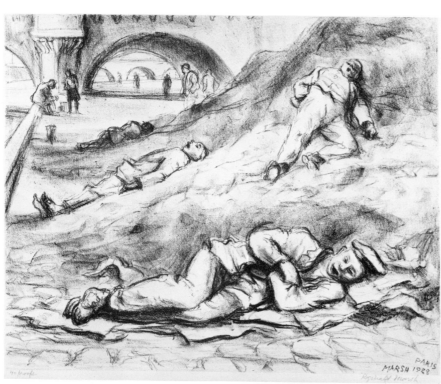

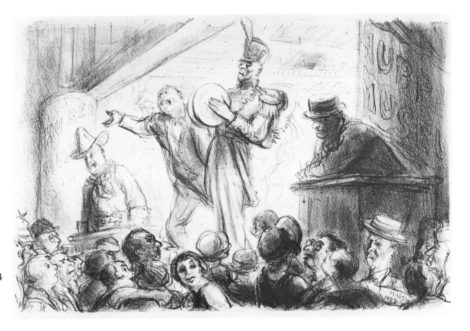

14. *Huber's Museum*
 1928.
 l.r.; MARSH
 1928
 Lithograph; 222 mm. x 343 mm.
 (8¾″ x 13½″) picture.
 Only state.
 Edition: Notebook No. 1, p. 5. Thirty-six
 impressions; BPL, FOGG, NYPL.
 Note: Illustrated in *Vanity Fair* 31, No. 4
 (Dec. 1928), p. 90.

 Photograph: Only state.

15. *Irving Place Burlesque*
 1928.
 u.l.; MARSH
 1928
 Lithograph; 247 mm. x 292 mm.
 (9¾″ x 11½″) picture.
 Only state.
 Edition: Notebook No. 1, p. 5. Twenty-five
 impressions; NYPL, Y.
 Note: Illustrated in *Vanity Fair* 31, No. 4
 (Dec. 1928), p. 90.

 Photograph: Only state.

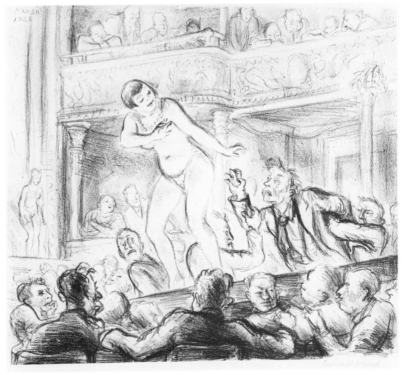

16. *The Bowery*
 1928.
 l.r.; R.M. 1928
 Lithograph; 210 mm. x 298 mm.
 (8¼″ x 11¾″) picture.
 Only state.
 Edition: Notebook No. 1, p. 5. Thirty-one
 impressions; P, (2) PMA, Y.
 Note: A Marsh drawing, illustrated in
 The New Yorker (Oct. 20, 1928), p. 15,
 is very similar to this lithograph.

 Photograph: Only state.

17. Loco Watering
 1927. Estimate. One of the impressions
 that was left in Marsh's estate has a
 1927 date after signature.
 Lithograph; 228 mm. x 305 mm.
 (9″ x 12″) picture.
 Only state.
 Printing: Unknown; NYPL.

 Photograph: Only state.

18. Erie R.R. Yards
 1928.
 l.r.; '28
 MARSH
 Lithograph; 228 mm. x 330 mm.
 (9″ x 13″) picture.
 Only state.
 Edition: Notebook No. 1, p. 5.
 Thirty-seven impressions; NYPL, Y.

 Photograph: Only state.

19. Penn. Station
1929.
l.r.; R. MARSH 1929
Lithograph; 286 mm. x 393 mm.
 (11¼″ x 15½″) picture.
Only state.
Edition: Notebook No. 1, p. 5. Fifteen
 impressions; *9/15* BPL, BOW, NS.
Note: There is some relationship to
 Marsh's painting: *Subway Station*,
 1930, Collection Louis D. Cohen, King's
 Point, N.Y.

Photograph: Only state.

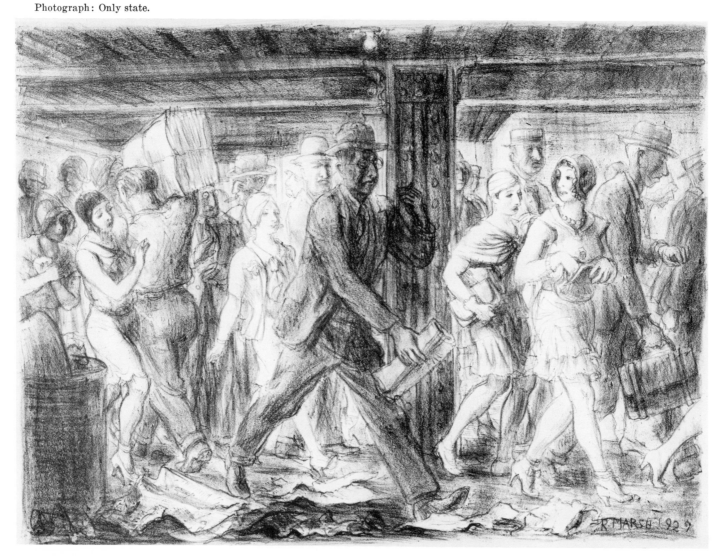

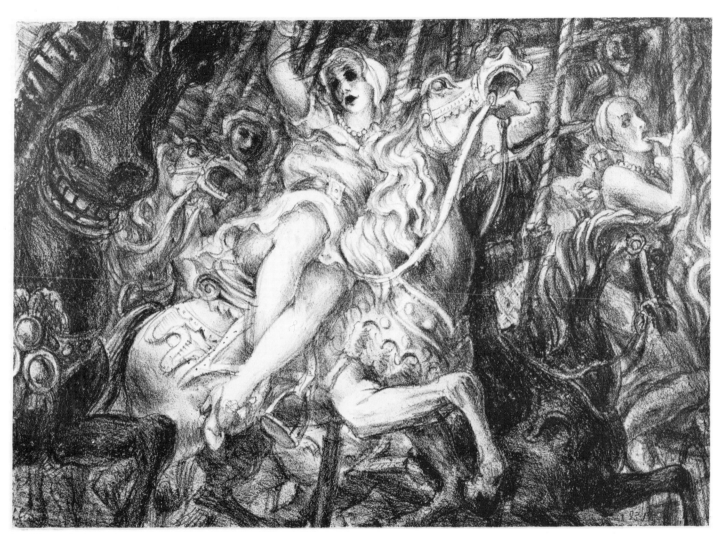

20. *Merry-Go-Round*
 1931.
 l.r.; 1931
 Lithograph; 210 mm. x 305 mm.
 (8¼″ x 12″) picture.
 Only state.
 Edition: Ten impressions; *1/10* private
 collection, BPL, NYPL.
 Note: Impression 1/10 touched with a
 notation in the margin that this was
 done by the artist. Marsh told the
 owner of this impression that he was
 not satisfied with this print. The
 additions to this impression were an
 attempt to correct the drawing of the
 main figure's face.

 Photograph: Only state.

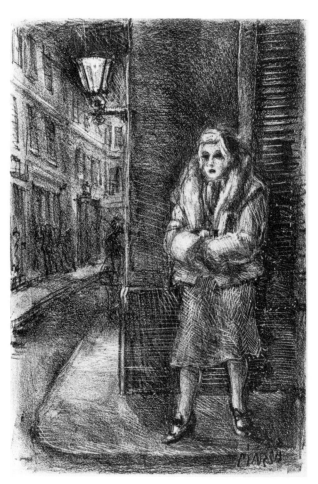

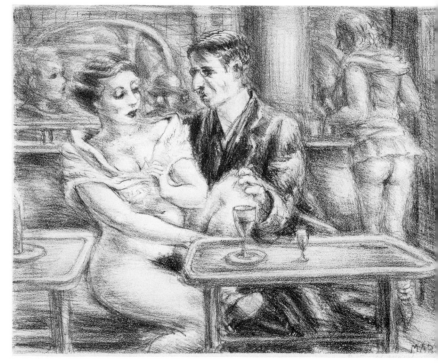

21. The Poule
1932.
l.r.; 1932
 MARSH
Lithograph; 247 mm. x 165 mm.
 (9¾" x 6½") picture.
Only state.
Edition: Twenty impressions; 4/20 LC,
 (2) NYPL.

Photograph: Only state.

22. Courtship
1932.
 32
l.r.; MARSH
Lithograph; 190 mm. x 241 mm.
 (7½" x 9½") picture.
Only state.
Edition: Twenty-two impressions; *6/22*
 Z, 10/22 LC, *14/22* NYPL.

Photograph: Only state.

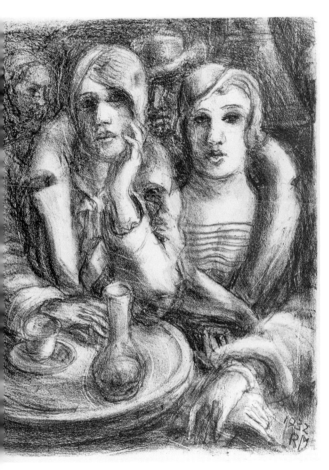

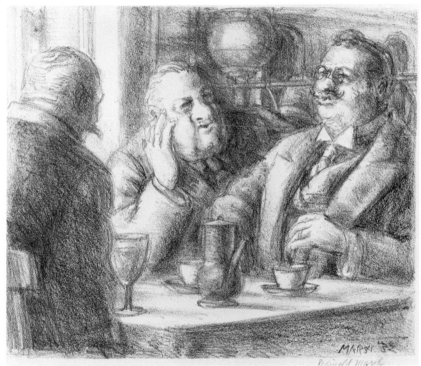

23. Café Dôme
1932.
l.r.; 1932
 RM
Lithograph; 228 mm. x 178 mm.
 (9″ x 7″) picture.
Only state.
Edition: Twenty-one impressions; several
 impressions left in Marsh's estate had
 proof numbers that indicated the
 edition size; 7 LC, *9* NYPL.

Photograph: Only state.

24. Café Brasserie
1932.
l.r.; MARSH '32
Lithograph; 184 mm. x 222 mm.
 (7¼″ x 8¾″) picture.
Only state.
Edition: Twenty-two impressions; *3/22*
 NYPL, *15/22* Z, 21/22 LC.

Photograph: Only state.

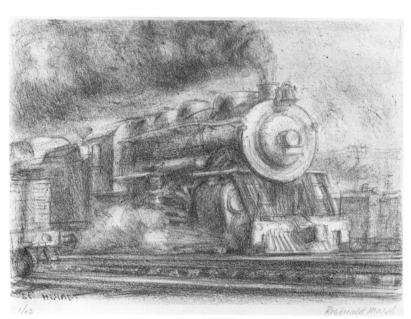

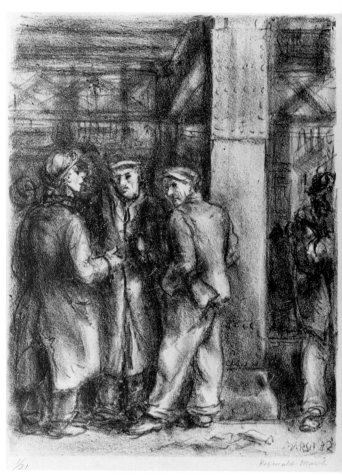

25. *Railroad*
1932.
l.l.; MARSH '32
Lithograph; 184 mm. x 253 mm.
 (7¼″ x 10″) picture.
Only state.
Edition: Twenty-two impressions; 2/22
 LC, *15/22* Z, 15 PLNNJ, *22/22*
 NYPL.

Photograph: Only state.

26. *The Bowery—Upright*
1932.
l.r.; MARSH '32
Lithograph; 241 mm. x 184 mm.
 (9½″ x 7¼″) picture.
Only state.
Edition: Twenty-one impressions; *2/21*
 NYPL, *14/21* BPL.

Photograph: Only state.

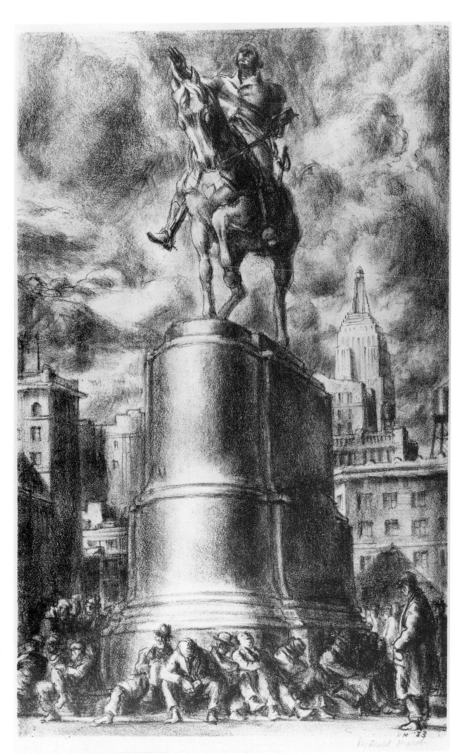

27. *Union Square*
 1933. (May 10, 1933.)
 l.r.; RM '33
 Lithograph; 343 mm. x 215 mm.
 (13½″ x 8½″) picture.
 Only state (two proofs, *1/2* private
 collection).
 Edition: Contemporary Print Group,
 three hundred impressions (1935),
 published in *The American Scene*, No.
 1-A; No. 5 BMA, No. 27 MOMA, BPL,
 NYPL.
 Note: Marsh recorded the following in his
 1933 Desk Calendar: "Start lithograph,
 May 13 draw litho, 14 home, draw
 litho . . . ," Nov. 9 "Litho group party
 . . . , 15 Carry prints to League exhibit."
 Painting, same design: *Washington
 Takes Union Square*, 1933, present
 ownership and location unknown.

 Photograph: Only state.

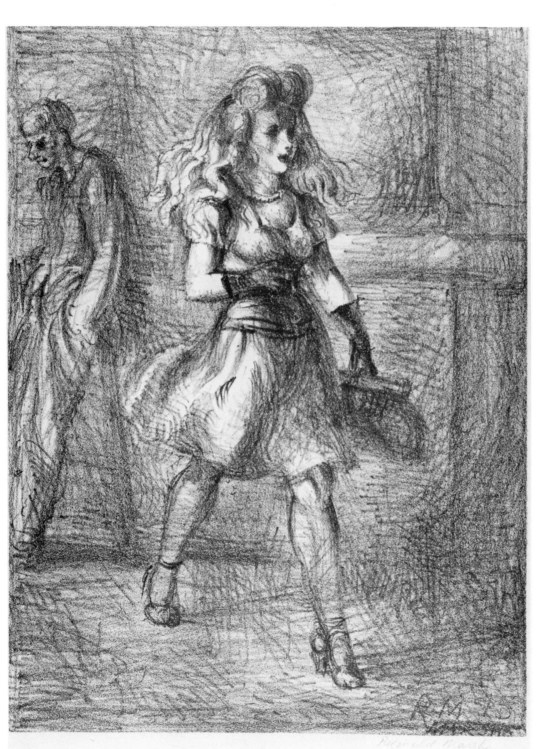

28. *Girl Walking* (*Elevated*)
 1945.
 l.r.; RM 45
 MARSH
 Lithograph; 226 mm. x 203 mm.
 (10½″ x 8″) picture.
 Only state.
 Edition: Published by Associated
 American Artists, two hundred and f[i]
 impressions; ACH, BPL, NAT, NYP
 PMA.
 Note: Marsh's records indicate the rece[
 of $202.85 from AAA in 1945.

 Photograph: Only state.

29. Erie R.R. Loco Watering
1929. Notebook No. 1, p. 6:
 "R = locomotive litho 1929."
l.l.; RM
Lithograph; 210 mm. x 317 mm.
 (8¼″ x 12½″) picture.
Only state.
Edition: Twenty-five impressions; 1/25
 KIA, LOS, NYPL, Z.
Note: Impression 1/25 in the Los Angeles
 County Museum of Art has Nov. 4,
 1929, stamped on verso. Date may have
 been stamped by Downtown Gallery; it
 seems that this was a gallery practice.
 Same basic design as S.85; apparently
 the lithograph was done prior to the
 etching, based on available dates.
 Painting same design: *Erie Locomotive
 Watering*, 1928. Collection of Mrs.
 Reginald Marsh.

Photograph: Only state.

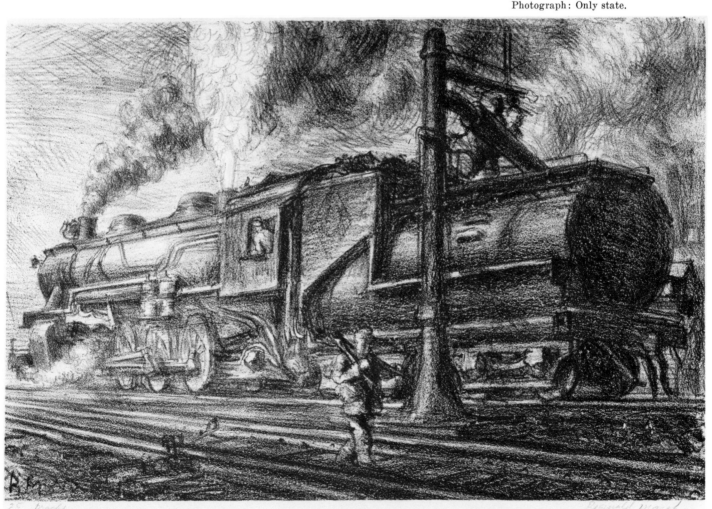

30. *Switch Engines, Erie Yards,*
 Jersey City, Stone No. 3
 1948.
 Lithograph; 228 mm. x 330 mm.
 (9″ x 13″) picture.
 Only state.
 Edition: Print Club of Cleveland, two
 hundred fifty-three plus ten "artist's
 proofs" printed by George C. Miller,
 New York (1948), on Umbria Italia
 wove paper; ACH, ADW, BMA, BOW,
 CIN, CL, DIA, (2) MMA, NGA, (2)
 NYPL, P, Y.
 Note: Drawing for the lithograph or the
 engraving in the author's collection
 (DIV-3).

 Photograph: Only state.

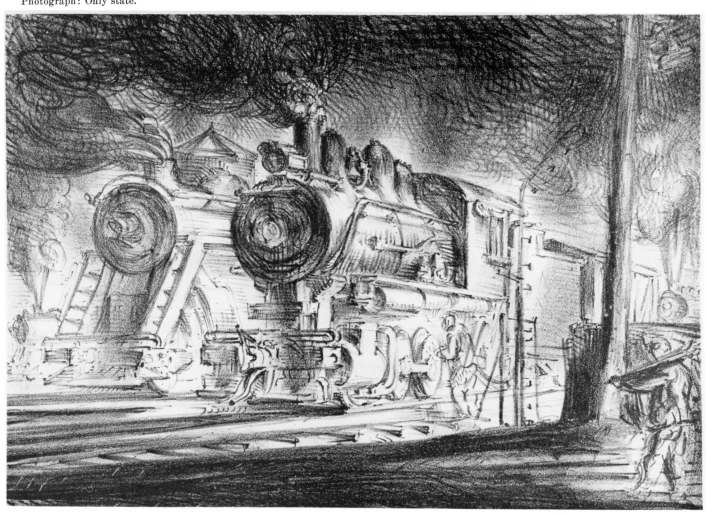

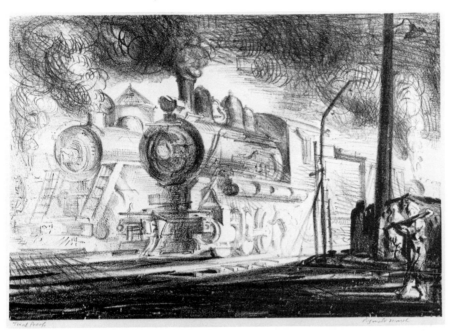

30A. *Switch Engines, Erie Yards,*
Jersey City, Stone No. 1
1948.
Lithograph; 228 mm. x 330 mm.
 (9″ x 13″) picture.
Only state.
Printing: One impression left as part of
 Marsh's estate was signed in Marsh's
 hand (l.l.) "Geo. [?] Miller (Litho)
 Printers proof." CL, NYPL.
Note: Same basic design as S.30; a trial
 stone.

Photograph: Only state.

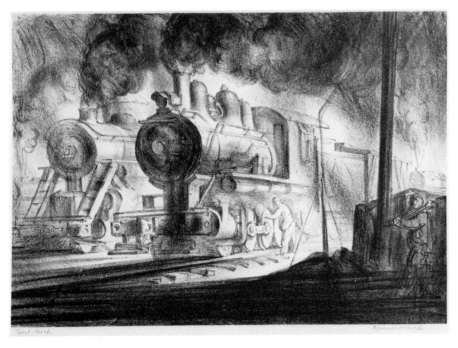

30B. *Switch Engines, Erie Yards,*
Jersey City, Stone No. 2
1948.
 Lithograph; 228 mm. x 330 mm.
 (9″ x 13″) picture.
 Only state.
 Printing: One trial impression, CL.
 Note: Same basic design as S.30; a trial
 stone.

 Photograph: Only state.

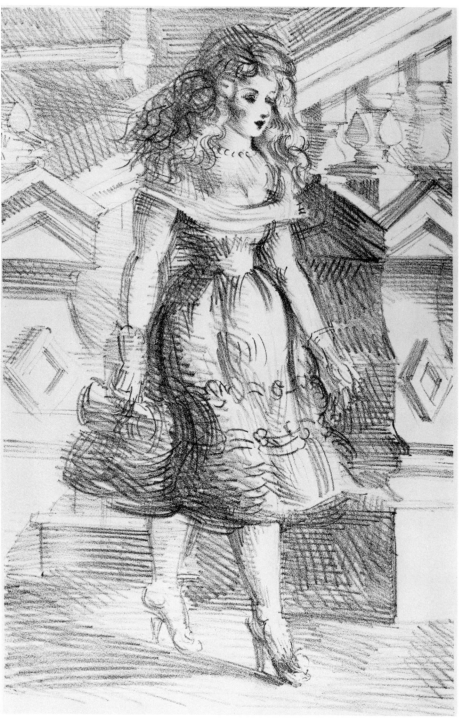

31. *Girl Walking in Front of Brownstone**
1950. Estimate.
Lithograph; 343 mm. x 228 mm.
(13½″ x 9″) picture.
Only state.
Printing: Unknown.
Note: Similar to drypoint S.235. A signed
trial proof impression has been located
in the Associated American Artists
gallery that suggests it was submitted
for publication. "O.K. for Printing"
appears on this impression.

Photograph: Only state.

31A. *New York*
1927.
Lithograph; 343 mm. x 481 mm.
(13½″ x 19″) picture.
Only state.
Printing: Marsh, six impressions; one
impression signed and numbered "#6"
was left as part of Marsh's estate.

Photograph: No photograph available.

Etchings and engravings

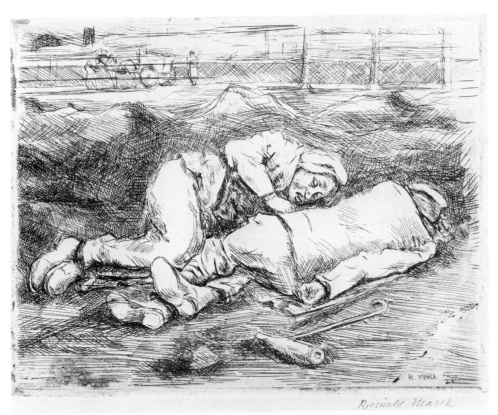

Reginald Marsh

32. *Two Tramps by Seine*
1926.
l.r.; R MARSH,
'26
Etching; 122 mm. x 161 mm.
(4¾" x 6¼") plate.
State I (two proofs: *1* NYPL, *2* Z)
Design nearly complete.
State II (one proof: *3*) Some lines added
to man's shoe in foreground and to
middle ground around figures. Lines on
face of figure lightened. Diagonal lines
added center area of background figure.
State III (two proofs: *5, 6* NYPL) More
lines added around figures in middle
ground. Also central area of figures
darkened, possibly drypoint additions,
judging by the rich blacks created by
these lines. Lines under forward figure's
arm developed.

State IV (two proofs: *7* BPL, *8*) Ground
around figures developed; mounds of
earth and rocks are more clearly
defined. Several strong lines added near
feet in foreground.
State V Many lines added to areas
surrounding figures, creating large
dark areas around figures. Lines also
added to various parts of the figures.
More lines added to distant background,
extending the fence and adding trees.
Mounds of earth or rocks behind figures
now larger.
State VI Burr seems to have been removed
in the lower right corner of the proof;
possibly in other areas as well. There is
some question if this is a new state.
Final state.
Printing: Marsh, three impressions on
Umbria (Feb. 12, 1929); *4* PMA, *5*
NYPL, *7* BPL.

Note: Marsh inscribed "Earliest
Etching" on mat for proof 3.

Photograph: Final state.

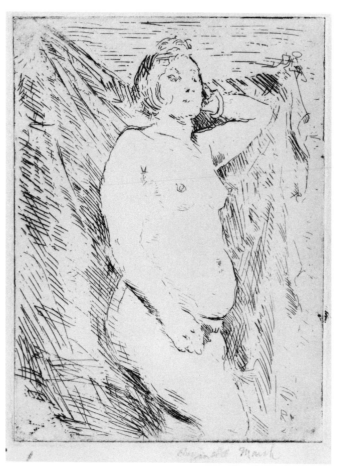

33. *Female Nude**
 1925. Estimate.
 l.r.; RM
 25 (Number not clear; it may be 26)
 Etching; 108 mm. x 89 mm.
 (4¼″ x 3½″) plate mark.
 Only state.
 Printing: Unknown.
 Plate not found.
 Note: In the 1956 catalog this print was
 listed as having been completed in
 1926. Further scrutiny of the date on
 the only known proof suggests that it
 might be 1925. If this is so, it would
 make this Marsh's earliest known
 etching.

 Photograph: Only state.

34. *People on Balcony**
 1927. Estimate.
 Drypoint; 82 mm. x 63 mm.
 (3¼″ x 2½″) plate mark.
 State I (one proof) Design complete.
 State II (one proof) Horizontal lines
 added in upper left, also some vertical
 lines added in extreme upper left. Final
 state.
 Printing: Unknown.
 Plate not found.

 Photograph: Final state.

35. *Easter Greetings**
1927. Estimate.
Drypoint; 63 mm. x 89 mm.
 (2½″ x 3½″) plate mark.
Only state.
Printing: Unknown.
Plate not found.

Photograph: Only state.

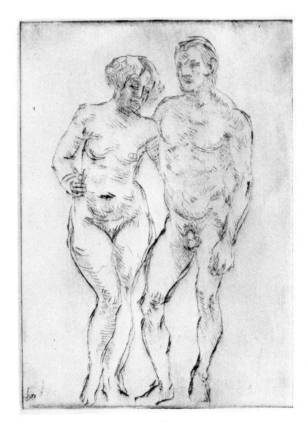

36. *Male and Female Nude**
1927. Estimate.
Drypoint; 89 mm. x 63 mm.
 (3½″ x 2½″) plate mark.
Only state.
Printing: Unknown.
Plate not found.

Photograph: Only state.

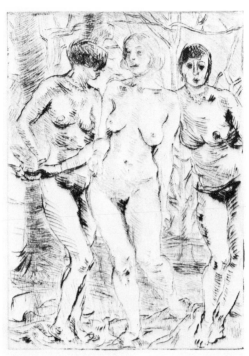

37. *Three Female Nudes**
 1927. Estimate.
 Drypoint; 89 mm. x 63 mm.
 (3½″ x 2½″) plate mark.
 State I (two proofs: *1, 2* NYPL) Single
 standing female nude.
 State II (*4* NYPL) Two female nude
 figures added. Also, trees and ground
 added to original design. Final state.
 Printing: Unknown.
 Plate not found.

 Photograph: Final state.

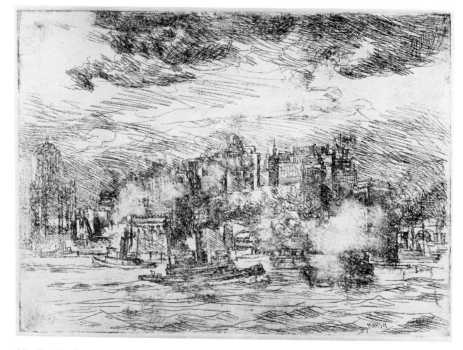

38. *Skyline**
 1927.
 MARSH
 l.r.; 27
 Etching; 140 mm. x 190 mm.
 (5½″ x 7½″) plate mark.
 Only state.
 Printing: Unknown.
 Plate not found.

 Photograph: Only state.

39. *Burlesk Runway*
 1927. (Feb. 7, 1927) Date stamped on
 back of PMA impression.
 l.l.; MЯ
 Etching; 127 mm. x 171 mm.
 (5″ x 6¾″) plate mark.
 State I (two proofs: *1* PMA, *2* WB)
 Design complete, mostly in outline with
 some diagonal lines added in various
 areas.
 State II (two proofs: *4* NYPL, Z)
 Cross-hatching added throughout.
 Background darkened. All figures
 modeled heavily.

State III Some lines added throughout.
 Final state.
Printing: Highest numbered impression
 located 17 CL; PMA.
Plate not found.

Photograph: Final state, 12.

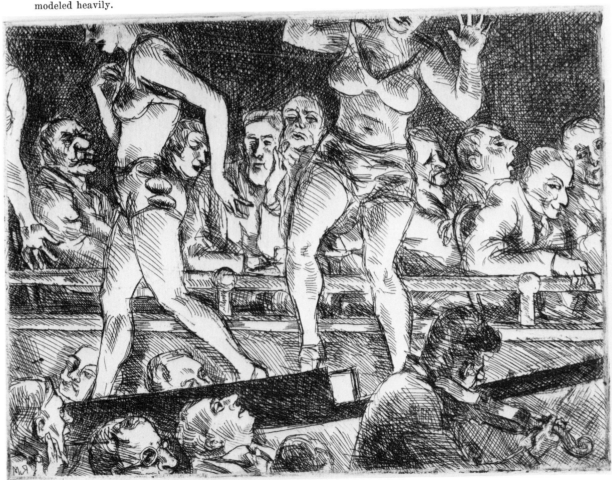

*40. Martha Grace**
　1927.
　l.r. RM
　　　27'
　Etching; 102 mm. x 63 mm.
　　(4" x 2½") plate mark.
　State I (one proof: *1*) Design complete.
　State II (one proof: *2*) Dark area under
　　chin lightened, lines added on neckline
　　and hair.
　State III Initials and date added in lower
　　right. Final state.
　Printing: Unknown.
　Plate not found.
　Note: The subject of this print is an
　archeologist living in Greece.

　Photograph: Final state, 3.

*41. Bryson Burroughs**
　1927.
　l.r.; MARSH
　　　1927
　Drypoint; 102 mm. x 76 mm.
　　(4" x 3") plate mark.
　State I (one proof: *1* WB) Design
　　complete.
　State II (three proofs: *2* NYPL, *3, 4*
　　NYPL) Many diagonal lines added to
　　head.
　State III (two proofs: *5* WB, *6* NYPL)
　　Cross-hatching added to face. Dark line
　　under lip scraped out. Final state.
　Printing: Unknown.
　Plate not found.

　Photograph: Final state, 5.

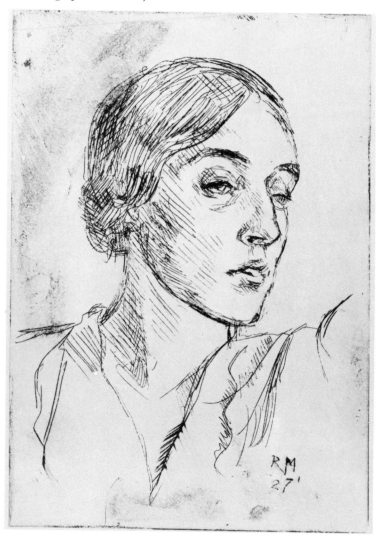

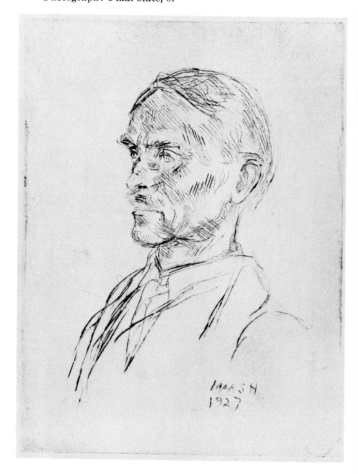

42. *Llewellyn Powys**

1927. Estimate.

Etching; 89 mm. x 63 mm.

(3½″ x 2½″) plate mark.

Only state.

Printing: Impressions *2, 3* NYPL, *5* WB.

Plate not found.

Note: Llewellyn Powys was a
distinguished English essayist who lived
from 1884 to 1939.

Photograph: Only state, 5.

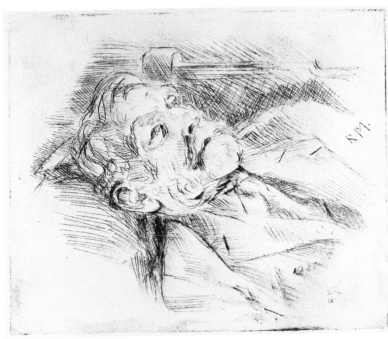

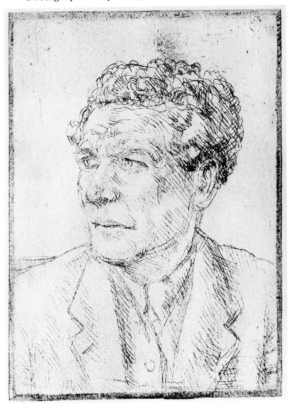

43. *Old Man's Head**

1927.

l.l.; 1927. r.; R.M.

Etching and drypoint; 102 mm. x 127 mm.

(4″ x 5″) plate.

State I Design complete.

State II Some random lines added. Date
added in lower right. Final state.

Printing: Highest numbered impression
located, *5* NYPL.

Photograph: Final state.

44. *Three Heads**
 1928.
 l.r.; SEPT 30 1928
 Drypoint; 76 mm. x 102 mm.
 (3″ x 4″) plate mark.
 Only state.
 Printing: *1* NYPL.
 Plate not found.

 Photograph: Only state.

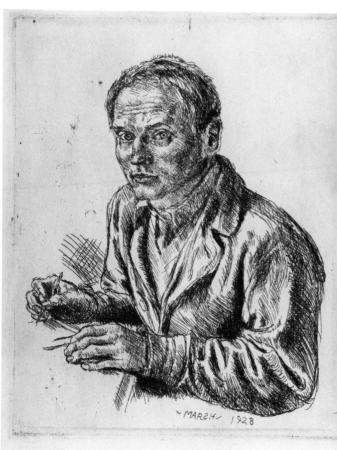

45. *Self-Portrait*
 1928.
 l.r.; MARSH 1928
 Etching; 102 mm. x 127 mm.
 (4″ x 5″) plate mark.
 State I Design complete.
 State II Many additional lines added
 throughout figure. Final state.
 Printing: Impression *8* NYPL, FOG
 NYPL.
 Plate not found.

 Photograph: Final state.

46. *Self-Portrait*
 1928. Notebook No. 3, pp. 5, 6. (December
 13, 1928)
 Etching; 70 mm. x 63 mm.
 (2¾" x 2½") plate mark.
 State I (one proof: 1 Umbria) Design
 complete.
 State II (two proofs: 2 Whatman, 3
 destroyed) Some engraving added.
 State III (two proofs: 3, 4) (Marsh
 considered these impressions State II)
 Stopped face completely and back of
 hand (RM).

State IV Final state.
Printing: Marsh, impressions 5 through 8
 (January 10, 1929); NYPL.
Plate not found.

Photograph: Final state.

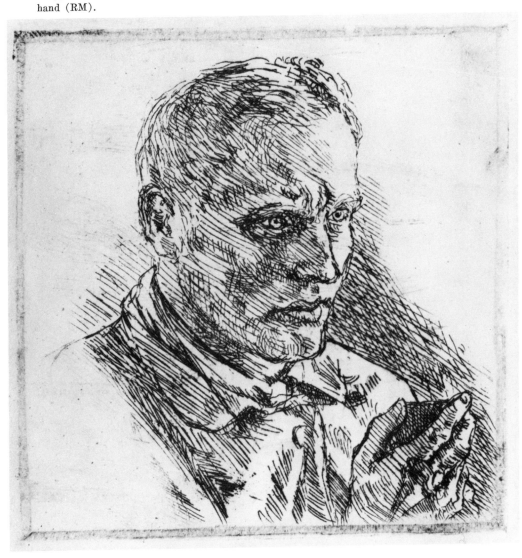

47. *Wild Party*
 1928.
 l.r.; 1928 MARSH
 Etching; 146 mm. x 215 mm.
 (5¾″ x 8½″) plate mark.
 State I Design complete, mostly in outline
 with some diagonal lines added in areas.
 State II Name and date added.
 Crosshatched lines added; greater
 clarification of forms. Final state.
 Printing: Impression NYPL.
 Plate not found.

 Photograph: Final state.

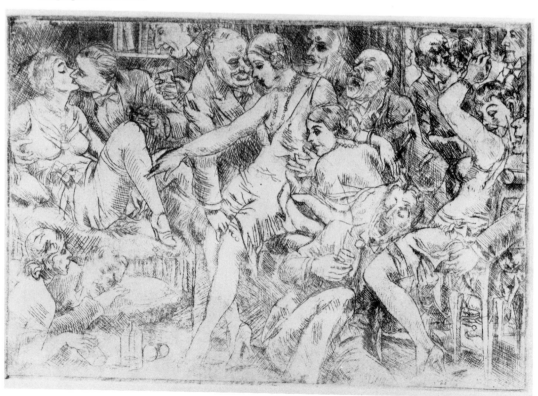

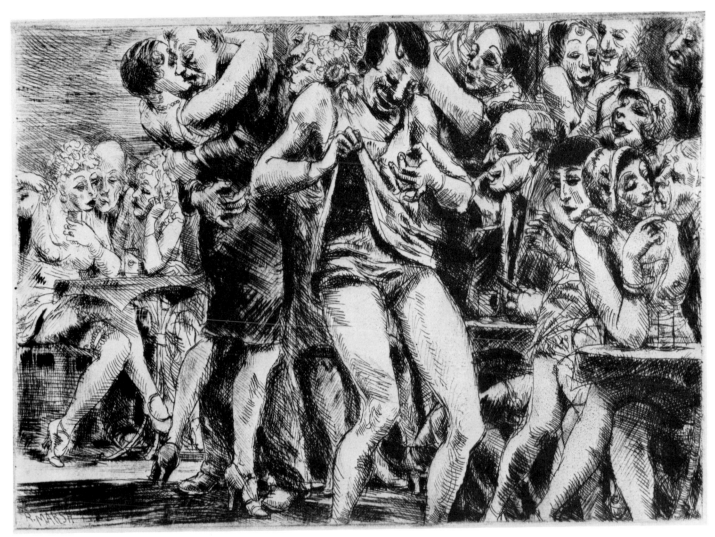

48. *Sugar Cane*
 1928. Notebook No. 3, last page.
 (February 1928)
 l.l.; R. MARSH 1928
 Etching; 152 mm. x 210 mm.
 (6″ x 8¼″) plate mark.
 State I (proof: *2*) Design complete. Area
 of upper left corner not etched—used as
 vise grip. Many areas developed with
 crosshatched lines.
 State II (proof: *4*) Lines added in upper
 left. Diagonal lines added to leg of
 woman at far left. Many other lines
 added throughout, creating dark areas.
 State III (three proofs: *6* NYPL, *7*, *9*)
 Horizontal lines to left of woman's leg
 at far left. Lines added to face of man
 seated between two women at far left.
 Strong vertical line added in upper
 right between two women.
 State IV (proofs: *9*, *10*, *11*)

Cross-hatching added to right leg of
woman in far left as well as to many
other areas.
State V (proof: *13*) Sweeping diagonal
lines added to dress of woman to the
left of main figure. Also, diagonal lines
added to left of main figure's right leg.
Lines added to both legs of woman to
left of main figure. Shadow on ground
darkened.
State VI (proof: *14*, *15* NYPL) Many
drypoint lines added in various parts
creating large dark areas. Floor
darkened in lower left. Horizontal lines
in upper left. Final state.
Printing: Unknown; early state proof, Z.
Plate not found.

Photograph: Final state, 16.

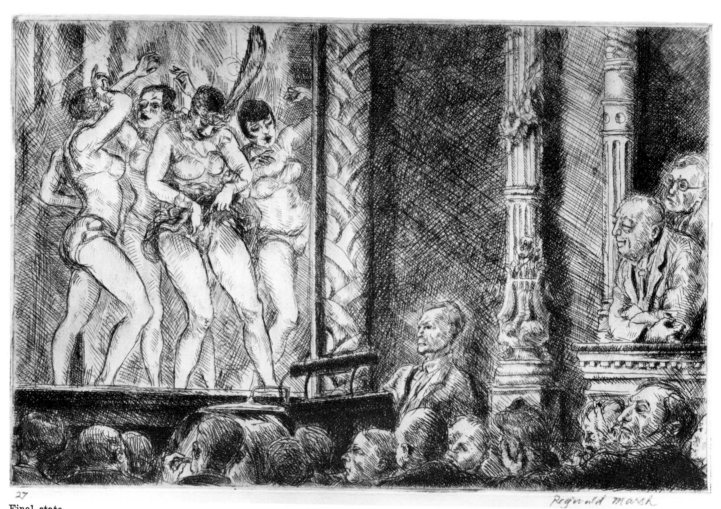

27.

Final state

Reginald Marsh

49. *Irving Place Burlesque (#2)*
1928. 1929 Red Star Diary. Notebook No.
 3, p. 2.
Etching; 178 mm. x 273 mm.
 (7″ x 10¾″) plate mark.
State I (two proofs: *1* NYPL, *2 1st
 state*) Design complete. Some
 crosshatched lines in center and far
 right.
State II (two proofs: *3 II State, 4*
 NYPL) Crosshatched lines added
 throughout.
State III (one proof: *5 only print of 3rd
 state*) Many lines added to center. Lines
 removed in upper left.
State IV (three proofs: *6 4th state, 7, 8*
 NYPL) Some lines replaced in upper
 left. Extreme right edge of plate not
 printed. Lines added to heads of men in
 lower left. Dark lines between thighs of
 main female figure removed.
State V (proof: *9 5th state*) Lines added
 to figures in lower left to darken
 general area. Extreme right edge of
 plate not printed.
State VI (two proofs: *10 6th state, 11
 6th state*, NYPL) Difficult to determine
 additional work because of poor
 impressions. Probably some scraping.
State VII (two proofs: *13 7th state*
 NYPL, 14) Scraping on upper part of
 central figure.
State VIII Diagonal lines added near
 lower edge of plate, possibly engraved.
 Final state.
Printing: Marsh, impressions through 37;
 15, 16 WB, *18,* 19, 21, 22, *25* NYPL, Z.
Plate not found.

Photographs: Final state, 27. Drawing,
 collection of the author.

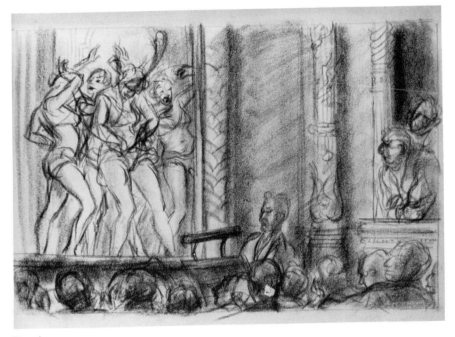

Drawing

50. *Skyline of Lower Manhattan**
1928.
l.r.; R. MARSH 1928
Etching; 63 mm. x 203 mm.
 (2½" x 8") plate mark.
State I (three proofs: 1, *2, 3* NYPL)
 Design complete. Diagonal lines added
 in some areas.
State II Lines added in foreground as
 well as to some buildings. Final state.
Printing: Impressions *5* NYPL, *6* WB.
Plate not found.

Photograph: Final state, 6.

51. *Brooklyn Bridge from Manhattan
Bridge*
1928. 1929 Red Star Diary.
l.r.; MARSH
 1928
Etching; 178 mm. x 279 mm.
 (7" x 11") plate mark.
State I (one proof: *1st state* touched
 extensively) Design complete.
State II (two proofs: *2 II state, 3* NYPL)
 Bridge at far left crosshatched. Lines
 added to buildings and boats in
 foreground. Lines added to tugboat
 and water in lower right.

State III (one proof: *4 3rd state only
 print*) Lines added to upper bridge and
 buildings in upper right section. Lines
 added to various parts of the water,
 tugboats, and foreground area.
State IV (proof: *5 4th state*) Many lines
 added; cables added to bridge. First
 addition of horizontal lines to sky.
 Cross-hatching added to buildings in
 background; smoke added to many of
 the boats.

State V (proof: *5th state 7*) Lines added
 to dark areas in foreground and bridge.
 Horizontal lines in sky increased. Tug
 near center and wharf area in
 background clarified; possibly these
 are drypoint additions.
State VI (proof: *9*) Lines added to water,
 center area, base of bridge, and
 buildings in foreground. Final state.
Printing: Impressions *6* NYPL, *11* ART,
 12 Whatman NYPL.
Plate not found.

Photograph: Final state, 9.

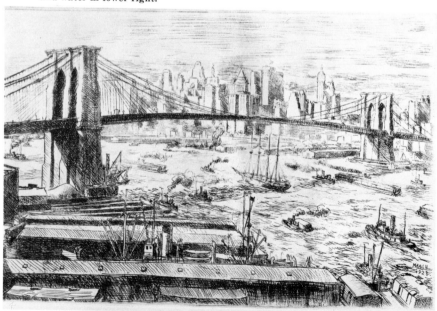

52. *Locomotive C C N J*

1928. Estimate.

l.r.; R. MARSH 1928

Etching; 178 mm. x 279 mm.
(7″ x 11″) plate mark.

State I (two proofs: *1, 2*) Design
complete

State II (two proofs: *3* NYPL, *4*)
Cross-hatching lines added. Track
connecting bar added in lower left.
Lines added to tracks.

State III (two proofs: *5 3rd state, 6*
NYPL) Additional lines—possibly
drypoint additions—in dark areas,
especially in front part of locomotive
cab and on face of locomotive.

State IV (proof: *7 4th state*) Again,
many lines—drypoint—added in dark
areas, especially in far right. Coat of
man in foreground darkened; man at
right darkened on his dark side.
Additions to form at top left.

State V Line added to lower edge of
foreground, on the cab, and to upper
area of locomotive wheels. Final state.

Printing: Impressions *11* NYPL, 12 LC,
14 NYPL.

Plate not found.

Photograph: Final state, 19.

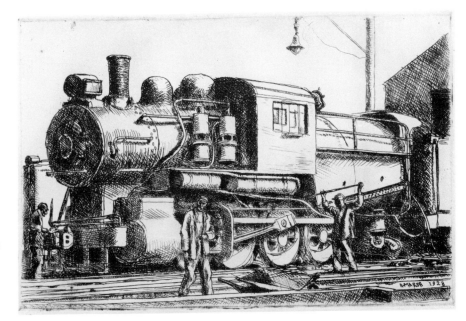

53. *Paris Tramp*

1928.

l.l.; R MARSH
PARIS '28

Drypoint (zinc); 102 mm. x 152 mm.
(4″ x 6″) plate.

Only state.

Printing: Marsh, 2, 3, 4 (December 15,
1929); NYPL, Z.

Plate damaged by corrosion. Condition
very poor.

Photograph: Only state.

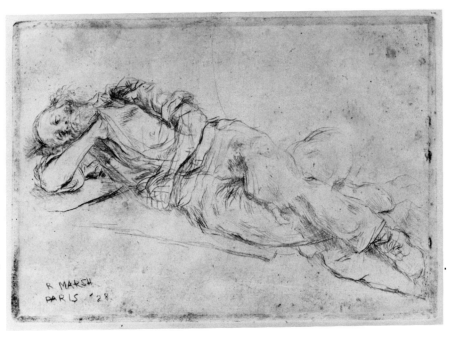

54. Bowery

1928. 1929 Red Star Diary.

Etching; 159 mm. x 146 mm.

(6¼" x 4¾") plate mark.

State I (one proof: *1 1st state*) A poor
ground—etched in strong acid 3
minutes (RM). Design complete; very
weak in center portion.

State II (one proof: *2*) Many lines added
to figures. Some lines appear to be
etched, others by drypoint.

State III (one proof: *3 3rd state*) Many
lines added to figures, mostly
crosshatched. Some lines appear etched,
others by drypoint, especially in upper
left and lower right of man's coat. Lines
added to arms of both figures in
foreground.

State IV (proofs: *4 4th state* NYPL, *5*
NYPL) Lines added to back of man's
coat at left, including a single line on
man's coat at far left. Lower center
area has lines added. Some engraving.

State V (proofs: *7 5th state*, *8* NYPL, *9*
FM, 10 FM) Many lines throughout
creating deep darks in all dark areas.
Coat at left is very dark, having the
richness of drypoint blacks. Area of
pants of a man at right darkened to
create pocket.

State VI (proof: *11*) Background area
has many crosshatched lines added.
Vise mark in lower right partially
effaced.

State VII Etched nitric (too strong)
heads in background (RM). Final state.

Printing: Marsh, 25 through 28
(February 17, 1929); 10, 14 NYPL,
16, 20, *21* FM, *28* BPL.

Plate not found.

Photograph: State VI, 11.

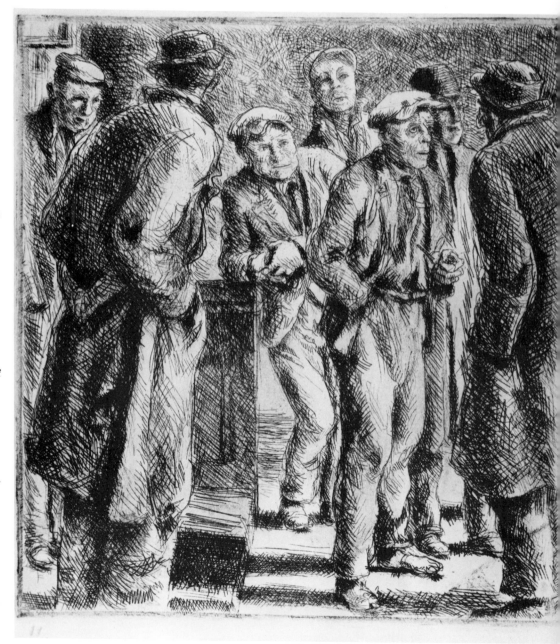

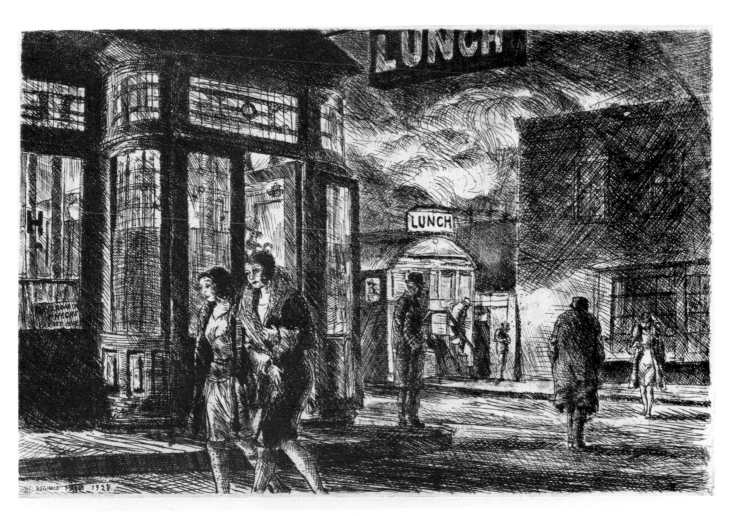

55. *Pavonia Ave.*
 1928. Notebook No. 3, pp. 97–98.
 l.l.; REGINALD MARSH 1928
 Etching; 178 mm. x 280 mm.
 (7″ x 11″) plate.
 State I (one proof: *1*) Design complete.
 Vise mark in upper left corner.
 State II (one proof: *2* NYPL) Redraw
 lines (RM).
 State III (two proofs: *3, 4*) Many lines
 added throughout.
 State IV (two proofs: *5 Third state, 6*
 NYPL) Redrew men and further
 buildings . . . redrew sky (RM). Seems
 to be some damage to plate, creating
 black smudgelike areas.

State V (one proof: *7*) Redrew sky, etc.
 (RM).
State VI Engraving added (RM).
 Changes are mostly in foreground, on
 woman's coat and near "LUNCH"
 sign. Final state.
Printing: Marsh, impressions 8 through
 19; *2, 3, 6, 8, 13* NYPL, *17* BPL, Z.
Note: Painting, same design: *Lunch,* c.
 1927, Collection Mrs. Reginald Marsh.
 Design somewhat altered, especially in
 distribution of lights and darks.

Photograph: Final state.

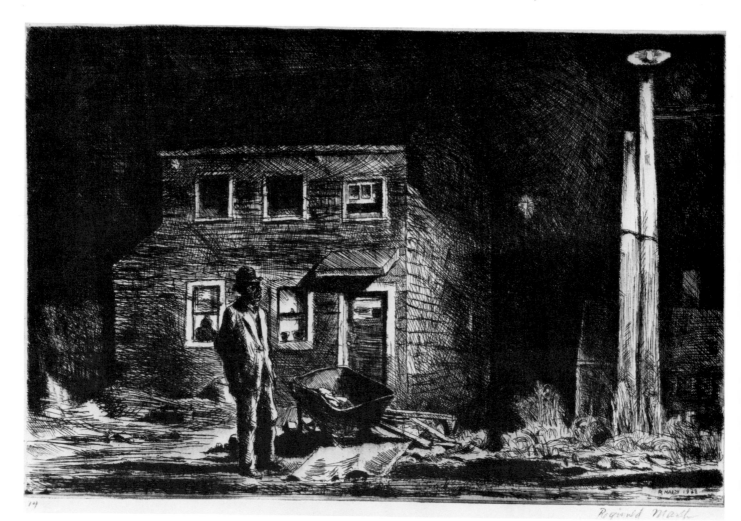

56. *Bar Buey (Negro Huts)*
 1928. 1929 Red Star Diary.
 l.r.; R. MARЅH 1928
 Etching; 178 mm. x 280 mm.
 (7″ x 11″) plate.
 State I (one proof: *1* touched extensively)
 Design complete.
 State II (one proof: 2) Stopped lamp and
 part between door and lower window
 (RM). Name and date added.
 State III (two proofs: *3, 4*) Tele pole,
 door, parts of front of house (RM).
 State IV (two proofs: *5* NYPL, 6) First
 graving (RM).

State V (two proofs: 7, 8) Many lines
 added to intensify dark areas. Strong
 horizontal lines added to buildings at
 far right.
Printing: Marsh, impressions 9 through
 14; 15 through 21 Whatman (November
 10, 1929); 22 through 24 (March 19,
 1931); highest numbered impression
 located, 25; *4* FM, 5, *21/50* BPL, *23*
 NYPL, Z.

Photograph: Final state, 14.

57. *Subway—Three Girls*
 1928.
 l.l.; R. MARSH c.r.; 1928
 Etching; 127 mm. x 102 mm.
 (5″ x 4″) plate mark.
 State I (one proof: *1* torn) Design
 complete. A few diagonal lines included.
 State II (proof: *2*) Many horizontal lines
 added to background. The number "4"
 darkened. Lines, and some
 cross-hatching added to figures.
 State III (two proofs: *5 3rd state, 6*
 NYPL) Lines added to right figure's
 legs, clothing. Figure at far left
 developed further. Many lines added to
 ground and shoes. "1928" added in
 lower right.
 State IV (proof: *7 4th state*) Diagonal
 lines added to subway post. Heavy dark
 lines—possibly drypoint—added to dark
 areas of figures. Lines added to top of
 machine, under arm of figure at far
 left.
 State V (proof: *9*) Left figure of main
 group has many lines added, making
 coat appear dark. Lines added to lower
 part of post. Horizontal lines added to
 lower part of machine. Diagonal lines
 added to ground.
 State VI Many lines added to background
 and other areas. Final state.
 Printing: Marsh, 10 (April 12, 1929)
 represents a new state (RM).
 Plate not found.

 Photograph: Final state.

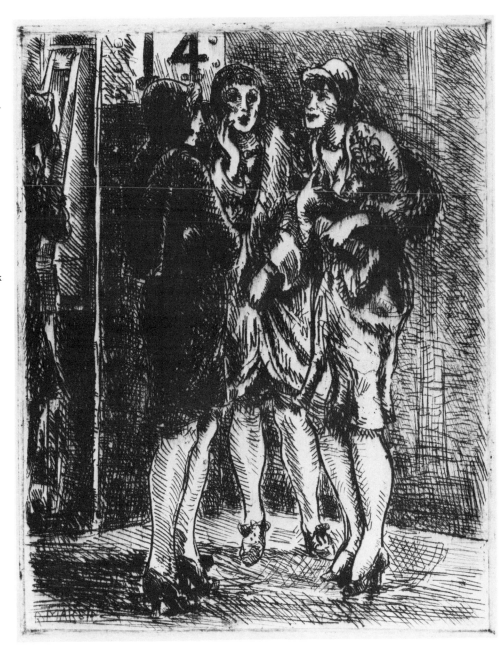

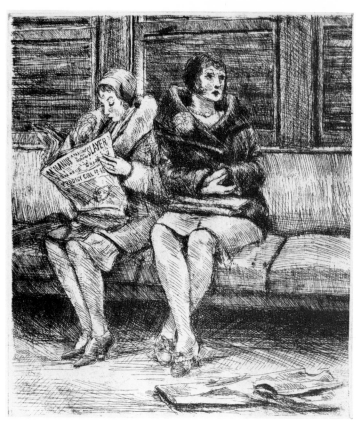

58. *Two Girls in Subway*
 1928. 1929 Red Star Diary.
 l.r. of c.; REGINALD MARSH 1928
 (removed when plate was cut)
 Etching; 178 mm. x 152 mm.
 (7″ x 6″) plate mark. Original plate
 178 mm. x 273 mm. (7″ x 10¾″) plate
 mark.
 State I (one proof: *1 1st state* Umbria)
 Design complete. Lightly drawn. Some
 cross-hatching in dark areas.
 State II (one proof: *2*) Lines added
 throughout; forms developed. Windows
 darkened considerably.
 State III (two proofs: *3, 4*) Stopped
 out girl's legs, streaks in windows
 (RM).
 State IV Plate cut in half—foul bites
 charcoaled and engraved a little (RM).
 Final state.
 Printing: Marsh, impressions 1 through 8
 Whatman; *10* BPL, 11 LC, *12* NYPL,
 (2) Z.
 Plate not found.
 Note: Two proofs in Collection Mr. & Mrs.
 Charles Zitner, one probably early state,
 maybe State II.

 Photograph: Final state, 9.

59. *2nd Ave. El.*
 1929. (March 22, 1929)
 l.l.; MARSH
 1929
 Etching; 178 mm. x 228 mm.
 (7″ x 9″) plate.
 State I (two proofs: *1, 2* Umbria MMA
 touched) Design complete. Dark areas
 very heavily drawn.
 State II (two proofs: *3, 4* Umbria PMA)
 Lines added throughout. Small head
 reflected in window seems to be a Marsh
 self-portrait.
 State III (one proof: *5* Umbria NYPL)
 Lines added to girl's legs, windows,
 newspaper, and other areas. Final
 state.
 Printing: Marsh, impressions 6 through 11
 (March 31, 1929); 12 through 17
 (November 6, 1929); highest numbered
 impression located, 25; *5* NYPL, *9* FM,
 10 LC, Z.

 Photograph: Final state, 13/50.

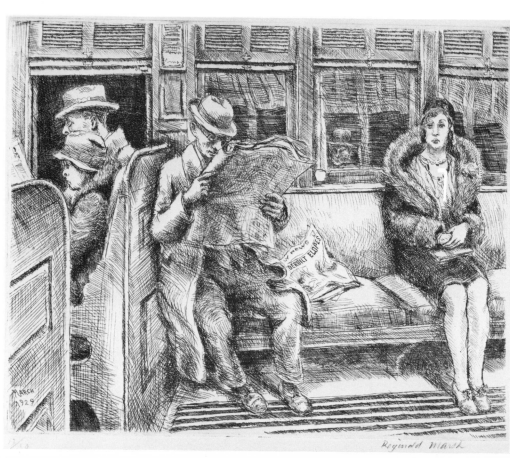

60. BMT (#1)

1929. (November 28, 1929)

l.l.; 1929

Etching; 152 mm. x 230 mm.
 (6″ x 9″) plate.

State I (two proofs: *1, 2* white Umbria
 touched and annotated) Design
 complete. Many forms fully developed.

State II (two proofs: *3, 4* Whatman
 NYPL) Many lines added throughout
 creating rich dark areas. White area on
 woman's coat toned down.

State III (two proofs: *5, 6* Barcelona)
 Window at far right may have been
 scraped thereby lightening this area.
 Some foul biting.

State IV (one proof: *7*) Foul-biting
 damage removed. Some engraving
 added. Diagonal lines added to the
 right of date. Final state.

Printing: Unknown.

Photograph: Final state, 7.

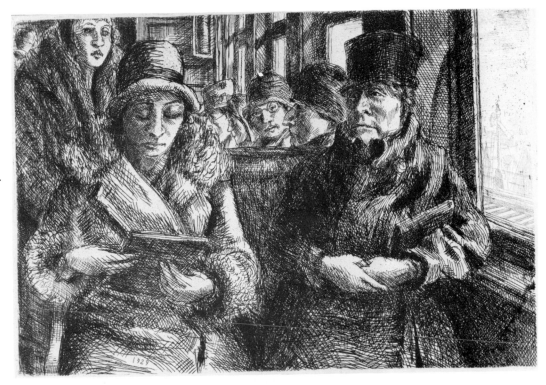

61. BMT (#2)

1929. (October 27, 1929)

u.l.; MARSH 1929

Etching; 102 mm. x 127 mm.
 (4″ x 5″) plate mark.

State I (two proofs: *1, 2* Umbria)
 Design complete.

State II (three proofs: 3 Whatman, 4, 5)
 Drawing added to newspaper. Many
 lines added throughout. Seat area at far
 left darkened. Faces of both women
 have additional drawing.

State III Some engraving added.
 Final state.

Printing: Marsh, impressions 4 through
 12 (November 4, 1929) mostly on
 Whatman; *11/50* NYPL, Z.

Plate destroyed. Notebook No. 8, p. 50.

Photograph: Final state, 10/50.

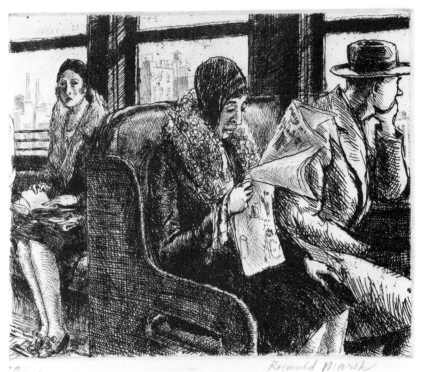

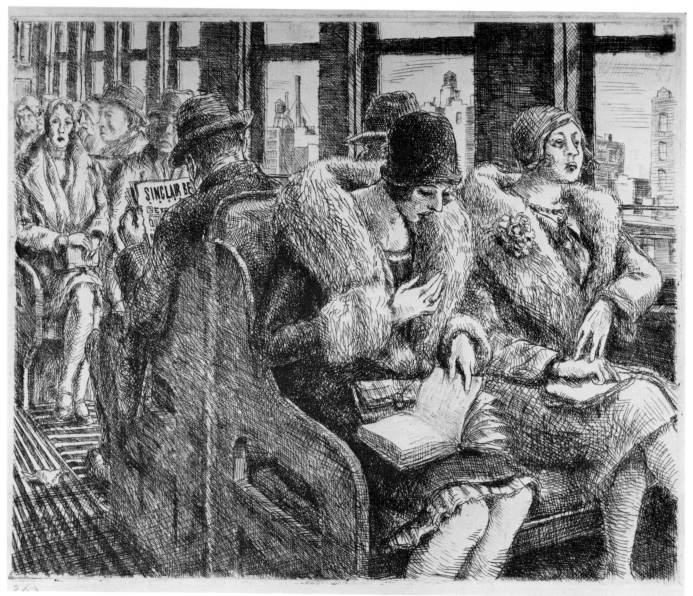

62. *BMT (#3)*

1929. (May 4, 1929)

l.l.; R. MARSH (Letters not clearly formed).

Etching; 203 mm. x 247 mm. (8″ x 9¾″) plate.

State I (one proof: *1*, touched and notated) Design complete. Most areas lightly drawn.

State II (one proof: *2* Umbria) Headline in newspaper added. Lines added to first four figures.

State III (one proof: *3* Navarre) Lines added to figures in foreground and all windows.

State IV (one proof: *4*) Lines added to main woman, to exterior and background.

State V (one proof: *5* Umbria) Many lines removed and lightened, especially on faces of men at far left; also, on book on woman's lap.

State VI (two proofs: *6, 7*) Underbitten (RM). Very faint lines added to faces.

State VII (two proofs: *8* WB, *9* Umbria NYPL) More lines added in foreground, possibly drypoint and engraving. Some lines added to faces in upper left. Final state.

Printing: Unknown.

Plate damaged; cut in half.

Note: Painting, same design: *Second Ave. El*, 1928, Collection Mrs. Reginald Marsh.

Photograph: Final state, 8/50.

63. *Bread Line*
1929.
l.l.; RM 1929
Etching; 128 mm. x 233 mm.
 (5″ x 9″) plate.
State I (two proofs: *1* Whatman,
 2 Umbria) Design complete.
 Foreground nearly completely
 developed.
State II (two proofs: 3 Umbria, 4)
 Drawing developed in various parts.
State III (eight proofs: *5* through 12)
 Drew lightly markings on coat, etc.
 (RM).
State IV Engraving added to main figure.
 Final state.
Printing: Marsh, impressions 13 through
 24 (November 7, 1929); 24 (October
 21, 1932) *6* NYPL, *7/50* MMA, 29 LC,
 Z.

Photograph: State III, 5.

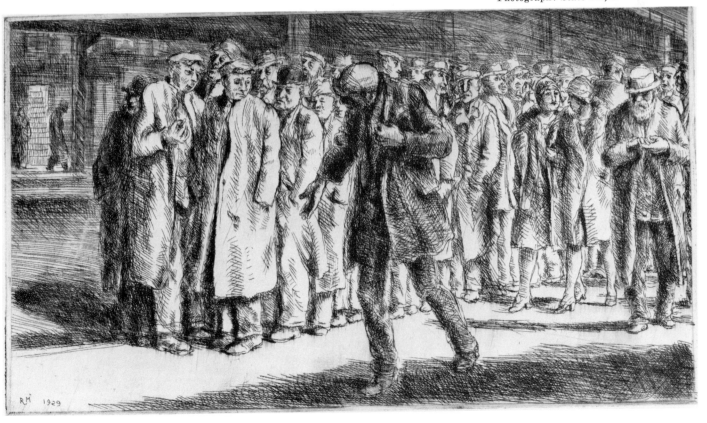

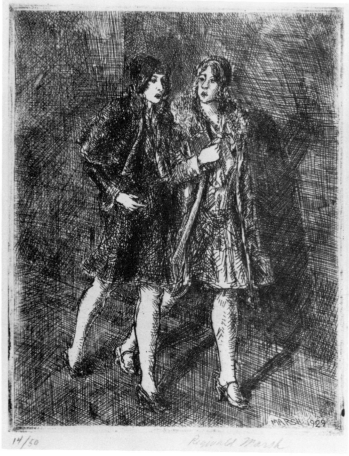

14/50 Reginald Marsh

64. *Two Flappers Walking*
 1929. (April 27, 1929)
 l.r.; MARSH 1929
 Etching; 127 mm. x 102 mm.
 (5″ x 4″) plate mark.
 State I (two proofs: *1, 2* Umbria Z)
 Design complete. Vise mark in upper
 right corner.
 State II (two proofs: *3, 4* Umbria and
 Whatman) Lines added in upper right
 corner.
 State III (one proof: *5* Umbria) Lines
 added to background, face, and neck.
 State IV (two proofs: *6, 7*) Lines added
 to background.
 State V (one proof: *8*) Engraving added
 on black coat and background.
 State VI More engraving added. Final
 state.
 Printing: Marsh, impressions 9 through
 11 Whatman; 12 through 16 (October
 18, 1929); *9* NYPL, *12* LC.
 Plate not found.
 Note: Painting same design but reversed:
 Two Flappers Walking, c. 1927,
 Collection Mrs. Reginald Marsh.

 Photograph: Final state, 14/50.

65. *Tombs Prison*
 1929. (June 7, 1929)
 l.r.; REGINALD MARSH 1929
 Etching; 203 mm. x 247 mm.
 (8″ x 9¾″) plate mark.
 State I (two proofs: *1, 2* Navarre MMA,
 touched) Design complete. Shaded areas
 created with parallel-line technique.
 Cross-hatching in main building. Vise
 mark in upper left corner.
 State II (two proofs: *3, 4* Anvil MMA,
 touched notations added) Lines added
 to fence and sky.
 State III (two proofs, *5, 6*) Lines added
 to sidewalk.
 State IV (five proofs: *7, 8* LC, *9* NYPL,
 10, 11) Graved and burnished out
 marks in sky (RM).
 State V Skyline drawn. Final state.
 Printing: Marsh, impression 12 (July 4,
 1930).
 Plate not found.

 Photograph: State IV, 11.

66. *Drillers*

1929. (February 1, 1929)

l.l.; Marsh 1929

Etching; 178 mm. x 273 mm.
(7″ x 11″) plate.

State I (one proof: *1* Umbria) Design complete, lightly drawn. Vise mark in upper left corner.

State II (two proofs: *2, 3* Umbria NYPL) Lines added to upper left corner. Foreground and middle ground developed. Two figures added to background.

State III Much drawing added throughut. Rocks in lower right covered with a maze of lines to flatten out this area. Forms in middle ground and background clarified greatly. Final state.

Printing: Marsh, 4 Umbria; 5 through 8 (1929 Red Star Diary); 9 through 13 (November 11, 1929); 9 BPL, *12* NYPL.

Surface of plate damaged.

Photograph: Final state, 13/50.

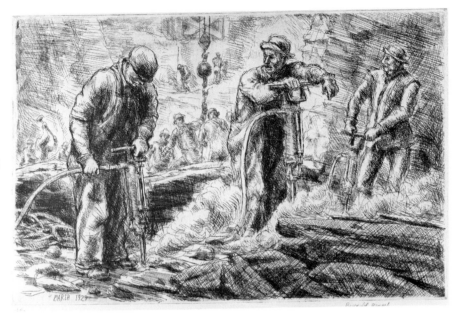

67. *Derrick-Loaders*

1929. (February 10, 1929)

l.l.; R. MARSH 1929

Etching; 253 mm. x 203 mm.
(10″ x 8″) plate mark.

State I (two proofs: *1* NYPL, *2*) Design complete. Mostly outline with upper and center area more heavily modeled.

State II (one proof: *3*) Some foul biting. Name and date in plate obliterated by addition of lines. All forms developed further.

State III (two proofs: *4* Umbria WB, *5* NYPL) Upper left corner has lines added. Ledge added in upper portion. Many lines added throughout, creating rich darks. Darks possibly created with a burin. Shadow added in lower center.

State IV Snake stone, charcoal, and water used to remove unwanted biting from plate (RM). Final state.

Printing: Marsh, impressions 5 through 8; 1, 6, 7 FM, 8 NYPL.

Plate not found.

Photograph: State III, 4.

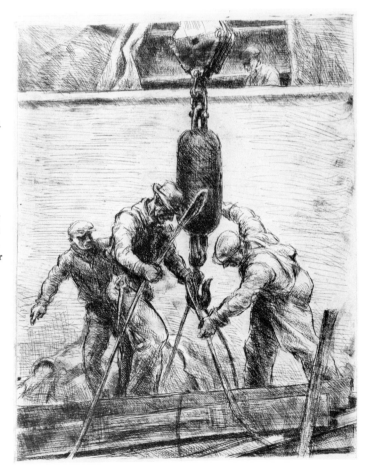

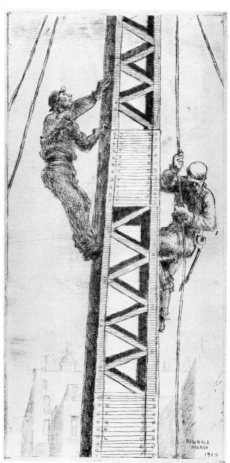

68. Derrick
1929. (December 13, 1929)
l.r.; REGINALD
 MARSH
 1929
Etching; 247 mm. x 127 mm.
 (9¾″ x 5″) plate mark.
Only state (two proofs: *1, 2* Whatman
 NYPL)
Printing: Unknown.
Plate not found.

Photograph: Only state.

69. Skyline from Governor's Island
1929. (May 19, 1929)
l.r.; NEW YORK REGINALD MARSH
 1929 (on one line)
Etching; 131 mm. x 288 mm.
 (5″ x 11¼″) plate.
State I (two proofs: *1, 2* MMA, touched
 with blue and brown wash) Design
 complete.
State II (two proofs: *3, 4* Navarre)
 Lines added to water. Many lines added
 to buildings. Wakes added to tugs.
 Windows added to some buildings.
State III (one proof: *5* MMA, touched)
 Tooled out municipal building and a
 few other parts, polished sky (RM).
State IV (six proofs: *6* NYPL, 7, 8
 Umbria, 9, 10, 11 Whatman) Bit plate
 too deeply. Spit bite with nitric, tug
 and waves (RM). Lines added to lower
 part of sky.
State V (one proof: 12) Charcoaled and
 stoned sky several hours (RM).
State VI (three proofs: 13, 14, *15*)
 Pressed lower sky lines hard with
 burnisher in order to diminish—scraped
 snaked, and charcoaled (RM). Lower
 sky lines effectively removed.
State VII Drew sky lines (RM). Final
 state.
Printing: Highest numbered impression
 located, *9/50* WB.

Photograph: Final state, 16.

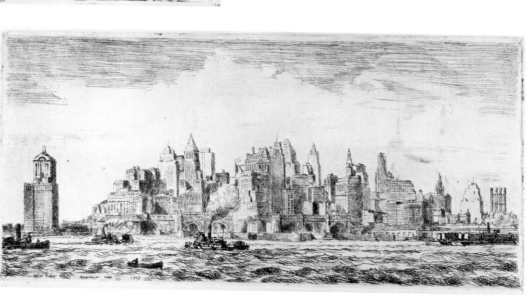

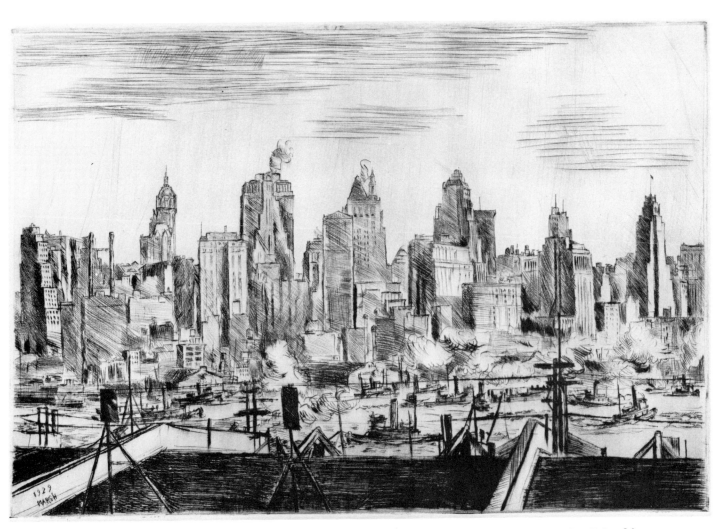

70. *Skyline from 110 Columbia Hts.*
1929. (December, 1929)
l.l.; 1929
 MARSH
Drypoint; 203 mm. x 305 mm.
 (8″ x 12″) plate mark.
State I (two proofs: *1, 2*) Design
 complete. Some shading added to
 buildings. Heavy shading in
 foreground.
State II (one proof: *3*) Name and date
 added in lower left. Many diagonal
 lines added to buildings. Some lines
 added to water and foreground.

State III (one proof: *4*) Lines added to
 roof in left center foreground.
 Distinctive black areas added to
 buildings, often rectangular in shape.
State IV (one proof: *5*) Horizontal lines
 added to sky. Dark side of buildings
 strengthened. Dark areas added under
 smoke in middle ground. Water
 darkened at far left near pier.
State V (one proof: *6*) Scraped out burr
 in sky, drew foreground vigorously, etc.
 (RM). Some strong darks added to
 buildings and boats. Lines added to sky
 at right. Final state.

Printing: Marsh, impressions 7, 8 and 9
 (February 28, 1929); *8* NYPL.
Plate not found.

Photograph: Final state, 9.

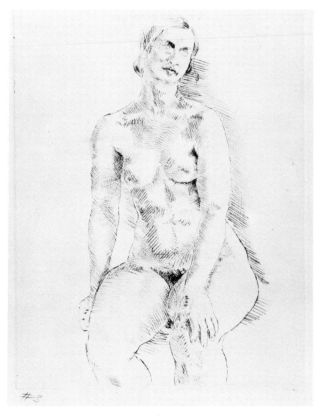

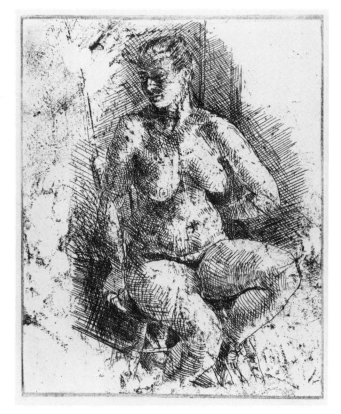

71. *Celia Copeland Nude*
 1930. (October 14, 1930)
 Drypoint; 127 mm. x 102 mm.
 (5″ x 4″) plate mark.
 Only state.
 Printing: Marsh, impressions 1 through 4
 (October 14, 1930); *1, 2* NYPL.
 Plate not found.

 Photograph: Only state, 3.

72. *Miss Hamlin (Nude)*
 1930. (February 22, 1930)
 Etching; 127 mm. x 102 mm.
 (5″ x 4″) plate mark.
 Only state.
 Printing: Marsh, impressions 1, 2 and 3
 Whatman; *2* NYPL.
 Plate not found.

 Photograph: Only state, 1.

73. *Audience Burlesk*
 1929. (December 20, 1929)
 Etching; 152 mm. x 203 mm.
 (6″ x 8″) plate.
 State I (two proofs: *1, 2*) Design
 complete. Most areas modeled.
 State II (one proof: *3* Whatman) Lines
 added to background and faces
 throughout.

State III (two proofs: *4, 5* Barcelona)
 More lines added throughout to darken
 some areas. Wall behind front figures
 darkened.
State IV Some drawing added. Final
 state.
Printing: Marsh, impressions 6 through 9
 Barcelona; *7* NYPL.
Portion of right corner of plate removed.

Photograph: Final state, 6.

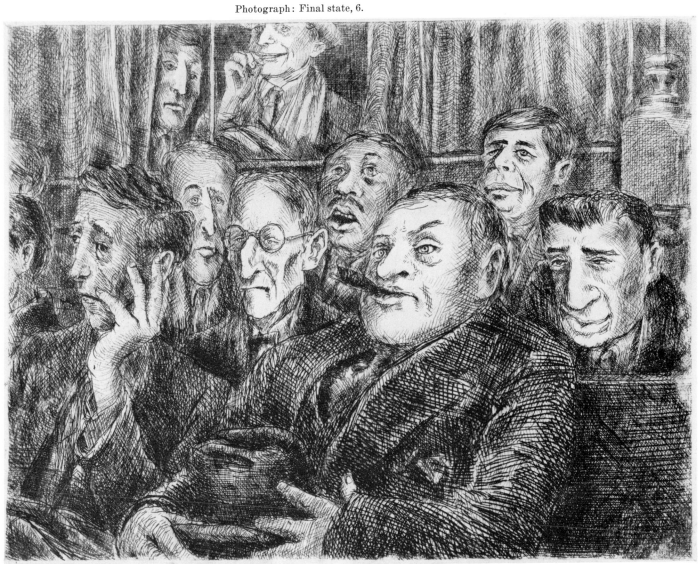

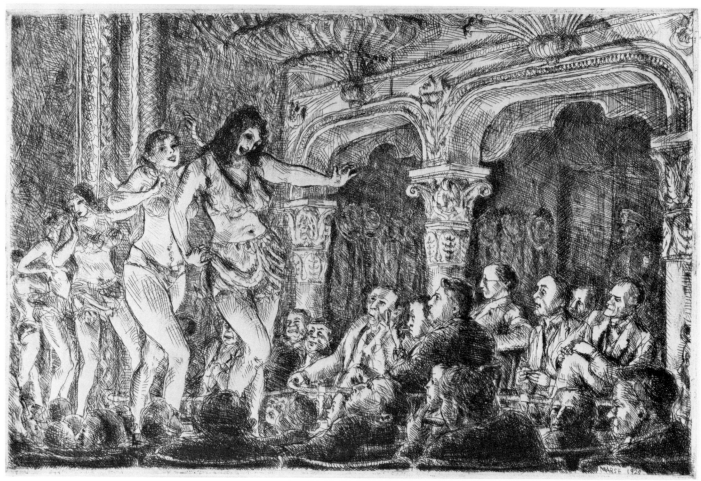

State V

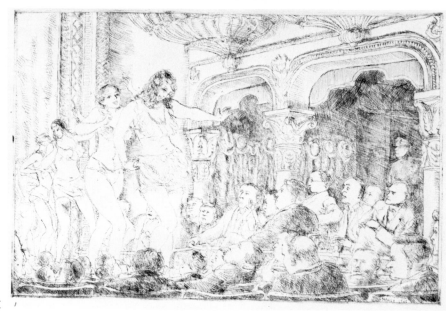

State I

State II

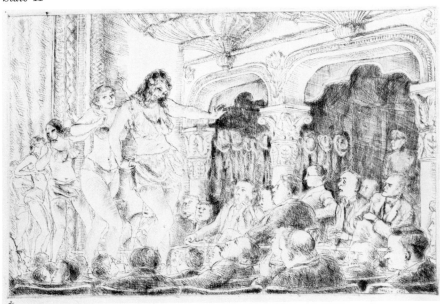

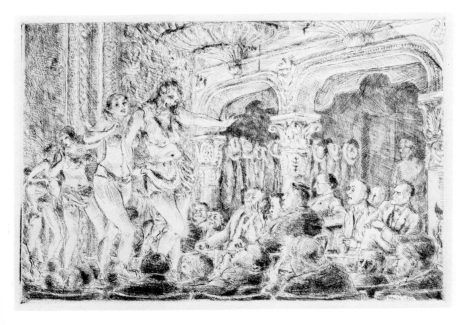

State IV

74. *Gaiety Burlesk*
1929.
l.r.; MARSH 1929
Etching; 178 mm. x 273 mm.
(7″ x 10¾″) plate mark.
State I (one proof: *1* Umbria WB)
Design complete; lightly drawn. Right
section and foreground more fully
developed. Vise mark upper left
corner.
State II (one proof: *2* Umbria WB)
Lines added to girls and to figures at
right. Background area has many lines
added.
State III (one proof: *3* Umbria)
Additional lines drawn on entire
theatre curtain, etc. Slight foul biting.
State IV (two proofs: *5*, 6 Umbria)
Theatre curtain redrawn; lines added
to policeman, hat, coats, and area
behind the girls.
State V (six proofs: 7, *8*, *9* NYPL, 10,
11, *12* Whatman) Policeman's face
scraped a little. Many lines added
throughout.
State VI Final state.
Printing: Marsh, impression 13
(February 9, 1930); *5* PMA, Z.
Plate not found.

Photographs: State V, 12. State I, 1;
State II, 2; State IV.

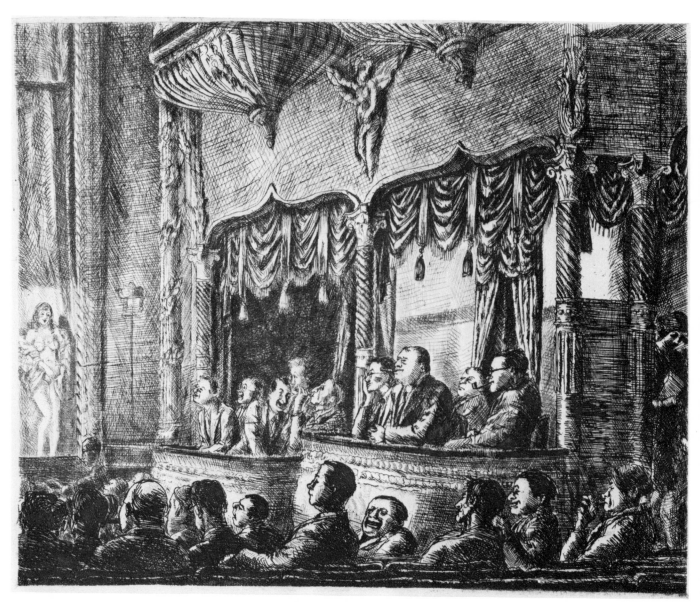

75. *Irving Place Burlesk*
 1929. 1929 Red Star Diary (probably
 November 2, 1929).
 Etching; 203 mm. x 254 mm.
 (8″ x 10″) plate.
 State I (two proofs: *1/50* MMA, touched
 extensively, 2 Whatman) Design
 complete.
 State II (one proof: *3*) Many lines added
 throughout, some drawing on girl.
 State III Lines added behind stage box,
 to girl and to proscenium arch. Final
 state.

Printing: Marsh, impressions 4 through
 14 Whatman; 15 through 24 Whatman
 (January 23, 1930); 25 through 28
 Whatman (February 17, 1930); *7/10,
 19* NYPL.

Photograph: Final state, 25.

76. *Star Burlesque Dancer*
 1929.
 l.r.; MARSH
 1929
 Etching; 127 mm. x 102 mm.
 (5″ x 4″) plate mark.
 State I (two proofs: *1, 2* Umbria) Design
 complete. Some foul biting.
 State II (four proofs: *3* WB, *4* NYPL,
 5, 6 NYPL Whatman) Rubbed down
 with scraper, snakestone, and charcoal
 for two hours (RM). Much foul biting.
 Vise mark covered. Lines added
 throughout. Final state.
 Printing: Unknown.
 Plate not found.

 Photograph: Final state, 3.

77. *Harlem Dancer*
 1929. (February 22, 1929)
 l.r.; MARSH
 1929
 Drypoint; 152 mm. x 203 mm.
 (6″ x 8″) plate mark.
 State I (one proof: *1* Umbria) Design
 complete.
 State II (one proof: *2*) Lines added in
 back of main figure, in back of group
 at right, and in lower right.
 State III (one proof: *3*) Floor lines
 added. Lower part of musicians
 darkened. Lines added behind head at
 far left, and in background at right.
 State IV (one proof: *4*) Additional lines
 in dark areas, especially in upper right.
 New lines in latticework to right of
 main figure.
 State V (one proof: *5*) Lines added in
 upper right, partially obliterating
 forms.
 State VI (one proof: *6*) Strong lines
 added on back of right shoulder of
 main figure; to background at right
 of latticework; to left of sphere near
 musicians. Final state.
 Printing: Marsh, impressions 7 through 9
 (February 24, 1929); *9* NYPL.
 Plate not found.

 Photograph: Final state, 8.

78. *Chop Suey Dancers (#1)*
 1929. (September 2, 1929)
 l.r.; MARSH 1929
 Etching; 203 mm. x 152 mm.
 (8″ x 6″) plate.
 State I (two proofs: 1 Umbria, 2 Anvil)
 Drawn with échoppe and magnifying
 glass (RM). Design complete.
 State II (two proofs: 3, 4) Unable to
 locate proofs; no information available.
 State III (one proof: 5) Lines added to
 darken hair, face, and clothing. Foul
 biting.
 State IV (four proofs: 6, 7, 8, 9) Scraped,
 smoked, charcoaled, added drypoint and
 engraving (RM). Final state.
 Printing: Marsh, impressions 6 through 9,
 and 10 through 17 Whatman (April 15,
 1930); highest numbered impression
 located, 18; *12* NYPL, 15 LC, Z.

 Photograph: Final state, 13.

79. *Chop Suey Dancers (#2)*
 1929. (June 25, 1929)
 l.r.; REGINALD MARSH 1929
 Etching; 178 mm. x 273 mm.
 (7″ x 10¾″) plate mark.
 State I (two proofs: 1, 2, one of these
 proofs in Z) Design complete.
 State II (one proof: 3) Lines added to
 girl, stockings, faces, etc. (RM).
 State III (one proof: 4) Lines added on
 stockings, flesh, etc. (RM).
 State IV Final state.
 Printing: Unknown.
 Plate not found.
 Note: Painting, same design: *Chop Suey
 Dancers*, 1929, Collection Mrs. Reginald
 Marsh.

 Photograph: Final state, 5.

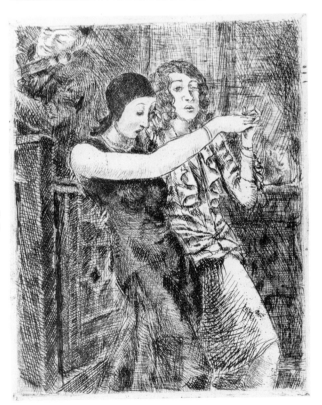

80. *Dancing Couple—Two Girls in
 Chop Suey*
 1929. (November 16, 1929)
 Etching; 127 mm. x 102 mm.
 (5″ x 4″) plate mark.
 State I (two proofs: *1*, 2 Umbria) Drawn
 in the bath (RM). Design complete but
 lines bitten very lightly. A few
 engraved lines added.
 State II Lines added to flesh and
 stockings, etc. (RM).
 State III Entire background darkened.
 Heavy cross-hatching at left and right
 sides of plate. Foul biting in lower
 right. Final state.
 Printing: Marsh, impressions *3*, 4, *5*, 6
 NYPL Whatman.
 Plate not found.

 Photograph: Final state, 5.

81. *Speakeasy—Julius' Annex*
 1929. (May 13, 1929)
 l.r.; MARSH 1929
 Etching; 152 mm. x 203 mm.
 (6″ x 8″) plate mark.
 State I (two proofs: *1, 2* Umbria MMA,
 notes and touched extensively) Design
 complete though mostly in line. Drapes
 and figure at right modeled heavily.
 State II (one proof: *3* Navarre) Lines
 added in foreground, to people at table
 and to walls.

State III Lines added under farther table
 and to tablecloth. Additions to area
 between lamps. Lines added to face of
 man at left in background and to man
 in doorway. Additional lines under
 chair leg in lower left. Final state.
Printing: Marsh, impressions 4 through
 9; *5* NYPL.
Plate not found.

Photograph: Final state, 9.

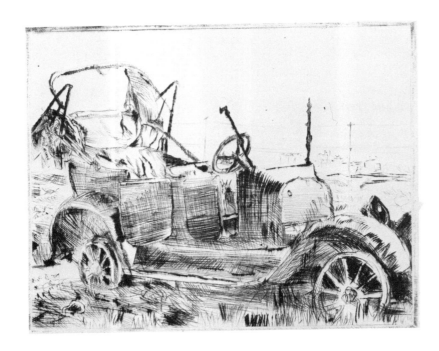

82. *Dead Auto*
 1929. (1929 Red Star Diary)
 Drypoint; 114 mm. x 152 mm.
 (4½″ x 6″) plate mark.
 Only state. (one proof: 1 Umbria)
 Printing: Unknown.
 Plate not found.

 Photograph: Only state.

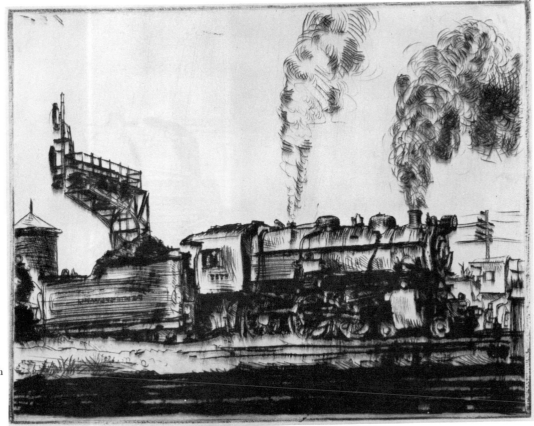

83. *Loco—Point Pleasant*
 1929. (April 9, 1929)
 Drypoint (zinc); 153 mm. x 203 mm.
 (6″ x 8″) plate.
 State I (one proof: *1* Umbria) Design
 complete.
 State II Final state.
 Printing: Marsh, impressions 2 through
 7; *5* NYPL, *7* PMA.
 Surface of plate corroded.

 Photograph: Final state, 3.

84. *Loco L.V.R.R.*
 Locomotive Lehigh Valley
 1929. (October 13, 1929)
 l.r.; 1929
 Etching; 178 mm. x 279 mm.
 (7″ x 11″) plate.
 State I (two proofs: *1, 2* Umbria,
 touched) Drawn in acid (RM). Design
 complete.
 State II (three proofs: *3, 4* NYPL, *5*
 Whatman) Lines added to smoke and
 sky.
 State III Lines added to smoke.
 Engraving added to tracks. Final state.
 Printing: Marsh, impressions 6 Umbria,
 7 through 14 Whatman (November 1,
 1929) and 15 through 17 (March 19,
 1930); *4/50* NYPL.

 Photograph: Final state, 7/50.

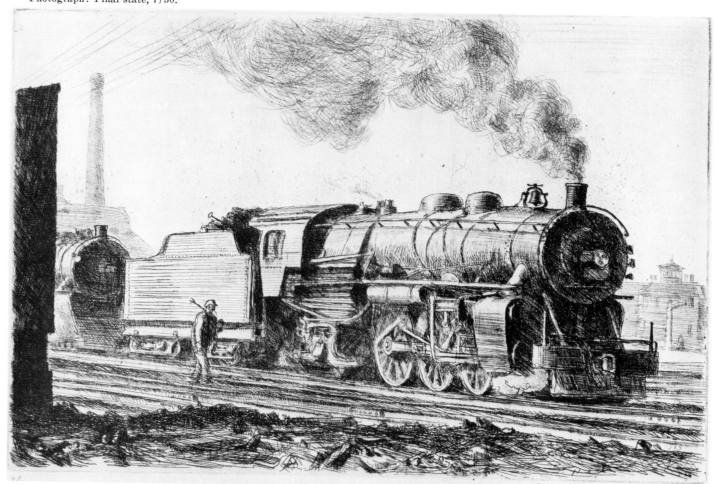

85. *Loco—Erie Watering*

1929. (December 24, 1929)

l.c.; MARSH

Etching; 178 mm. x 253 mm.
 (7″ x 10″) plate mark.

State I (two proofs: *1, 2* Whatman MMA, touched) Drawn in acid (RM). Design complete except figure and house at right not included.

State II (one proof: *3*) Lines added to prominent parts, smoke and man added at right. Also, lines added to background and little house.

State III (two proofs: *4, 5* Umbria) Many lines added to smoke.

State IV Figure and building at far right fully developed. Lines added to smoke. Final state.

Printing: Marsh, impressions 6, 7 Umbria; 8 through 18 Whatman; and 19 through 21; *9* NYPL, *11* Z, *17/50* BPL.

Edition: Sold 50–100 printed by Friends of American Art (RM envelope).

Plate not found.

Note: Same basic design as the lithograph, S.29. Perspective is much more evident in the lithograph, foreshortening helps to dramatize setting. It is thought he did the etching first.

Photograph: Final state, 7.

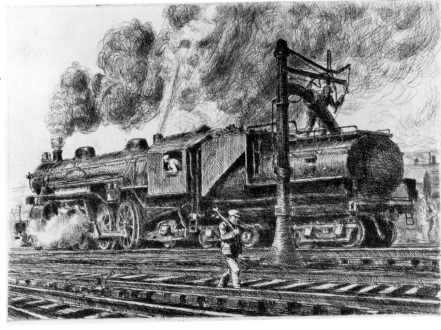

86. *Tank Car*
 Rail

1929. (November 9, 1929)

l.l.; R. MARSH 1929

Etching; 152 mm. x 222 mm.
 (6″ x 8¾″) plate mark.

State I (one proof: *1* Whatman) Design complete. Many areas developed. Some foul biting.

State II (one proof: *2*) Lines added to engine and area behind engine. Many lines added to smoke—heavy and light lines. Extensive foul biting created vertical lines.

State III (one proof: *3* Whatman NYPL) Scraped, snaked, and charcoaled this plate for hours (RM). Much foul biting remains. Marsh considered this State II.

State IV (two proofs: *4, 5* Barcelona FM) Lines in sky burnished and pressed together. Engraved lines added to tank car.

State V Lines added to distant smoke. Final state.

Printing: Marsh, impressions 6 through 18 Whatman; *5* NYPL, *6* NYPL, 12 LC.

Plate not found.

Photograph: Final state, 6.

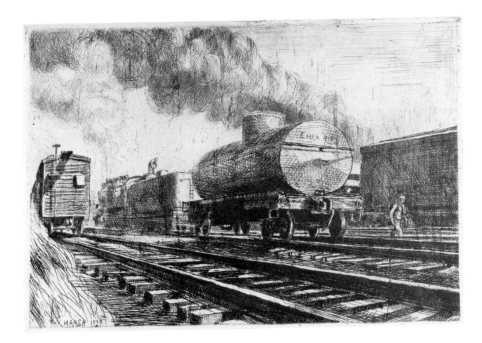

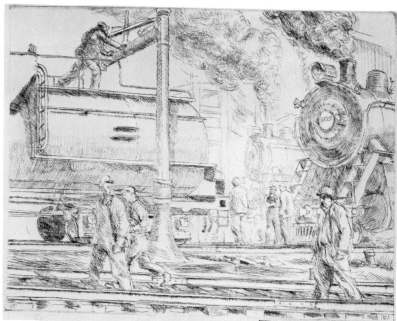

State I

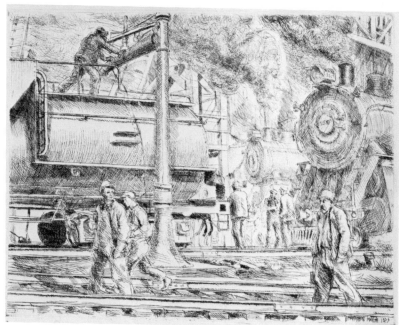

State II

87. *Erie R.R. Yards*
1929. (April 10, 1929)
l.r.; MARSH 1929
Etching; 230 mm. x 302 mm.
(9″ x 12″) plate.
State I (two proofs: *1, 2* Umbria NS,
touched) Design almost complete. Very
lightly drawn. Some area shaded.
State II (one proof: *3* Umbria) Some
lines redrawn. Ladder added in upper
left, girder forms in upper right corner.
Many other elements added to
background. Figure added to left of
central figure. Many lines added
throughout.
State III (one proof: *4* Umbria) Lines
added to three men in foreground. Lines
added to engine, coal car, water tower,
man, and distant view. Some foul biting.
Overall darkening of the plate.
State IV (three proofs: 5, 6, 7)
Charcoaled some of the background
(RM). Lines added to background.
State V (two proofs: 8, 9) Tooled out
steam under right locomotive and
added a little engraving (RM).
State VI Engraved lines around far
engine. Final state.
Printing: Marsh, impressions 10 through
17; *6/50* PMA, *11* NYPL, *12* Z, 13 LC,
14/50 BPL.
Note: Similar to painting: *Locomotive
Watering*, 1932, Collection Mrs.
Reginald Marsh. Also similar to etching
S.155. There is one related drawing in
The Fogg Art Museum.

Photographs: State V, 9/50. State I, 1;
State II, 3; State III, 4.

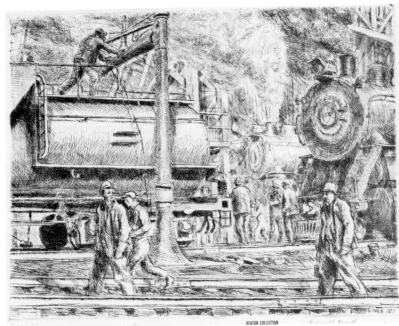

State III

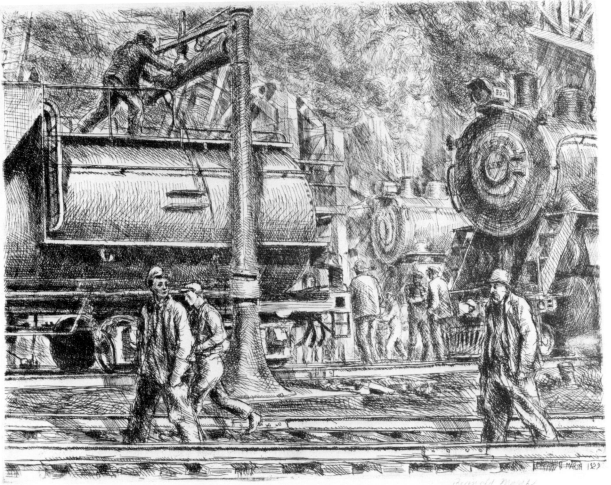

State V

88. *Loco—Going through Oneida*
 1930. (September 6, 1930)
 Engraving; 102 mm. x 177 mm.
 (4" x 7") plate.
 State I (two proofs: *1, 2* Whatman)
 Design complete.
 State II Some lines added to coal tender,
 engine, foreground, and smoke. Final
 state.
 Printing: Marsh, impressions 3, and 4
 through 7 Whatman; *5* NYPL, Z.
 Note: First engraving. Marsh noted that
 he did this engraving in Buffalo and
 Flushing during a period of 10–12
 hours.

 Photograph: Final state.

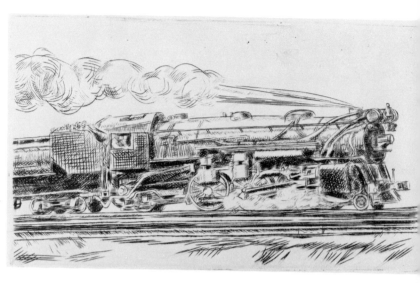

89. *Loco—Going through Jersey City*
 1930. (July 27, 1930)
 l.r.; REGINALD MARSH 1930
 Etching; 127 mm. x 254 mm.
 (5" x 10") plate.
 State I (two proofs: *1, 2* Whatman MMA
 touched with notations) Design
 complete.
 State II (two proofs: *3, 4*) Drew
 locomotive (RM). Lines added to
 building at far right. Foul biting mostl[y]
 in sky above building. Smoke darkened.
 State III (one proof: *5* Whatman NYPL)
 Snake stoned three hours. Smoke
 redrawn (RM). Final state. It appears
 from a study of Marsh's notes that he
 metal-polished and buffed the sky at
 this stage and made two proofs, both
 listed as 6.
 Printing: Marsh, impressions 7 Umbria;
 8 through 16 Whatman; 17 Barcelona.
 Peter Platt, impressions 18 through 23.
 Marsh, impressions 24 through 27 white
 Whatman. In addition, impressions
 27A, 27B, 27C left as part of Marsh's
 estate; *8* NYPL, 10 LC, *27C* NYPL, Z.
 Edition: Whitney, one hundred
 impressions (1969).
 Steel faced.
 Note: Painting, same design: *Erie
 Railroad,* c. 1932, Collection
 Mrs. Reginald Marsh.

 Photograph: Final state, 7.

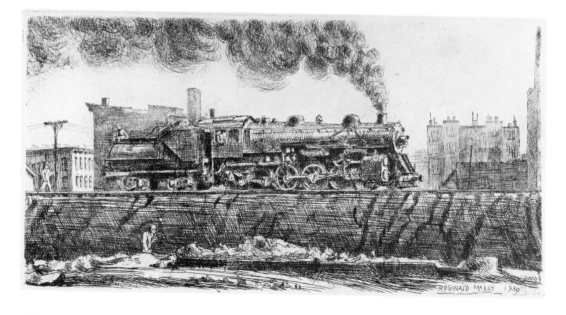

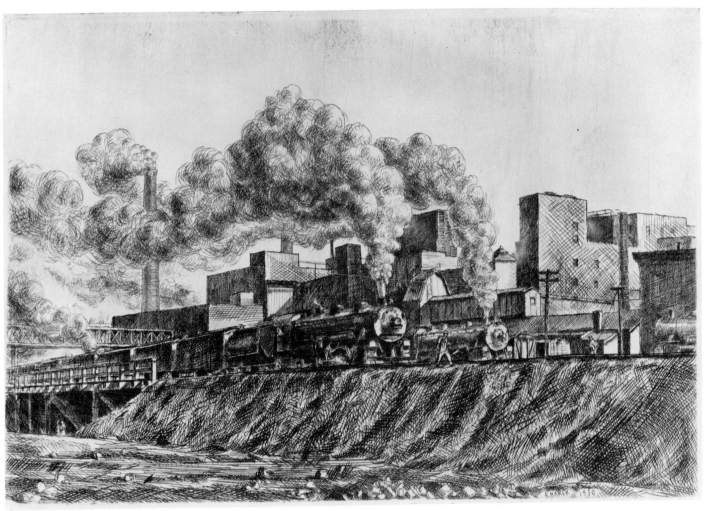

90. *Erie R.R. and Factories*
1930. (September 27, 1930)
l.r.; R. MARSH 1930
Etching (extensive engraving added);
 203 mm. x 304 mm. (8″ x 12″) plate.
State I (two proofs: *A, B* Umbria
 NYPL) Design complete.
State II (one proof: *C* NYPL) Lines
 added to smoke, locomotive, cars, and
 ground at lower left, some of this
 engraved.
State III (one proof: *D*) Buffed all burr
 and some heavy blacks on building
 (RM). Strong blacks added near base
 of chimney. A few lines engraved on
 bank.

State IV (one proof: *E*) Added lines to
 smoke, etc. Many engraved lines added
 to bank.
State V (one proof: *F*) Buffed burr and
 engraved (RM).
State VI (four proofs: G, I, J, K
 Whatman) Lines added to slope in
 foreground and to locomotive. Final
 state.
Printing: Marsh, impressions 1 through
 13 Whatman, 14 through 25; highest
 numbered impression located was 46;
 2 NYPL, MINN, Z.
Edition: Jones, one impression (1956).
Note: Painting, similar subject: *Locos*,
 c. 1931, Collection Mrs. Reginald Marsh.

Photograph: Final state, J.

91. *Fourteenth Street*
1930. (February 25, 1930)
Etching: 178 mm. x 254 mm.
 (7″ x 10″) plate.
State I (one proof: *1* Whatman) Design
 complete. Strong darks developed in
 coats.
State II (two proofs: *2, 3* Umbria) Face
 of woman at far right heavily modeled.
 Lines added to same woman's hands and
 bag. Umbrella of second woman from
 left has lines added. Lower left corner
 shadow extended.
State III (two proofs: *4, 5* Whatman)
 Extensive drawing added throughout,
 creating many black areas. Upper and
 lower parts of print especially
 developed. Foul biting.
State IV (two proofs: *6, 7* NYPL) Lines
 added to various parts. More foul
 biting.

State V (two proofs: *8* Whatman, *9*)
 Plate buffed by A. G. Miller after
 proof 8 was made (RM). Face of
 second woman from left removed; arms
 and hands of the three women at left
 removed.
State VI (one proof: *10* Whatman WB)
 More foul biting (RM). Areas removed
 in previous state redrawn. Lines added
 to woman's face, second from right.
 Final state.
Printing: Unknown.
Plate in very poor condition. Extensive
 hammering on reverse of plate; also
 some metal replacement.

Photograph: Final state, 10.

92. *Three Girls on Subway Platform*
1930. (July 17, 1930)
l.r.; REGINALD MARSH 1930
Etching; 153 mm. x 128 mm.
 (6″ x 5″) plate.
State I (two proofs: *1* MMA, touched,
 2 yellow Umbria) Drew with a scriber
 on the ground; this was done under the
 open sky as it is the best way to see
 (RM). Design complete.
State II (one proof: *3* Barcelona) Some
 lines added to figures and pillar.
State III (one proof: *4*) Buffed column,
 engraving added in background (RM).
State IV (one proof: 4 [It is thought
 that Marsh may have used this proof
 number twice.])
State V (two proofs: *5, 6*) Engraving
 added (RM).
State VI (four proofs: *7* BPL, *10* NYPL,
 8, 9) Burnished out line around arm
 at extreme right (RM).
State VII Lines added to bare parts of
 wall. Final state.
Printing: Marsh, impressions 11 through
 15 Whatman; Z.

Photograph: State V, 5.

92A. *Single Figure**
 1930. Estimate.
 Drypoint; 51 mm. x 108 mm.
 (2″ x 4¼″) plate mark.
 Only state.
 Printing: Unknown; one impression
 located April, 1961.
 Note: Paper was tacked to a board for
 drying after printing; this procedure
 was used for other Marsh prints in
 1930. He did not tack impressions
 thereafter.

 Photograph: Only state.

93. *2nd Ave. El.*
 1930. (March 18, 1930)
 Etching; 178 mm. x 229 mm.
 (7″ x 9″) plate.
 State I (two proofs: *1, 2* Umbria MMA,
 touched with notes) Design complete.
 State II (two proofs: *3,* 4 Whatman)
 Lines added to cushion and other areas
 including beyond window. Woman's
 face and legs have extensive drawing
 added.
 State III (two proofs: 4 Umbria, *5*
 Whatman MMA touched with notes)
 Lines added to seats, woodwork, outside
 window, and flesh.
 State IV Lines added to woodwork, coats,
 and other areas. Final state.
 Printing: Marsh, impressions 7 through
 15 Whatman; *10* NYPL, *12* NYPL,
 15 ACH, Z. Peter Platt, 16 through 21
 (Marsh did not consider Platt's
 impressions to be satisfactory.) Marsh,
 16 through 19 Whatman.
 Edition: Jones, one impression (1956);
 Whitney, one hundred impressions
 (1969).
 Steel faced.
 Note: Painting, same design: *Second
 Avenue El.*, 1929, The Benton
 Collection.

 Photograph: Final state, 6.

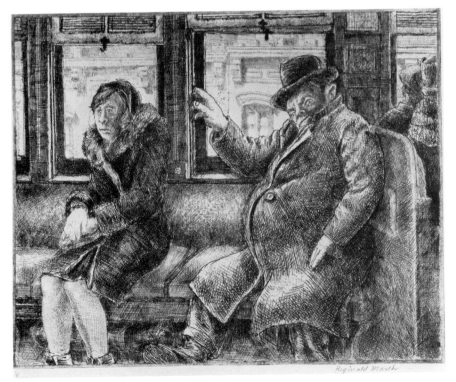

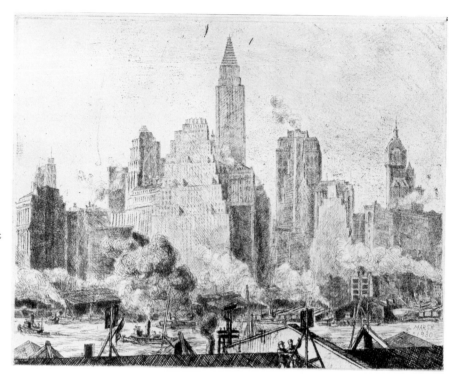

94. *Skyline from R. Laurents House*
1930. (February 6, 1930)
l.r.; MARSH
 1930
Etching; 178 mm. x 228 mm.
 (7″ x 9″) plate mark.
State I (two proofs: 1, 2 Whatman)
 Design complete. Much foul biting in
 upper portion of plate.
State II (one proof: *3*) Extensive
 drawing throughout. Possibly drypoint
 additions in black areas. Some
 additional foul biting.
State III (one proof: *4*) Diagonal lines
 added to Empire State and other
 buildings. Shadow side of buildings
 made very black.
State IV (one proof: *5*) Lines added to
 building. Very faint lines added to sky,
 beneath Empire State and to dark part
 of building at far left.
State V (two proofs: *6* NYPL, *7* Umbria
 WB) Horizontal lines added to building
 at right of Empire State. Darks
 strengthened around wharf buildings.
 Additional lines on smoke of foremost
 tug. Final state.
Printing: Unknown.
Note: This *plate* was listed in the 1956
 catalog. Location of plate presently
 unknown. Plate not located at Whitney,
 nor does Whitney record indicate
 receipt of plate.

Photograph: Final state, 7.

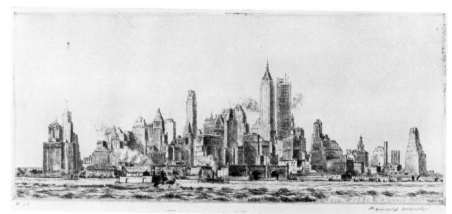

95. *N.Y. City from Governor's Island*
1930. (August 31, 1930)
l.r.; NEW YORK AUG. 1930
 REGINALD MARSH (in one line;
 NEW YORK obliterated in later
 states).
Etching; 128 mm. x 305 mm.
 (5″ x 12″) plate.
State I (three proofs: *A, B* Whatman
 MMA, touched extensively; *C* Umbria
 NYPL [proof B offset on Japanese
 paper]). Design complete.
State II (one proof: *D*) Drawing added
 throughout. Lines on boat and water
 made darker.

State III (one proof: *E*) Buffed out
 shadow of dark building at far left
 (RM). Engraved lines added to replace
 buffed-out area.
State IV (one proof: *F*) Engraving
 added.
State V (one proof: *G*) More engraving
 added. Final state.
Printing: Marsh, impressions 3 through
 12; *8* NYPL. Peter Platt, 13 through
 18. Marsh, 19 and 20.
Note: Marsh wrote: "Sept. 7, 1930 clear
 but hazy" at bottom of MMA proof;
 this suggests that he might have drawn
 this directly from nature.

Photograph: Final state, 20.

96. *Chop Suey Dancers*
 1930. (October 12, 1930)
 l.r.; MARSH
 1930
 Etching; 203 mm. x 152 mm.
 (8″ x 6″) plate.
 State I (two proofs: *A* NYPL, *B*) Design
 complete, lightly modeled.
 State II (one proof: *C*) Lines added to
 eyes and hair, and to background at
 right of woman's hat. Additional lines
 on skirt of woman at left. Some foul
 biting in lower right corner.
 State III (one proof: *D*) Use a
 four-point needle for the first time
 (RM). Many lines added throughout.
 State IV (one proof: *F*) [Marsh may
 have meant E]) Engraving added
 (RM). Difficult to discern additions,
 possibly because Marsh made very fine
 lines.
 State V Burr removed (RM). Final state.
 Printing: Marsh, impressions 1 through
 14 Whatman; *13* NYPL, Z.
 Note: Painting, same design: *Chop Suey
 Dancers*, 1930, Collection Mrs. Reginald
 Marsh.

 Photograph: Final state, 5.

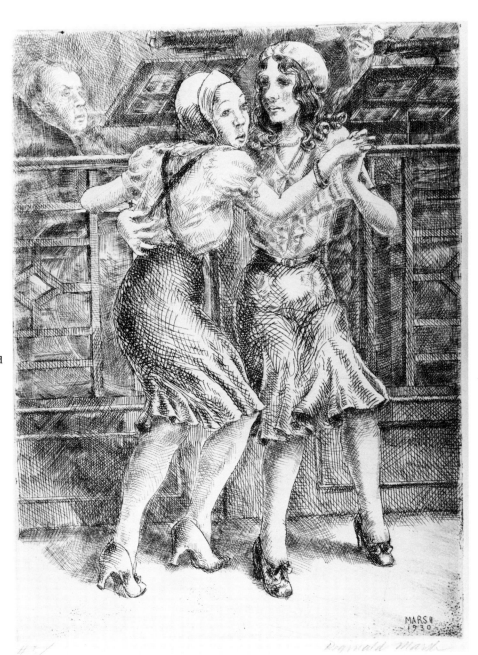

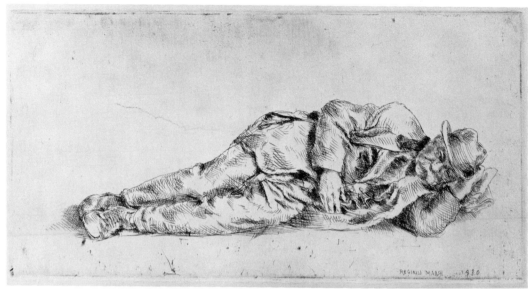

97. Mr. Weaver Asleep
 1930. (October 31, 1930)
 l.r.; REGINALD MARSH 1930
 Etching; 114 mm. x 235 mm.
 (4½″ x 9¼″) plate mark.
 Only state. (three proofs: A, B, *C*
 NYPL).
 Printing: Unknown; BPL.
 Plate not found.

 Photograph: Only state.

98. Llewellyn Powys
 1930. (October 26, 1930)
 l.r.; MARSH 1930 (1930 in a vertical
 position).
 Etching; 126 mm. x 102 mm.
 (5″ x 4″) plate.
 State I (two proofs: A-1, B-2) Design
 complete.
 State II A few lines etched. Engraving
 added on coat. Final state.
 Printing: Marsh, impressions 1 through
 17 Whatman, 18 and 19 on Antique;
 3 NYPL, 12 LC, Z.
 Note: See notes for S.42.

 Photograph: Final state, 12.

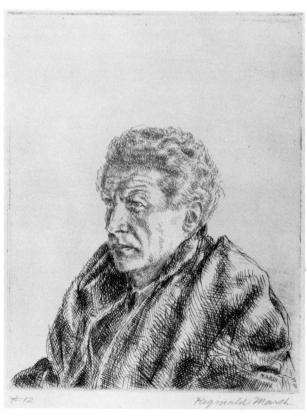

99. *Merry-Go-Round*
 1930. (November 30, 1930)
 l.r.; MARSH
 1930
 Etching; 179 mm. x 255 mm.
 (7″ x 10″) plate.
 State I (two proofs: *A* BPL, *B* MMA)
 Design complete.
 State II (one proof: *C*) Two girls' faces
 removed and redrawn.
 State III (one proof: *D*) Engraving
 added to man's coat, horse at far left,
 second horse from left, and many other
 areas.
 State IV (one proof: *E*) More engraving
 and scraping.

State V (one proof: *F*) Lines added to
 foreground horses, secondary figures,
 and background.
State VI (one proof: *G*) Engraving
 added. Final state.
Printing: Marsh, impressions 1 through
 42 Whatman; 42a through 58; *28*
 NYPL, 38 CL, *43* PMA, PLNNJ, Z.
Edition: Jones, eight impressions (1956);
 Whitney, one hundred impressions
 (1969).
Steel faced.

Note: Same basic design as the lithograph
 S.20. Painting, same design:
 Merry-Go-Round, 1930, present location
 unknown. Some changes in details.
 Reproduction of a small painting, same
 basic motif as etching, in 1943 Art
 Students League Summer catalog.
 Lloyd Goodrich noted that both sides
 of this painting had been cut down
 in the reproduction.

Photograph: Final state, 5.

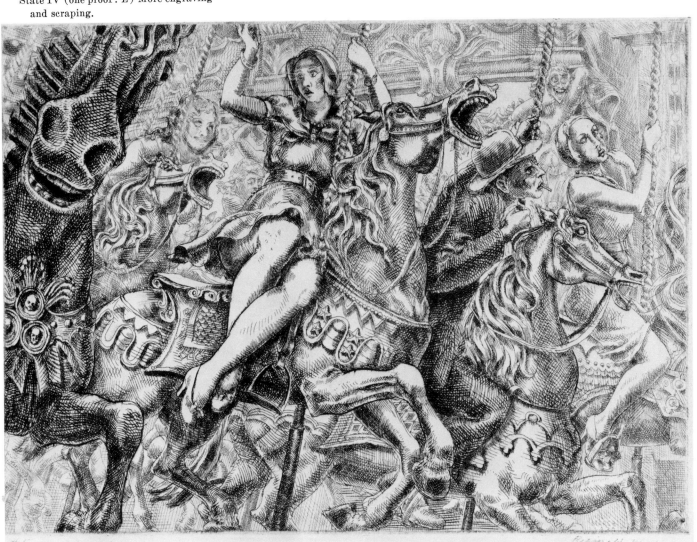

100. Third Ave. El.
 1931. (January 17, 1931)
 l.r.; 1930
 MARSH
 Etching; 153 mm. x 229 mm.
 (6″ x 9″) plate.
 State I (two proofs: A, *B* NYPL) Design
 almost complete; buildings not
 included.
 State II (two proofs: C, D Whatman)
 Buildings drawn in outside windows.
 State III (one proof: *E*) Lines added
 to foreground and secondary figures.
 State IV (one proof: *F* PMA) Engraving
 added to fur collar and lines around
 woman's head at far right. Many lines
 added to side of seat. Final state.

Printing: Marsh, impressions 2, and 3
 through 14 Whatman; *9* NYPL, *14*
 MMA, BPL, Z.
Edition: Jones, thirteen impressions
 (1956).
Note: Painting, same basic design:
 Third Avenue El, 1931, Collection
 Dr. Seymour Wadler, New York.
 Central figure entirely changed.

Photograph: Final state, 4.

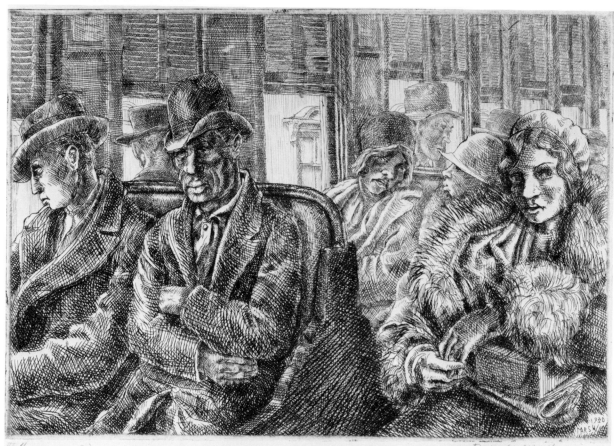

Final state

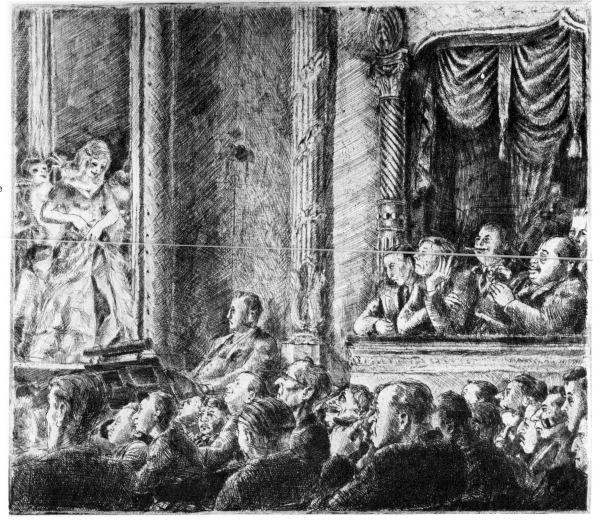

101. *Irving Place Burlesk*
1930. (April 20, 1930)
l. edge; R MARSH 1930
Etching; 254 mm. x 305 mm.
(10″ x 12″) plate.
State I (two proofs: *1*, touched, *2*
Whatman) Very deep foul biting
everywhere (RM). Design complete.
Plate was buffed by A. G. Miller to
remove foul biting; then proof 3 was
made.
State II (one proof: *3*) Almost every
head in foreground, torsos of men in
box, and vertical central area have
been removed.
State III (one proof: *4*) Heads in
foreground and men in box redrawn.
Other areas of the plate have new lines
added.

State IV (one proof: *5* yellow Umbria)
Drawing added throughout. Faces of
girls more defined, stage background
darkened. Shadow to the right of stage
darkened. Shadow of center column
developed, diagonal line added to empty
vertical area, and entire upper right
corner developed. Faces of foreground
figures have more drawing added.
State V (one proof: *6*) Some drawing
added to curtains.
State VI (one proof: *7* white Umbria)
Some drawing added to background
areas.
State VII (one proof: *8* Umbria) Some
foul biting throughout right side.
State VIII Engraved considerably (RM).
Final state.
Printing: Marsh, impressions 9 through
12 (August 1, 1930); 13 through 17
Whatman (October 31, 1930). Peter
Platt, 17 through 22. Marsh, 23 through
32 Whatman (March 13, 1931); 32a,
32b NYPL, 32c, and 33 (October 14,
1932); *15* MMA, ACH, PMA, Z.

Edition: Jones, seven impressions (1956);
Whitney, one hundred impressions
(1969).
Steel faced.
Note: Painting, same design: *Irving
Place Burlesque*, 1930, Collection
Mrs. Marilyn Lo Bell. Three drawings
for the etching in the Philadelphia
Museum of Art: 1, figure and details of
architecture; 2, compositional study;
3, composition study "squared off."

Photographs: Final state VII. State I;
State II; State III 4; three drawings,
The Benton Collection; painting, Mrs.
Marilyn Lo Bell.

101. Irving Place Burlesk

Drawing

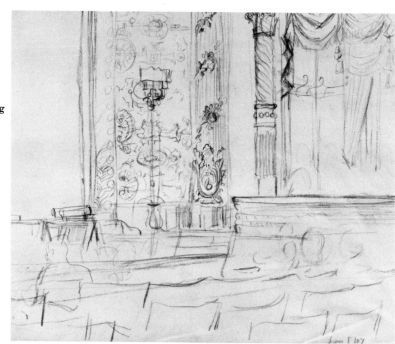

Drawing

State I

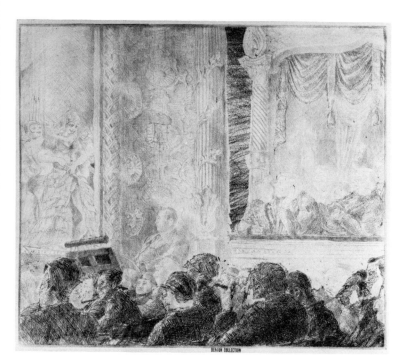

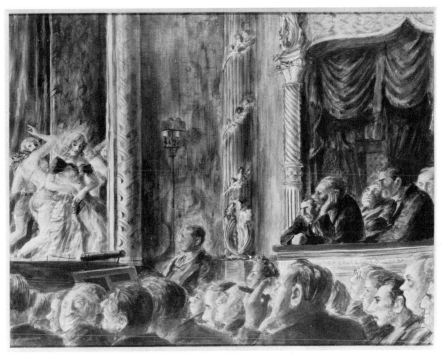

Painting

ate II

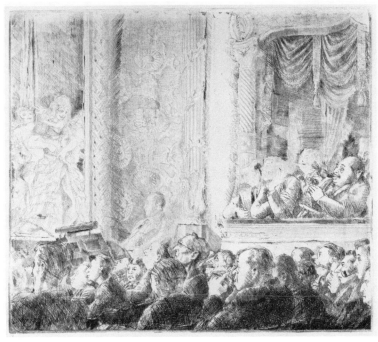

State III

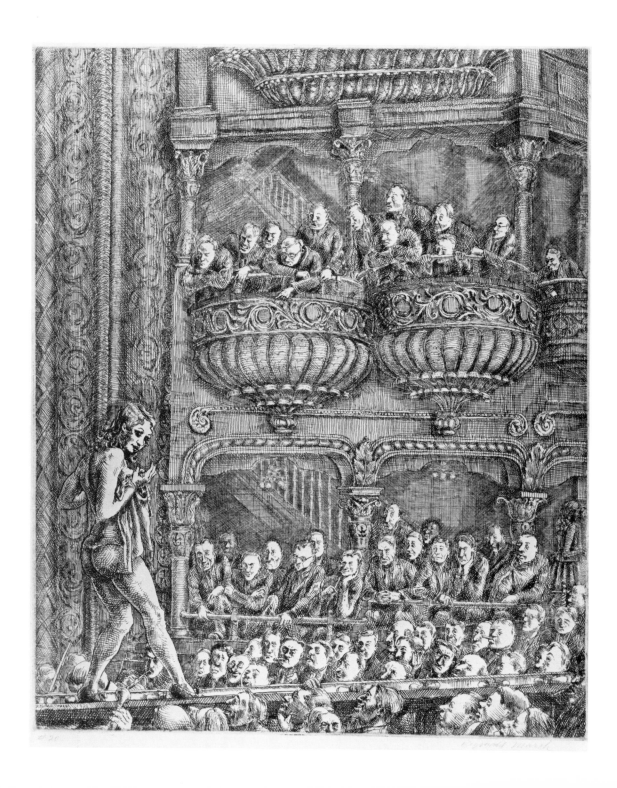

Drawing

102. *Gaiety Burlesk*
1930. (November 23, 1930)
l.r.; REGINALD MARSH 1930
Etching; 305 mm. x 254 mm.
(12″ x 10″) plate.
Only state (one proof: A) Four and a
half days steady drawing on this print
(RM). Design complete.
Printing: Marsh, impressions 1 through 9
on Whatman (November 25, 1930);
10 through 15 Whatman (December 7,
1930); 16 through 25 Whatman (March
31, 1931); 25A, 25B, 25C, 26 Whatman
(May 15, 1932); 26a, 26b, 27, 27b, 28,
29, 29a Rives (October 14, 1932);
30 through 39, including 39a (October
2, 1934); *4* WMAA, 5 MFA, *13* MMA,
18 NYPL, *28* CL, 31/39 LC, 37 FOGG,
Z.
Edition: Jones, nine impressions (1956);
Whitney, one hundred impressions
(1969).
Steel faced.
Note: Drawing for the etching in the
author's collection (DIV-14).

Photograph: Only state, 20; drawing

103. *Schoolgirls in Subway—Union Square*
1930. (April 13, 1930)
l.r.; R. MARSH
 1930
Etching; 247 mm. x 203 mm.
 (10″ x 8″) plate.
State I (two proofs: *1, 2* Umbria NYPL)
 Design complete except for background
 forms.
State II (one proof: *3* Umbria) Foul
 biting. Background defined, side of
 column darkened.
State III (one proof: *4*) Drawing added
 to all dark areas and background.
State IV (one proof: *5*) Drew lines
 (which printed strong) on blank wall
 in last 5 minutes (RM).
State V (one proof: *6*) Bad grounding
 and etching destroyed (RM). Final
 state.
Printing: Unknown.
Note: Painting, same subject and general
 design: untitled, catalog number
 S.28–3, Collection Mrs. Reginald Marsh.

Photograph: State III, 4.

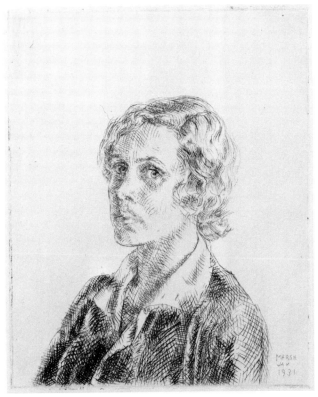

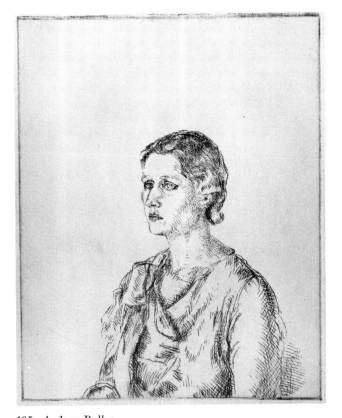

104. Betts
 1931. (January 4, 1931)
 l.r.; MARSH
 JAN
 1931
 Etching; 127 mm. x 101 mm.
 (5″ x 4″) plate.
 State I (two proofs: *A* NYPL, *B*) Design
 complete
 State II (one proof: C) Dark areas
 strengthened.
 State III (one proof: *D*) Hair lengthened
 at neckline. Engraved lines added to
 blouse.
 State IV (two proofs: E, F) Engraved
 eye pupil, etc. (RM).
 State V (two proofs: G, H) Drew a
 little (RM).
 State VI (two proofs: *I, J* Whatman)
 Upper lip burnished off, drew blouse
 (RM). Final state.
 Printing: Unknown; Z.
 Note: Portrait of Marsh's first wife,
 Betty Burroughs.

 Photograph: Final state, I.

105. Audrey Buller
 1932. (June 22, 1932)
 Etching; 127 mm. x 102 mm.
 (5″ x 4″) plate mark
 Only state (three proofs: *A, B* NYPL, *C*).
 Printing: Unknown.
 Plate destroyed. Notebook No 8.
 Note: Marsh's records indicate that this
 print was started on June 22, 1932;
 however, he included this plate in his
 listing of 1931 plates in Notebook
 No. 8, p. 54.

 Photograph: Only state, C.

106. *Dave Morrison*
　1931. (March 24, 1931)
　Etching; 178 mm. x 127 mm.
　　(7″ x 5″) plate mark.
　State I (two proofs: *A* NYPL, *B*) Design
　　complete. Foul biting on upper half of
　　plate.
　State II Drew a little on head and coat
　　(RM). Final state.
　Printing: Unknown.
　Plate destroyed. Notebook No. 8, p. 54.

　Photograph: State I, B.

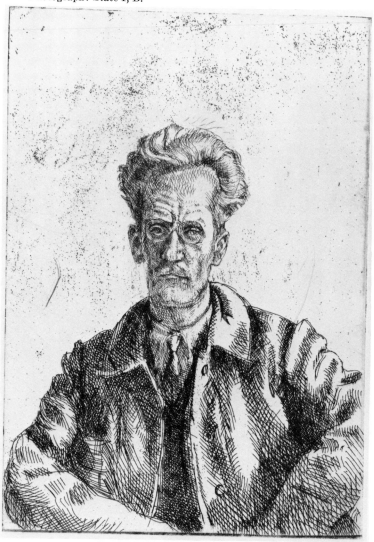

107. *Louise Miller*
　1931.
　l.r.; RM
　　1931
　Etching; 127 mm. x 102 mm.
　　(5″ x 4″) plate.
　State I (two proofs: A, *B*) Design
　　complete except for dark area in left
　　corner. Vise mark evident in upper
　　right corner.
　State II (one proof: *C*) Buffed off
　　shoulder, August 29, 1931 (RM). Left
　　corner darkened; initials and date
　　somewhat obliterated. Forms developed
　　throughout.
　State III (one proof: *D*) Lines added
　　across lower jaw, near corner of mouth,
　　on neck.
　State IV Eye sockets and side of cheek
　　darkened. Vise mark completely
　　removed. Final state.
　Printing: Marsh, impressions 1
　　(September 12, 1931); 2 through 13
　　(September 15, 1931); 3 LC, *9* NYPL,
　　13 BPL, Z.

　Photograph: Final state, 12.

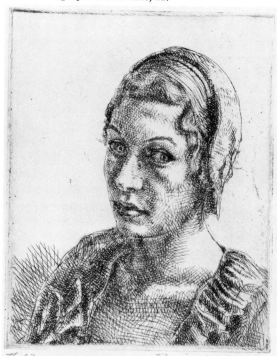

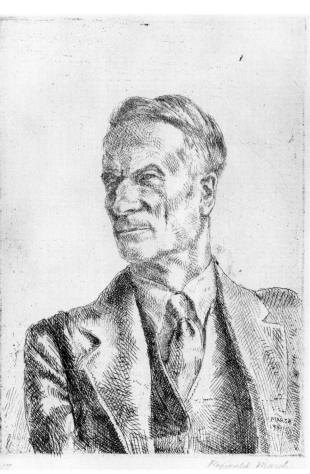

108. *Kenneth Hayes Miller*
 1931.
 l.r.; MARSH
 1931
 Etching; 178 mm. x 127 mm.
 (7″ x 5″) plate mark.
 State I (two proofs: *A* NYPL, *B*) Design
 complete except for chair which is
 added and then removed in later states;
 right shoulder and lapel not modeled.
 State II (two proofs: *C*, *D* NYPL) Light
 lines added to coat, lapel, and right
 shoulder.
 State III (proof: *E*) Chair added to left
 corner.
 State IV (proof: *G*) Some lines added to
 chair and coat; shadow placed to left
 of chair.
 State V (one proof: *H*) Shoulder and
 chair removed.

State VI Shoulder redrawn.
State VII Horizontal lines added to lower
 left corner. Final state.
Printing: Marsh, impressions 1
 (September 12, 1931); 2 through 13
 Whatman (September 14, 1931); 14
 through 16 (December 6, 1931); **and**
 three impressions that Marsh considered
 failures (December 21, 1931); 14, 14a,
 14b (January 2, 1932)—he considered
 the latter two failures; 15 (October 13,
 1932); 15a, 16, 17, 18 (October 24,
 1932); and 19 through 24 Rives white
 (October, 1934); *4*, 5 BOW, 7 MMA,
 8 MOMA, 13 LC, 14a NYPL, NYPL,
 (2) Z.
Plate destroyed. Notebook No. 7, p. 1.

Photograph: Final state.

109. *Joan (The Tabloid)*
 1931. (January 9, 1931)
 l.l.; MARSH 1931
 Etching; 203 mm. x 153 mm.
 (8″ x 6″) plate.
 State I (two proofs: *A* MMA touched
 extensively, *B* Whatman) Single figure
 standing reading newspaper.
 State II (two proofs: *A* PMA, B
 Whatman [There is some confusion in
 Marsh's records as these proof numbers
 seem to be a duplication]) Background
 added.
 State III (one proof: *C* LC) Drew
 foreground post and secondary areas
 (RM). Final state.
 Printing: Marsh, impression 2 (March 13,
 1931); 3 through 14 (March 16; 1931);
 and 15 Rives (October 15, 1932);
 7 NYPL, Z.

 Photograph: Final state, 6.

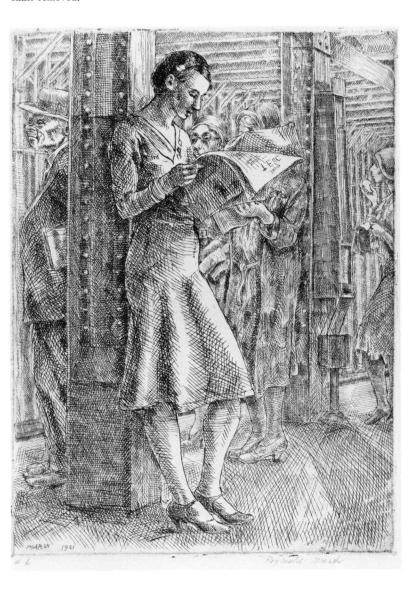

110. *Delza*
 Delza #1 Nun
 1931. (October 11, 1931)
 l.l.; MARSH 1931
 Etching; 178 mm. x 127 mm.
 (7″ x 5″) plate mark.
 Only state.
 Printing: Marsh, impressions 1 through 4
 Whatman (October 11, 1931);
 4 NYPL.
 Plate destroyed. Notebook No. 7, p. 1;
 No. 8, p. 54.

 Photograph: Only state, 3.

111. *Delza*
 Delza #2 Greek
 1931. (October 11, 1931)
 l.l.; MARSH 1931
 Etching; 178 mm. x 127 mm.
 (7″ x 5″) plate mark.
 Only state.
 Printing: Marsh, impressions 1 through 4
 Whatman; *4* NYPL.
 Plate destroyed. Notebook No. 7, p. 1;
 No. 8, p. 54.

 Photograph: Only state, 3.

112. *Dance Marathon*
> 1931. (August 27, 1931)
> Etching; 178 mm. x 127 mm.
> (7″ x 5″) plate.
> State I (one proof: A) Design complete.
> State II (one proof: 1) Drew all but
> light areas (RM).
> State III Some engraving added (RM).
> Final state.
> Printing: Marsh, impressions 2, 3 through
> 14 Whatman; *6* NYPL, 10 LC, Z.
>
> Photograph: Final state, 11.

113. *Wrestlers*
> 1931. (August 27, 1931)
> Etching; 178 mm. x 128 mm.
> (7″ x 5″) plate.
> Only state (two proofs: A, B).
> Printing: Marsh, impressions 2 through
> 13 Whatman; *11* NYPL.
>
> Photograph: Final state, 3.

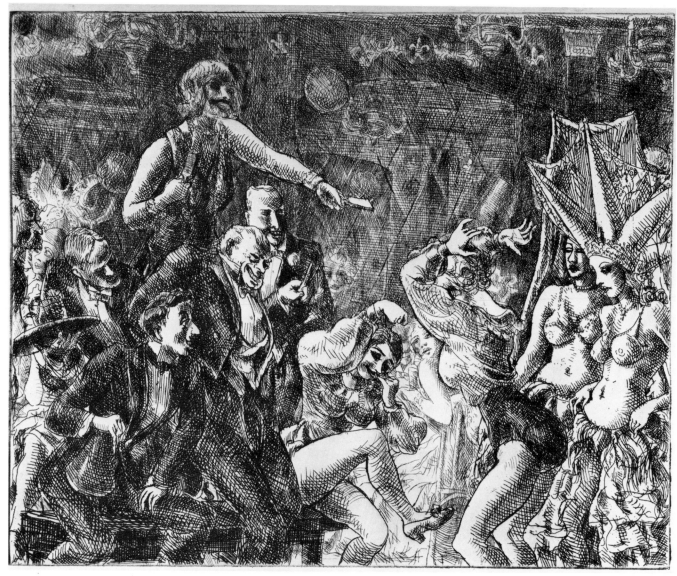

114. *Texas Guinan*
 1931. (January 2, 1931)
 Etching; 203 mm. x 253 mm.
 (8″ x 10″) plate mark.
 State I (two proofs: A, B) Design
 complete. Vise mark evident in upper
 left corner.
 State II (proof: C) Face of main figure
 darkened; upper left corner also
 darkened.
 State III (proof: D) More drawing
 added to back wall. Final state.
 Printing: Unknown.
 Plate not found.
 Note: Painting, similar design: *Texas
 Guinan*, 1930, Collection Edward Root,
 Hamilton College.

 Photograph: Final state.

161

The Barker
1931. (March 8, 1931)
l.r.; MARSH
1931
Etching; 255 mm. x 205 mm.
(10″ x 8″) plate.
State I (two proofs: *A, B*) Design
complete.
State II (two proofs: *C, D*) Drawing
added to foreground figures, to coat of
majordomo, and to other parts of
figures.
State III (one proof: *E*) Sky darkened
considerably. Many lines added
throughout.
State IV (one proof: *F*) Engraving
added. Final state.
Printing: Marsh, impressions 2 (March
13, 1931); 3 through 14 (March 15,
1931); 15 through 31 (March 20, 1931);
2 MMA, *3* NYPL, *24* BPL, 29 MFA,
31 ACH, *31* MMA, PMA.
Edition: Jones, eleven impressions
(1956); Whitney, one hundred
impressions (1969).
Steel faced.
Note: Painting, similar design:
Wonderland Circus Side Show, 1930,
Collection Mr. and Mrs. Sheldon
Shapiro, St. Louis, Missouri.

Photographs: Final state, 8; painting,
Collection Mr. and Mrs. Sheldon
Shapiro.

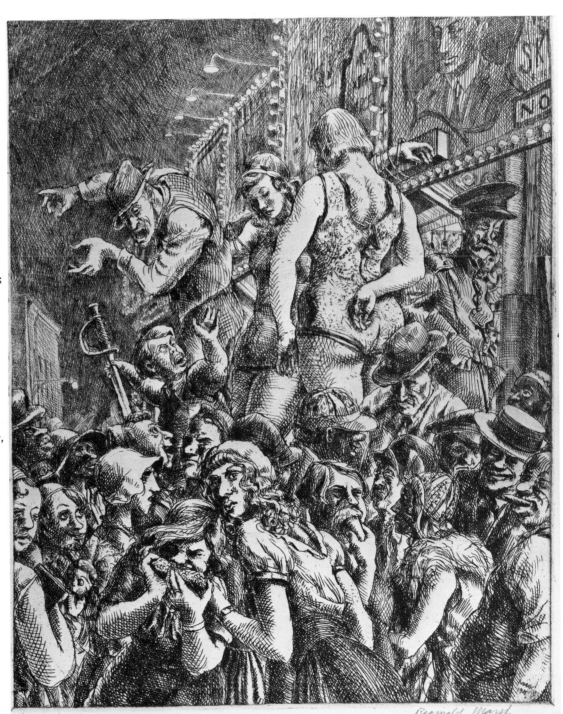

Final state

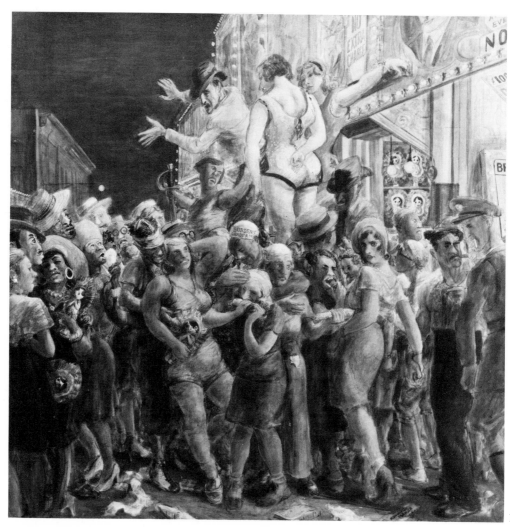

Painting

115. The Barker

116. *Chatham Sq.*
 1931.
 l.r.; R. MARSH 1931
 Etching; 203 mm. x 279 mm.
 (8″ x 11″) plate mark.
 State I (two proofs: *A* NYPL, *B*) Design
 complete.
 State II (proof: *D* NYPL) Foul biting.
 State II (one proof: *E*) Attempt made
 to remove extensive foul biting.
 State III (one proof: *F*) More drawing
 added to men and background.
 State IV (three proofs: *G* NYPL paper
 discolored, H NYPL, *I* NYPL; Marsh
 considered all three proofs failures)
 Drawing on men and distant
 background. Final state.
 Printing: Marsh, impressions 1, 2
 (September 13, 1931).
 Plate not found.
 Note: Drawing for the etching is dated
 April 27, 1931. Painting, same design:
 Chatham Square, 1931, University Art
 Museum, University of Texas.

 Photograph: Final state.

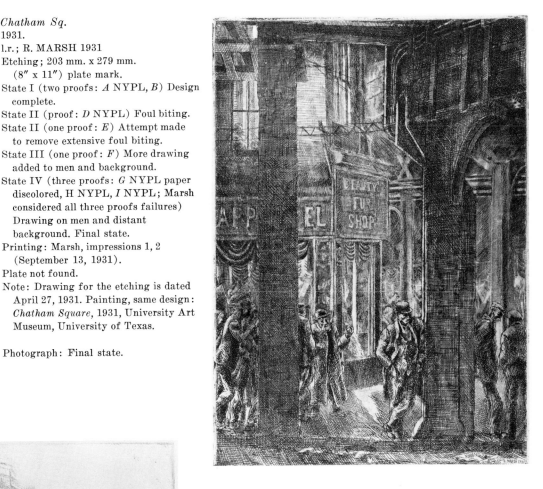

117. *Gas Tanks Atlantic City*
 1931. (August 29, 1931)
 l.r.; MARSH 1931
 Etching; 203 mm. x 253 mm.
 (8″ x 10″) plate mark.
 State I (two proofs: A, B) Design
 complete.
 State II Extensive work done on this plate
 with buffing machine in an attempt to
 create a place for a figure in the
 composition. Engraved. Drew man, near
 tank and ground, to reopen lines (RM).
 Final state.
 Printing: Unknown; NYPL.
 Plate destroyed. Notebook No. 7, p. 1;
 No. 8, p. 54.
 Note: One unnumbered impression left in
 Marsh's estate was touched.

 Photograph: State I, A.

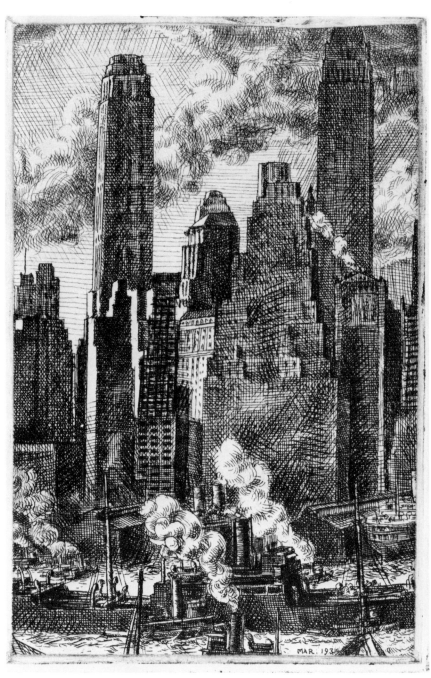

118. *Wall Street (Skyline from Laurents)*
1931. (March 29, 1931)
l.r.; MAR. 1931
Etching; 151 mm. x 102 mm.
 (6″ x 4″) plate.
State I (two proofs: A, *B*) Design
 complete.
State II (two proofs: *C*, I, Marsh
 considered this proof poor) Drawing
 added to ship, buildings, and sky.
State III Drawing added to sky. Some
 engraving. Final state.
Printing: Marsh, impressions 1 through
 16 Whatman (April 11, 1931); *14*
 NYPL.
Edition: Whitney, one hundred
 impressions (1969).
Steel faced.

Photograph: Final state, 6.

119. *Woodstock*
1931.

1931
MARSH

l.r.; WOODSTOCK
Etching; 127 mm. x 152 mm.
 (5″ x 6″) plate mark.
Only state.
Printing: Unknown; NYPL.
Plate not found.

Photograph: Only state, A.

120. *Snow's Farm*
1931. (July 26, 1931)
l.r.; MARSH 1931
Etching; 203 mm. x 254 mm.
 (8″ x 10″) plate.
State I (two proofs: *A* Umbria, *B*
 Whatman) Design complete. Distant
 ground very faint.
State II (one proof: C Umbria)
 Extensive drawing on foreground,
 secondary places, and background.
State III (two proofs: *1, 2* Whatman)
 Drawing added to foreground and
 middle ground.
State IV (three proofs: 3, 4, *5*)
 Engraving added to sky creating
 distinct dark areas, also building
 darkened.
State V (one proof: 6) Reopened lines
 on farmhouse, trees next to it, and sky
 (RM) in upper left.
State VI (one proof: 7) Engraved trees
 (RM) at left of farmhouse. Final
 state.
Printing: Marsh, impressions 8 through
 12 (October 21, 1932); 7 LC, 11 ART,
 9 NYPL, Z.
Note: This print was the first work Marsh
 made in his new etching room.

Photograph: Final state, 10.

122. *Palm Tree*
 1931. (February 24, 1931)
 l.r.; R. MARSH ORMOND
 1931
 Etching; 254 mm. x 127 mm.
 (10″ x 5″) plate mark.
 State I (one proof: A) Design complete
 except for sky. Vise mark in upper left
 corner.
 State II (one proof: *B*) Lines added in
 upper left corner.
 State III Spit bit sky in Dutch, buffed
 side of house and gravel. Made print
 [impression] 8A (RM). Many diagonal
 lines added to sky. Final state.
 Printing: Marsh, impressions of State II,
 1 through 8 Whatman (March 22,
 1931); *1* NYPL, 2 LC, Z.
 Plate destroyed. Notebook No. 7, p. 1;
 No. 8, p. 54.

 Photograph: Final state, 8A.

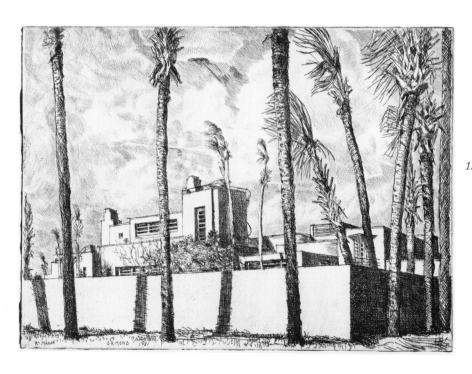

121. *Ormond House*
 1931. (February 24, 1931)
 l.l.; R. MARSH ORMOND 1931
 Etching; 178 mm. x 254 mm.
 (7″ x 10″) plate.
 State I (one proof: *A*) Design complete
 except for sky.
 State II (two proofs: B, C) Sky and
 cloud forms added. Final state.
 Printing: Marsh, impressions 1 through
 13 Whatman (March 5, 1931), 14
 through 18 (October 18, 1932); *5*
 NYPL, 10 LC, *11* MMA, Z.

 Photograph: Final state.

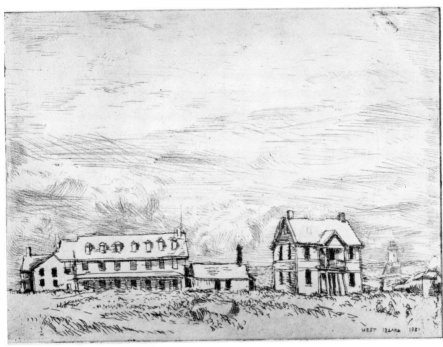

123. *West Island*
1931. (July 26, 1931)
l.r.; WEST ISLAND 1931
Etching; 127 mm. x 178 mm.
 (5″ x 7″) plate mark.
Only state (one proof: *A*).
Printing: Unknown.
Plate not found.

Photograph: Only state, A.

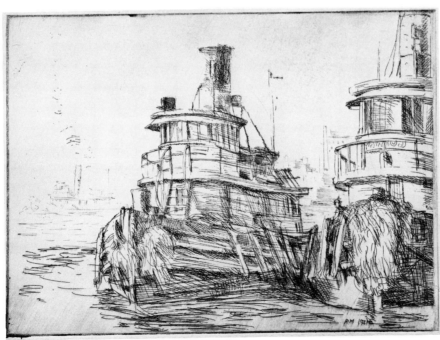

124. *Tugboats*
1931. (September 12, 1931)
l.r.; RM 1931
Etching; 127 mm. x 178 mm.
 (5″ x 7″) plate mark.
Only state (one proof: *A*).
Printing: Unknown.
Plate not found.

Photograph: Only state, A.

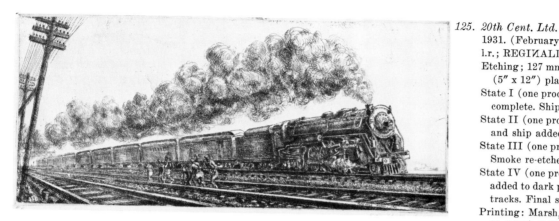

125. *20th Cent. Ltd.*
 1931. (February 24, 1931)
 l.r.; REGINALD MARSH 1931
 Etching; 127 mm. x 305 mm.
 (5″ x 12″) plate.
 State I (one proof: A Whatman) Design
 complete. Ship not included.
 State II (one proof: *B*) Skyline drawn
 and ship added.
 State III (one proof: *C* Whatman)
 Smoke re-etched.
 State IV (one proof: *D*) Engraving
 added to dark parts of clouds and on
 tracks. Final state.
 Printing: Marsh, impressions 2 (March
 13, 1931), 3 through 14 Whatman
 (March 18, 1931); 5 LC, *14* NYPL, Z.
 Note: Painting, same design: *The
 Limited,* 1931, Collection Mrs. Reginald
 Marsh.

 Photograph: Final state, 3.

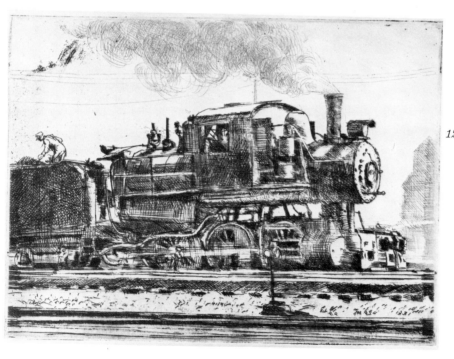

126. *Switch Engine LVRR*
 1931. (September 12, 1931)
 l.r.; R.R. MARSH 1931
 Etching; 127 mm. x 178 mm.
 (5″ x 7″) plate mark.
 State I (two proofs: *A, B* Z) Design
 complete except for smoke and man on
 top of car. Foul biting in upper left
 corner.
 State II (two proofs: *C,* D Whatman)
 Smoke drawn, man added, much
 darkening of engine and tracks. Final
 state.
 Printing: Unknown.
 Plate not found.

 Photograph: Final state, C.

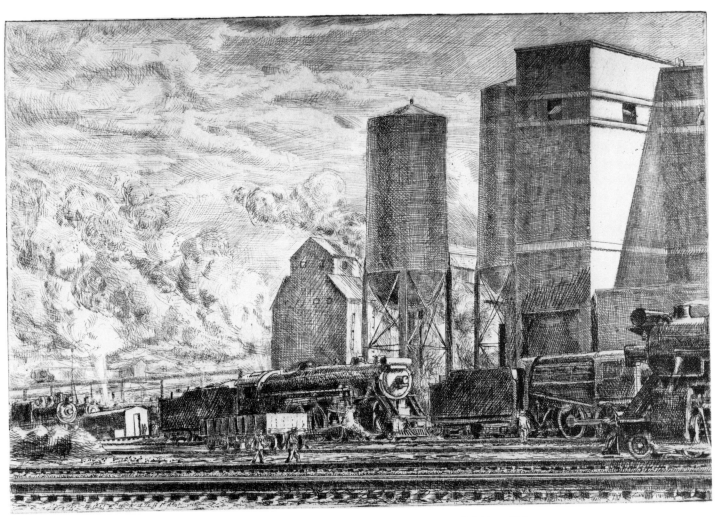

127. *CRRNJ*
1931. (October 27, 1931)
l.r.; REGIИA MARSH 1931
Etching; 203 mm. x 298 mm.
(8″ x 11¾″) plate mark.
State I (two proofs: A, B *Second Trial Proof* Whatman) Design complete.
State II (one proof: C) Drawing added to secondary material such as in left background; some drawing added to smoke.

State III (one proof: D extensive drawing added) Machine-buffed the sky (RM). Cloud forms changed.
State IV (five proofs: E MMA, F, G, H, I NYPL proof E touched extensively. Marsh considered all these proofs failures) Drew smoke (RM).
State V (two proofs: J, K) Additions made in foreground, engines, and parts of buildings. Extensive drawing added to sky. Final state.

Printing: Unknown.
Plate not found.
Note: MMA has early state proof, unnumbered, touched.

Photograph: Final state, J.

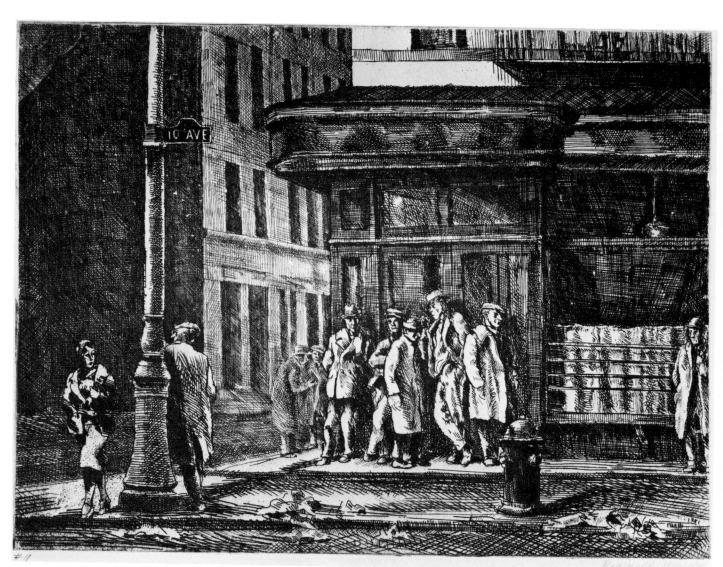

Final state

128. *Tenth Ave. at 27th St.*
1931. (April 11, 1931)
l.r.; 1931
 MARSH
Etching; 203 mm. x 279 mm.
 (8″ x 11″) plate.
State I (two proofs: A, B Whatman)
 Design complete.
State II (one proof: *D* NYPL) Lower
 edge of plate beneath curb darkened
 with crosshatched lines. Final state.
Printing: Marsh, impressions 3 through
 17 Whatman (May 31, 1931); 7 AD,
 16 NYPL.
Edition: Jones, sixteen impressions
 (1956); Whitney, one hundred
 impressions (1969); MMA.
Steel faced.

Note: Marsh's 1931 Desk Calendar,
 Monday, April 6, 1931, contains the
 following entry: "first drawing for
 etching 27 St. 10th Ave. evening."
 Painting, same design: *Tenth Avenue,*
 1931, Collection Mrs. Reginald Marsh.
 Figures and light different in the
 painting.

Photographs: Final state, 11; painting,
 Collection Mrs. Reginald Marsh.

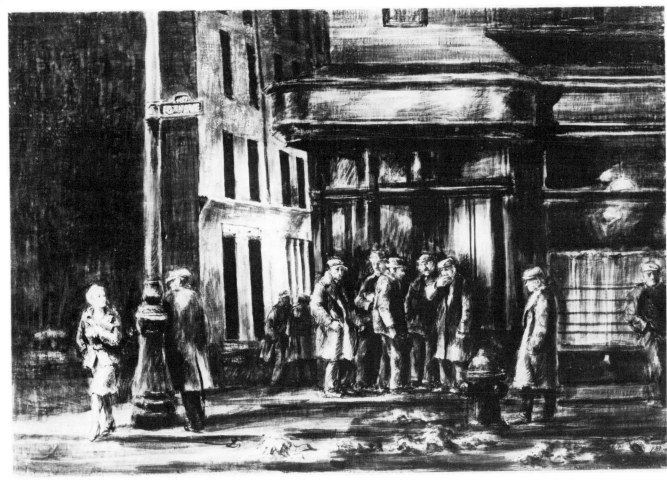

Painting

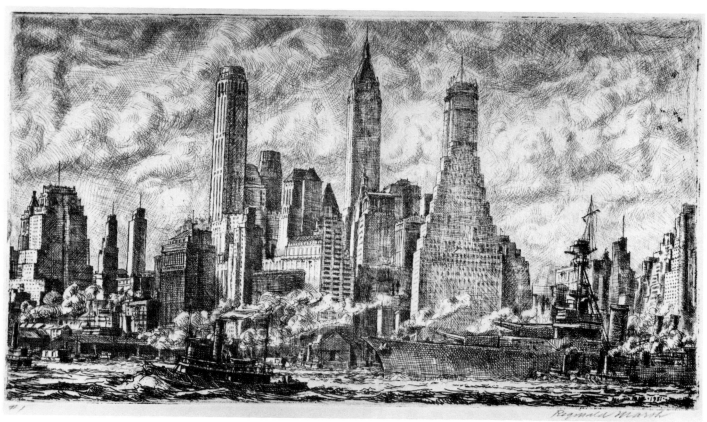

129. *Skyline from Pier 10 Bklyn*
1931. (June 17, 1931)
l.r.; REGINALD MARSH 1931
Etching; 165 mm. x 305 mm.
 (6½″ x 12″) plate.
State I (two proofs: A, *B Second Trial Proof*, touched extensively) Design complete except for sky and addition to building.
State II (one proof: C) Extensive drawing added to sky.
State III (two proofs: *D*, E Whatman) Drawing added to battleships, buildings, and sky.
State IV Some lines re-etched by spit biting, probably near lower edge of plate. A few touches of engraving. Final state.

Printing: Marsh, impressions 1 (September 13, 1931), 2 through 13 Whatman (September 20, 1931), 14 through 18 (October 18, 1932); 9 LC, *14* NYPL, MMA, Z.
Edition: Jones, eleven impressions (1956); Whitney, one hundred impressions (1971).
Steel faced.
Note: Painting same design: *New York Skyline*, 1931. Marsh's notes indicate that the painting was started May 20, 1931.

Photograph: Final state, 1.

0. P.R.R. Loco Waiting to Be Junked
1932. (August 16, 1932)
Etching; 152 mm. x 298 mm.
(6″ x 11¾″) plate mark.
State I (two proofs: *A, B* MMA,
touched) Drew design from nature in
two afternoons (RM). Design complete
except for tracks and sky.
State II (one proof: *C,* touched) Drawing
added to tracks and distant material.
State III (one proof: I) Cinders in track
and sky drawn.
State IV (three proofs: 2, 3, 3a) Some
engraving and drypoint added to sky
and tracks.
State V Engraving added to tender. Final
state.
Printing: Marsh, impressions 4, 5, 6, 7,
7a, 8, 9, 10, 10a, 11 through 19
(November 1, 1932); *3* NYPL, 4 CGA,
6 LC, Z.
Plate destroyed. Notebook No. 7, p. 1;
No. 8, p. 56.

Photograph: State IV, 2.

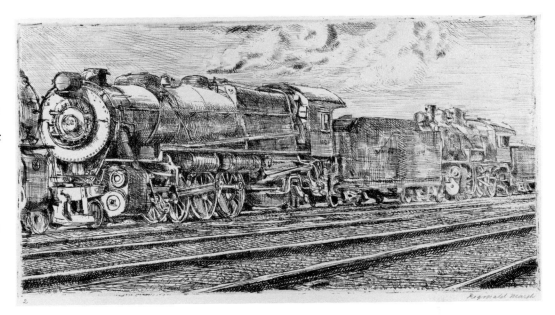

131. Iron Steamboat Co.
1932. (November 28, 1932)
l.r.; RM 1932
Etching; 178 mm. x 229 mm.
(7″ x 9″) plate.
State I (two proofs: *A,* B, touched)
Design complete.
State II (one proof: C) Drawing added
to garments, faces, waves, shadows,
musical instruments, and sky.
State III (one proof: D) Drew clothes,
accents, flesh shadows (RM).
State IV (one proof: *E/1* LC) Tooled
out foul biting (RM).
State V (one proof: F/2) Engraving
added to central figure's right shoulder
and other areas; some of this may have
been done in State VI.
State VI (two proofs: *G/3* WMAA, 4
Rives) More engraving done (RM).
Final state.
Printing: Marsh, the highest numbered
impression located, 21; *11* NYPL, early
state Z.
Note: Painting, same design & title, 1932,
destroyed.

Photograph: Final state, 4.

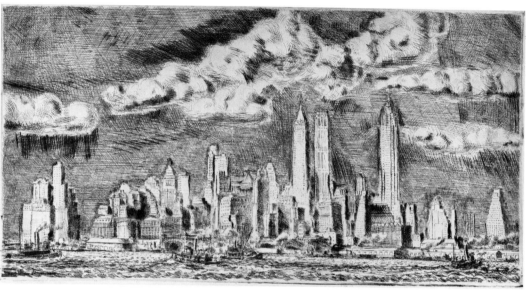

132. *N.Y. (Skyline from Governor's Island*
 1932. (August 30, 1932)
 l.r.; REGINAID MARSH 1932
 Etching and drypoint; 152 mm. x 298 mm
 (6" x 11¾") plate mark.
 State I (three proofs: *A* MMA, torn in
 half, touched, A counterproof tissue,
 B Rives) Design complete except for
 sky and smoke from tugs.
 State II (two proofs: *C* Umbria NYPL,
 touched, *D* Rives NYPL) Entire sky
 area covered with lines, smoke modeled
 State III (one proof: *1*) Mostly addition
 to sky.
 State IV (one proof: *2*) Drypoint
 additions throughout, burr retained.
 State V (one proof: *3*) Drypoint
 additions, burr retained (RM).
 State VI (one proof: *4*) Drypoint
 additions, burr retained (RM).
 State VII (one proof: *5*) Burr removed
 (RM).
 State VIII (one proof: *6*) More drypoint
 additions (RM).
 State IX (one proof: *7*) Scraped,
 burnished, and charcoaled plate (RM)
 Final state.
 Printing: Unknown; Z.
 Plate destroyed. Notebook No. 7, p. 1;
 No. 8, p. 56.

 Photograph: State VIII, 6.

133. *Dance Marathon*
 1932. (December 15, 1931)
 Engraving; 178 mm. x 128 mm.
 (7" x 5") plate.
 State I (three proofs: *1, 2, 3*) Design
 complete.
 State II (one proof: *3a*) Cross-hatching
 added to girl's legs; a few lines added
 to her skirt.
 State III (one proof: *3b*) Diagonal lines
 added to girl's skirt and blouse,
 cross-hatching added to man's arm and
 trousers.
 State IV (one proof: *3c* NYPL)
 Engraved (RM).
 State V (one proof: *3d*) Engraved (RM).
 Cross-hatching added to woman's arm
 and right side of collar, also side of
 right leg.
 State VI (one proof: *3e*) Engraved
 (RM).
 State VII (one proof: 3f) Burr scraped
 off, especially on faces. Lines added to
 lower part of man's trousers. Final
 state.
 Printing: Marsh, impressions 3g Umbria
 and *3h* Rives white (August 10, 1932);
 NYPL, Z.

 Photograph: Final state, 3g.

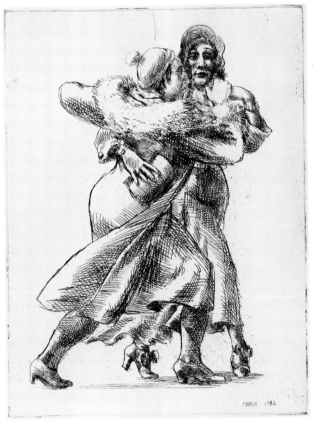

134. *Dancers Chop Suey*
 1932. (January 4, 1932)
 l.r.; MARSH 1932
 Etching; 203 mm. x 152 mm.
 (8″ x 6″) plate mark.
 Only state (two proofs: A, *B* Umbria)
 Printing: Unknown.
 Plate not found.

 Photograph: Only state, B.

135. *Flushing Landscape (Monkey Hill)*
 1932. (May 28, 1932)
 l.l.; MO*И*KEY HILL l.r.; RM 1932
 Etching; 127 mm. x 178 mm.
 (5″ x 7″) plate mark.
 State I (one proof: *A* NYPL) Drew
 this design from nature using a
 Whistler Needle (RM). Design
 complete.
 State II (one proof: *1*) Drypoint added
 to figure. Final state.
 Printing: Unknown.
 Plate not found.

 Photograph: Final state.

136. Coney Island Beach
 1932. (August 15, 1932)
 l.r.; R.M. 1932
 Etching; 152 mm. x 203 mm.
 (6″ x 8″) plate mark.
 Only state (two proofs: *A* NYPL, *B*)
 Design complete. Foul biting in several
 areas.
 Printing: Unknown.
 Plate not found.
 Note: Painting, same design: *Coney
 Island Beach*, 1932, Collection Mrs.
 Reginald Marsh.

 Photograph: Only state.

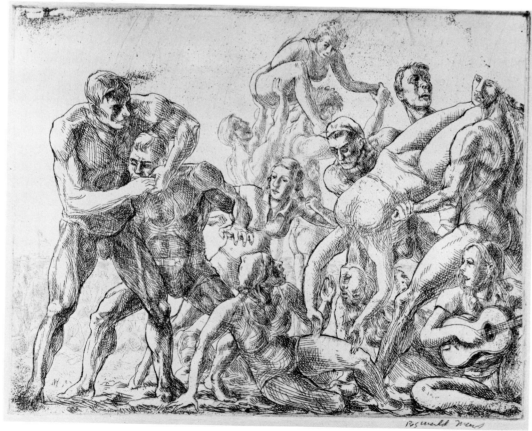

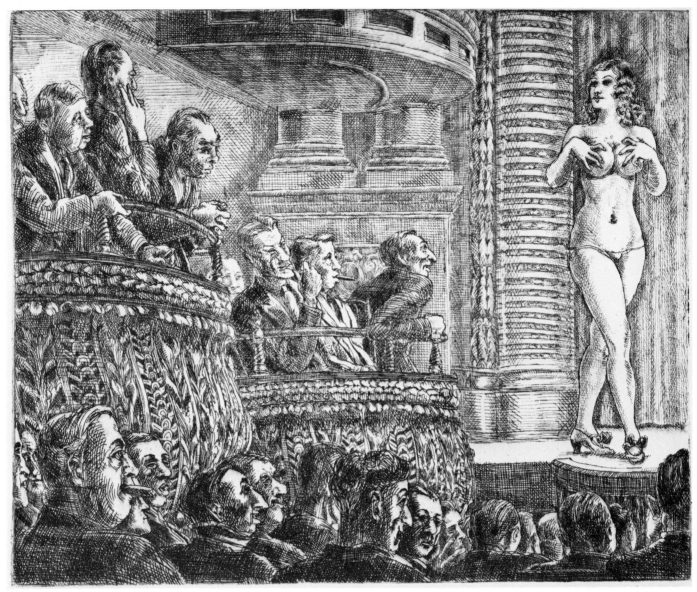

137. *New Gotham Burlesk*
 1932. (December 4, 1931)
 Etching; 203 mm. x 247 mm.
 (8″ x 9¾″) plate mark.
 State I (two proofs: *A* NYPL, *B*
 Whatman) Design complete.
 State II (two proofs: *C* NYPL, *D*)
 Drawing added to nude figure.
 State III (one proof: *E*) Drawing added
 to boxes, nude, curtain, and other parts.
 State IV (three proofs: F, *G*, H) Kenneth
 Hayes Miller's face, and shadow on
 box drawn; also some drawing on
 flesh.

State V (one proof: I) Tooled out by
 machine and wheel, head (Miller?),
 and girl's breasts.
 Redrew girl's breasts and bit wide
 lines. (RM). Final state.
Printing: Unknown.
Plate not found.
Note: Gave proof H to Billy Minsky
 (RM). Painting, same design: *Minsky's
 New Gotham*, 1930, Collection Mr. &
 Mrs. Albert Hackett. Used new press
 for first time December 6, 1931 (RM).

Photograph: State IV, G.

138. *Steeplechase*

1932. (July 18, 1932)

l.r.; RM 1932

Etching; 203 mm. x 280 mm.
(8″ x 11″) plate.

State I (one proof: *A*) Design complete. Vise mark in upper left corner.

State II (one proof: *B*) Drawing added to near horse and rail; second horse, sailor's suit, and rail; far woman, horse, and rail; flesh and cloth (RM). Upper left corner etched.

State III (one proof: *C*) Lines bitten in faces and balustrade. Drawing added to sailor's sleeve, trousers, rear of third horse. A few heavy lines added to the horses (RM).

State IV (one proof: D) A great deal of engraving added to background, used a light graver (RM).

State V (one proof: E) Engraving added to horses' legs (RM).

State VI (two proofs: 1, 2) Burnished part of the background (RM) in order to lighten some parts.

State VII (one proof: *3* NYPL) Engraving added (RM).

State VIII (one proof: *4*) Engraving added (RM).

State IX (one proof: *5*) Engraving added (RM).

State X Engraved a little on saddle (RM). Final state.

Printing: Marsh, impressions 6 through 19 (October 30, 1932); 5 MOMA, 6 CGA, 7 LC, 19 PMA, 23 NYPL, *24* MMA, 25/40 ACH, Z.

Edition: Jones, one impression (1956); Whitney, one hundred impressions (1969).

Steel faced.

Note: Paintings, similar design: *George Tilyou's Steeplechase*, 1932, Collection The Sara Roby Foundation.

Photograph: Final state, 9.

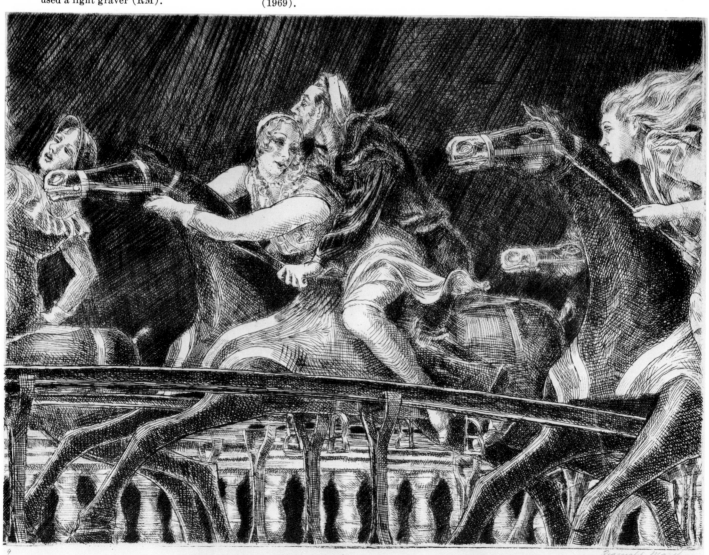

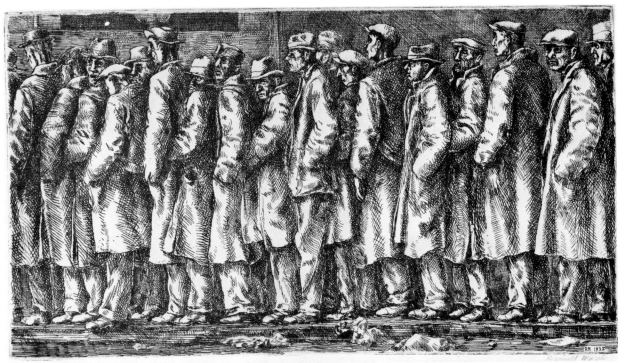

Final state

Drawing

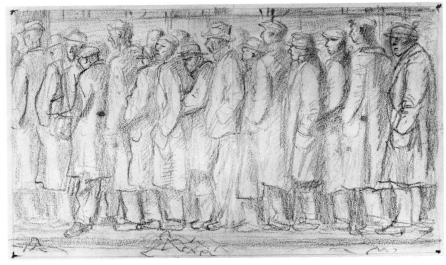

139. *Bread Line—No One Has Starved*
1932. (April 25, 1932, calendar)
l.r.; RM 1932
Etching; 166 mm. x 305 mm.
 (6½″ x 12″) plate.
State I (two proofs: *A*, B destroyed)
 Design complete.
State II (two proofs: *C, D*) Some
 engraving added. Also etched (RM).
 Lines added to coats of two men at left.
State III (two proofs: E, F) Engraving
 added (RM).
State IV (two proofs: 1, 2 CAR) A few
 lines added (RM).
State V (one proof: 3) Engraving added
 (RM).
State VI Engraved neck of fourth man,
 burnished to left (RM). Final state.
Printing: Marsh, impressions 5, 5a, 6
 through 18, 18B, 19, 20 Rives—
 nineteen impressions in all (October 2,
 1932); 8 MOMA, *14* NYPL, 16 UMO,
 18B NYPL, FOGG, Z.
Edition: Jones, three impressions (1956);
 BPL; Whitney, one hundred
 impressions (1969).
Steel faced.
Note: Illustrated: *Modern Graphic Arts.*
 Parke-Bernet Galleries, Auction Cat.
 2044, 1961.

Photographs: Final state, 10; drawing,
The Benton Collection.

Final state

140. *Tattoo-Shave-Haircut*

1932. (July 5, 1932)

MARSH

l.r.; 1932

Etching; 255 mm. x 255 mm.
 (10″ x 10″) plate.

State I (two proofs: *A, B* NYPL, plus
 three tissue proofs, one of which was
 offset) Design complete.

State II (one proof: *C*) Drawing added
 to five key figures, lines added in middle
 ground, on faces and globe. Some
 engraving added (RM).

State III (one proof: *D* WB) Engraving
 added (RM).

State IV (one proof: *E*) Engraving
 added (RM).

State V (one proof: *F*) No information
 available.

State VI (one proof: *G*) Scraped (RM).
 Shoulder of figure next to barber pole
 removed.

State VII (one proof: *H*) Engraved on
 figure (RM). Lines added to figure next
 to pole.

State VIII (one proof: *I* WB) Scraped
 and buffed over sign, sleeve, central
 figure's hat. Much engraving added
 (RM).

State IX (one proof: 1 ART) Removed
 head by scraper and buffer. Redrew
 central head (RM).

State X Engraving added (RM).

Printing: Marsh, impressions 2, 3, 4, 4a,
 5, 6, 7, 7a, 8, 9, 9a, 10, 11, 12, 13, 14,
 15, 16, 17, 18 (November 5, 1932), 19,
 20, 21, 22, 22a and 23 through 31
 (October 10, 1934); 5 LC, *11* NYPL,
 25/40 ACH, 27 UMO, 28 BPL, 29
 FOGG, MMA, Z.

Edition: Jones, one impression (1956);
 Whitney, one hundred impressions
 (1969).

Steel faced.

Note: Painting, same design: *Tattoo and
 Haircut*, 1932, Art Institute of Chicago,
 gift of Mr. & Mrs. Earle Ludgin. 1932
 Desk Calendar, June 7, 1932,
 "Commerce Tattooing on the Bowery
 48 x 48" indicates that the painting was
 started before the etching. There are
 two related drawings in The Fogg
 Museum, one drawing in The
 Philadelphia Museum of Art.

Photographs: Final state, 7; drawing;
 painting, Collection Art Institute of
 Chicago. *Tattoo and Haircut*: Courtesy
 of the Art Institute of Chicago.
 Courtesy of Philadelphia Museum of
 Art, photograph by A. J. Wyatt, staff
 photographer.

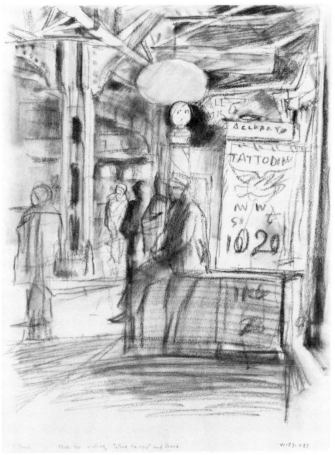

Drawing

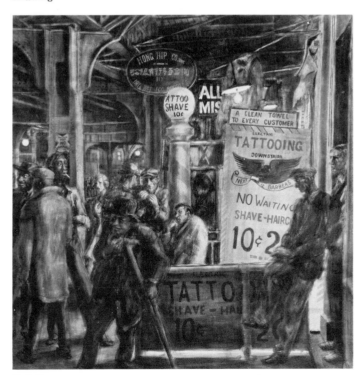

Painting

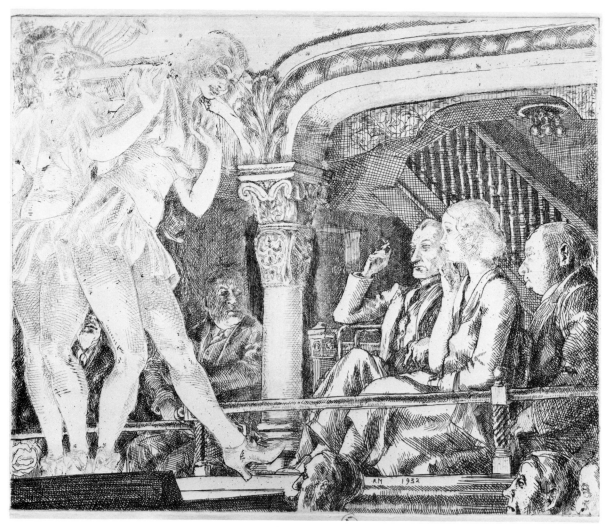

141. *Gaiety Burlesk*
1932. (April 10, 1932)
l.r.; RM 1932
Etching; 203 mm. x 253 mm.
 (8″ x 10″) plate.
State I (two proofs: *A, B* Japan touched)
 Design complete. Foul biting.
State II (two proofs: *C, D*) Portions of
 foul biting removed (RM). Hands
 added and lower left area near girl's
 feet developed. Lines added to faces of
 figures at right. Many lines added
 throughout.
State III (two proofs: *J*, K yellow
 Umbria) Drawing added to upper box
 and parts of background. Added lines
 to flesh parts and also a few delicate
 tints (RM). It is not known if Marsh
 made proofs E, F, G, H, or I. Possibly
 proofs were made to see the progress
 of the scraping.

State IV (two proofs: *L*, R) Scraped and
 buffed (RM) girl's faces, column, and
 entire top part of plate. Proofs: M,
 N, O, P were probably made to note
 the progress of the scraping.
State V (one proof: *J* this proof number
 used again) Drew pillar, drew faces and
 shadow on column (RM). Final state.
Printing: Unknown, Z.
Lost (RM). Notebook No. 8, p. 56. Plate
 located but in very poor condition.
Note: Painting, same design: *Gayety
 Burlesque*, 1932, Collection Grace
 Eustis, Washington, D.C. 1932 Desk
 Calendar, "Start to paint *Gayety
 Burlesque* 24 x 30" Thursday, April 14,
 1932, indicates that the etching was
 started before the painting; however,
 the etching was never completed.

Photograph: Final state, J.

142. *Star Burlesk*

1933. (November 4, 1933)

Etching; 305 mm. x 230 mm.
 (12″ x 9″) plate.

State I (one proof: *A*) Design complete.
 Vise mark in upper left corner.

State II (two proofs: B, C) Drawing
 added to heads, flesh, and some of the
 architecture. Upper left corner etched.

State III (three proofs: D, E, *F* NYPL)
 Spit bit light lines, engraved and tooled
 out (RM) some parts such as around
 navel. Final state.

Printing: Marsh, impressions G/1
 (December 21, 1933), 2 through 17
 white Rives (January 26, 1934); 4/40
 ACH, 6 UMO, *8* MMA, Z. G/1 given
 to Isabel Bishop (RM).

Edition: Jones, fourteen impressions
 (1956); Whitney, one hundred
 impressions (1969).

Steel faced.

Note: Painting, same design, but
 reversed. *Star Burlesque*, 1933, The
 Benton Collection.

Photographs: Final state, 2; painting,
 The Benton Collection.

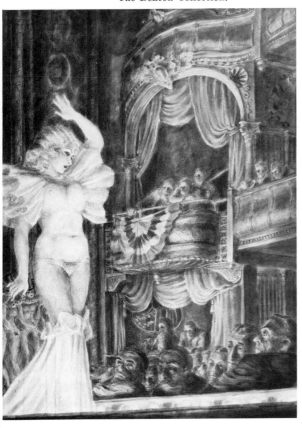

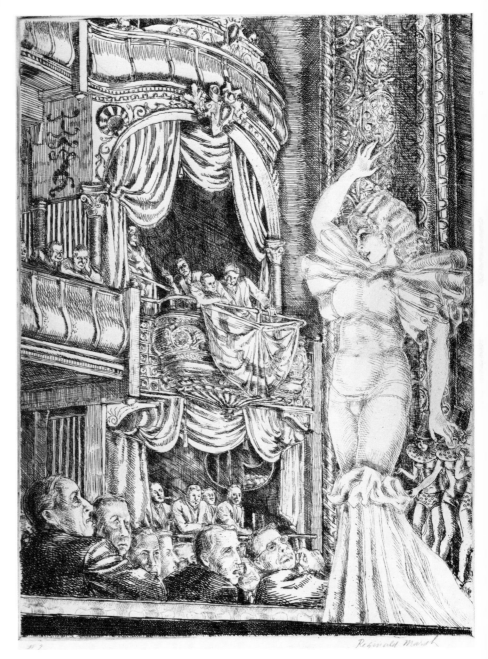

143. Box at the Metropolitan

1934. (April, 1934)

Etching and engraving; 255 mm. x
 204 mm. (10" x 8") plate.

State I (one proof: *A*) Design complete.

State II (one proof: *B* NYPL) Engraved
 a great deal effacing the burr (RM).

State III (one proof: *C*) No information
 available.

State IV (one proof: 1) Drawing added
 on left man's face and dinner jacket,
 lines bitten deeper (RM).

State V Engraved a little (RM). Vise
 mark completely removed. Final state.

Printing: Marsh, impressions 3 through
 22 (September 7, 1934); *10* NYPL,
 ACH, BPL, MMA, NGA, Z. Charles
 White, ten impressions (October 23,
 1936).

Edition: Whitney, one hundred
 impressions (1969).

Steel faced.

Note: Marsh noted (May 20, 1934) that
 making impression C was the first use
 of his press at 4 East 12th Street.

Photograph: Final state, 6.

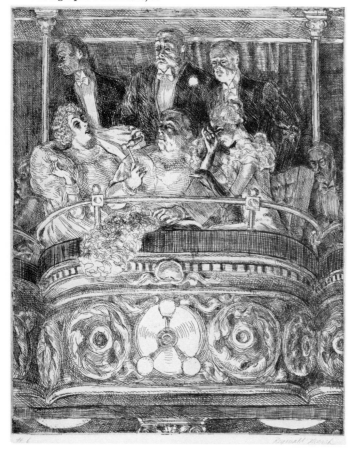

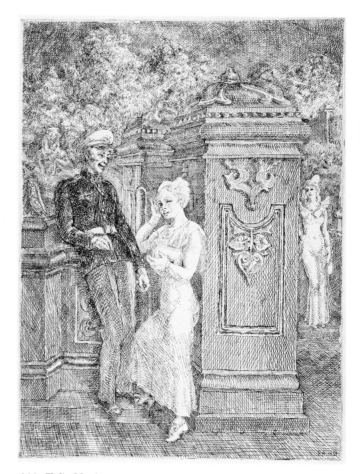

144. U.S. Marine

1934. (September 30, 1934)

l.r.; RM 1934

Etching; 204 mm. x 152 mm.
 (8" x 6") plate.

State I (one proof: *A*) Design complete.

State II (two proofs: *B, C*) Lines added
 to marine's coat.

State III Spit bite in Dutch a few parts
 (RM). Final state.

Printing: Marsh, impressions 1 through
 13, 13a, and 14 through 19 (October 13,
 1934); *6* NYPL, *9* LC, Z.

Note: Painting, same design: *United
 States Marine*, 1934, Collection Mrs.
 Reginald Marsh.

Photograph: State II, B.

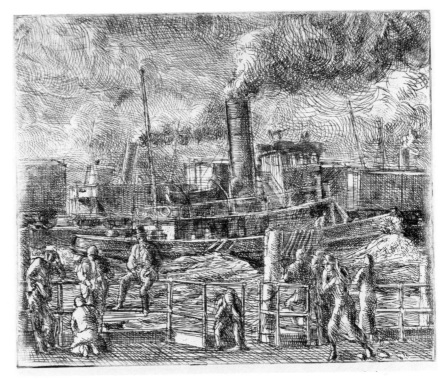

145. *Tug at Battery*
 1934. (October 4, 1934)
 Etching (zinc) ; 203 mm. x 254 mm.
 (8″ x 10″) plate.
 State I (three proofs: *1, 2, 3*) Design
 complete.
 State II (one proof : incorrectly
 numbered "3") Final state.
 Printing: Marsh, impressions 4, 4 (he
 used this number twice), 4 through 14,
 14a, 15 through 21 ; 5 ACH, 21 BPL,
 NYPL.
 Surface of this plate corroded, causing
 extensive damage.

 Photograph: Final state, 3.

146. *Tug—Chas. D. McAllister*
 1934. (October 10, 1934)
 Etching ; 76 mm. x 127 mm.
 (3″ x 5″) plate mark.
 Only state (one proof : A) Drawn from
 nature directly on the grounded plate
 (RM).
 Printing: Marsh, impressions 1 through
 12 (November 20, 1934) ; 7 Z.
 Plate destroyed. Notebook No. 7, p. 2 ;
 No. 8, p. 58.

 Photograph: Final state, 9.

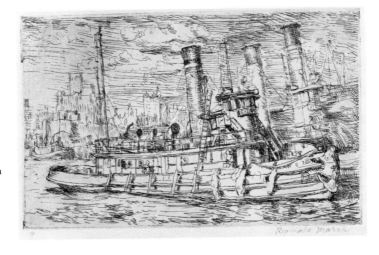

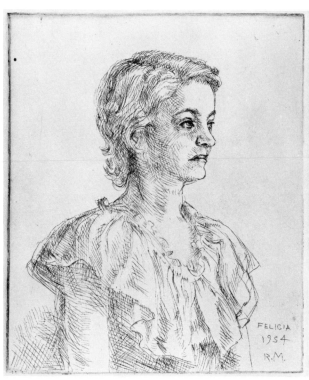

147. *Felicia*
 1934. (July 13, 1934)
 l.r.; FELICIA
 1934
 R.M.
 Etching; 114 mm. x 102 mm.
 (4½″ x 4″) plate mark.
 Only state.
 Printing: Marsh, impressions 1, 2;
 2 NYPL.
 Plate destroyed. Notebook No. 7, p. 2;
 No. 8, p. 58.

 Photograph: Only state.

148. *Zoric Shumatoff*
 1935. (February 10, 1935)
 Etching; 127 mm. x 102 mm.
 (5″ x 4″) plate mark.
 State I (four proofs: *A, B, C, D* MMA
 touched) Design complete except for
 chair.
 State II (one proof: *E*) Chair added.
 State III (one proof: *F* WB) Tooled
 down lips (RM). Additional lines
 engraved on chair. Final state.
 Printing: Unknown.
 Plate destroyed: Notebook No. 7, p. 2;
 No. 8, p. 58.

 Photograph: Final state.

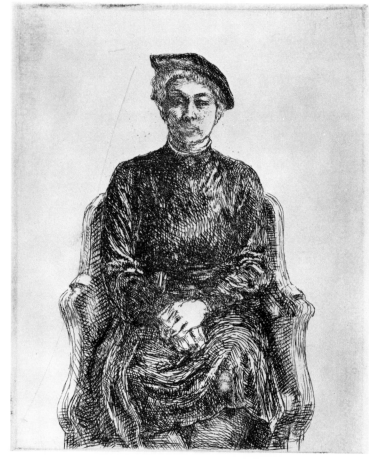

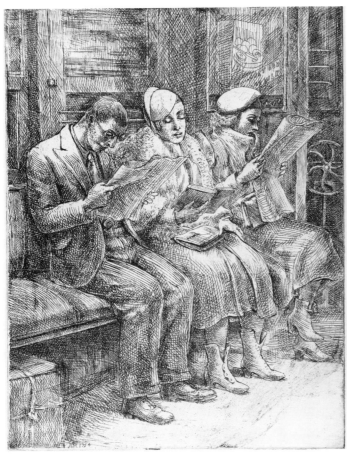

149. *Subway—Three People*
1934. (March 15, 1934)
l.l.; RM 1934
Etching; 228 mm. x 178 mm.
 (9″ x 7″) plate.
State I (two proofs: *A, B*) Design
 complete.
State II (three proofs: C, D, *1*) Many
 lines added to various parts of print,
 especially in dark areas.
State III Scraped (RM). Vertical area
 above center woman darkened. Diagonal
 lines added in upper right corner and
 lower left corner. Final state.
Printing: Marsh, impressions 2 through 9,
 and 9a, 10a, 10b, 10c and 7 flops (RM);
 2 NYPL, 4 LC, Z.
Note: Painting, same design: *New Lots
 Express*, 1934, Collection Mrs. Reginald
 Marsh.

Photograph: Final state, 5.

150. *Guy Pène du Bois School of Art*
1934. (December 23, 1934)
u.r. 1934–5
 GUY PÈNE du BOIS
 SCHOOL OF ART
l.r.; RM
Etching; 203 mm. x 152 mm.
 (8″ x 6″) plate mark.
Only state. Drawn from life (RM).
Printing: Marsh, impressions 1, 2, 3;
 3 NYPL, Z.
Plate not found.

Photograph: Only state, 4.

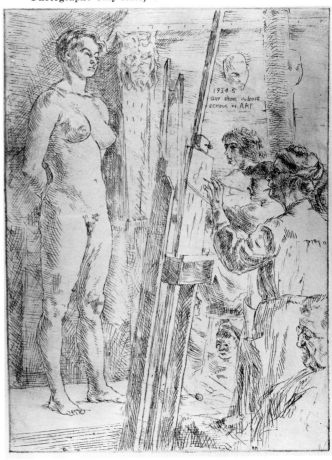

151. *George Washington—Union Square*
 1934. (June 17, 1934)
 Etching; 178 mm. x 127 mm.
 (7″ x 5″) plate mark.
 Only state. (two proofs: *1, 2*).
 Printing: Unknown; Z.
 Plate not found.
 Note: Similar design (reversed) as
 lithograph (S.27).

 Photograph: Only state, 1.

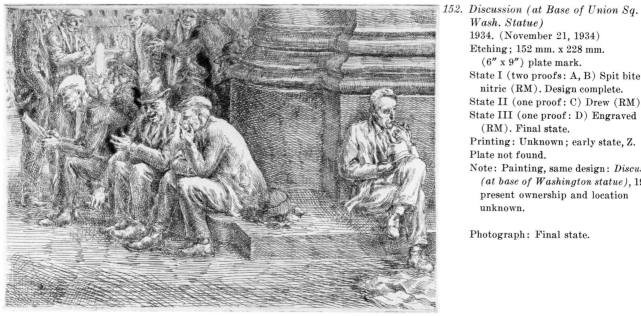

152. *Discussion (at Base of Union Sq.*
 Wash. Statue)
 1934. (November 21, 1934)
 Etching; 152 mm. x 228 mm.
 (6″ x 9″) plate mark.
 State I (two proofs: A, B) Spit bite in
 nitric (RM). Design complete.
 State II (one proof: C) Drew (RM).
 State III (one proof: D) Engraved
 (RM). Final state.
 Printing: Unknown; early state, Z.
 Plate not found.
 Note: Painting, same design: *Discussion*
 (at base of Washington statue), 1934,
 present ownership and location
 unknown.

 Photograph: Final state.

Drawing

153. *Coney Island Beach*
 1934. (July 13, 1934)
 l.r.; RM 1934
 Etching; 254 mm. x 253 mm.
 (10″ x 10″) plate.
 State I (two proofs: A, *B*) Design
 complete. Vise mark in lower left
 corner.
 State II (three proofs: 1/A, 2/B, 3/C—
 there is some confusion as to the actual
 numbers or letters used) Lower right
 corner etched. Lines added in lower left
 part of plate on tube, hat, back of head.
 State III (one proof: D) The ceiling
 falls on the plate. Tooled out bruises
 caused by the accident. Drew a little
 on the sky (RM).
 State IV (three proofs: 1, 2, *3* Marsh
 noted that he should renumber these)
 A few touches of engraving added in
 damaged area and in a few other spots.
 Final state.
 Printing: Marsh, impressions 1 through
 14 (August, 1934); ART, MMA, Z.
 Edition: Whitney, one hundred
 impressions (1971).
 Steel faced.
 Note: Painting, same design: *Coney
 Island Beach*, 1934, Yale University
 Art Gallery. Marsh noted that his
 painting of the same subject and design
 was begun by projecting an impression
 of the etching onto his painting panel,
 so that he could transfer the design.
 This procedure was not always used.
 Many of the prints were made after or
 while the paintings were being done.

 Photographs: Final state; drawing, The
 Benton Collection; painting, Collection
 Yale University Art Gallery.

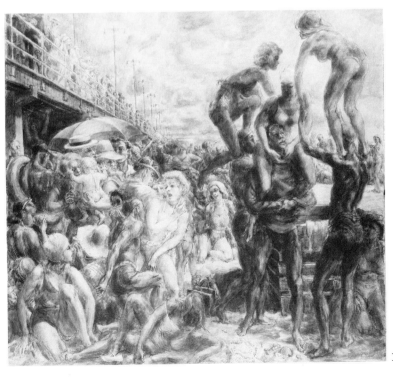

Painting

153. *Coney Island Beach*

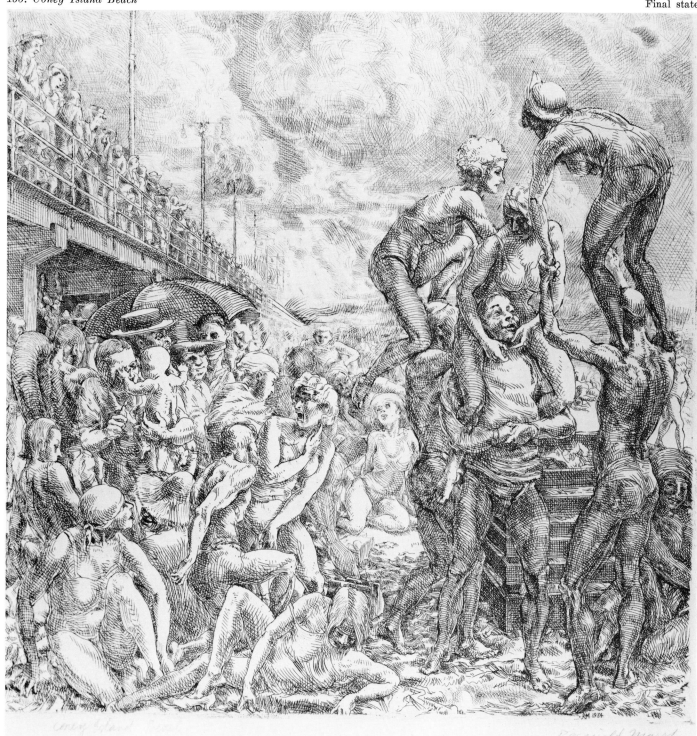

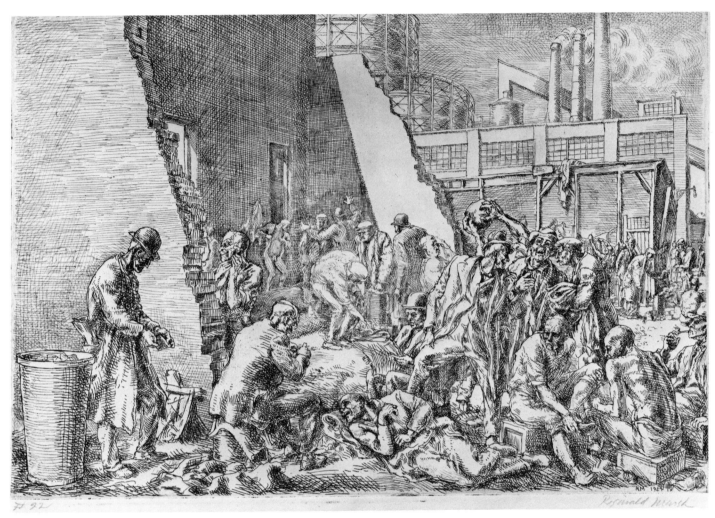

154. *East Tenth Street Jungle*
 1934. (July 15, 1934)
 l.r.; RM 1934
 Etching; 203 mm x 305 mm.
 (8″ x 12″) plate.
 State I (two proofs: A, *First Proof First State, Second Proof First State*)
 Design complete except for sky and smoke.
 State II (one proof: C) Drawing added to foreground, wall, background, and sky.
 State III (two proofs: *Third State— Trial Proof*, Z) Drew (RM).
 State IV Drew above (RM). Final state.
 Printing: Marsh, impressions 1, 2, 3 (August, 1934); *2* NYPL, *8* MMA, 17 POR, FOGG; the highest numbered impression located 22.

Edition: Jones, seven impressions (1956); BPL; Whitney, one hundred impressions (1971).
Note: Painting, same design, some notable changes in details: *East Tenth Street Jungle*, 1934, Collection Charles J. Rosenbloom, Pittsburgh. There are two related drawings in the Fogg Museum.

Photographs: Final state, 22.

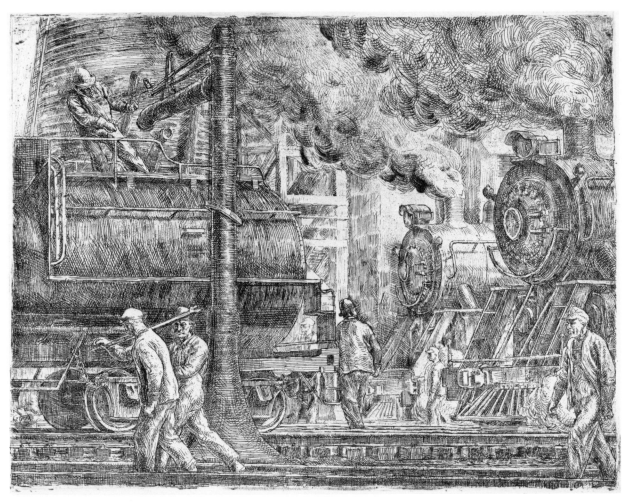

155. *Erie R.R. Locos Watering*
1934. (February 18, 1934)
l.r.; 1934
Etching; 229 mm. x 305 mm.
 (9″ x 12″) plate.
State I (two proofs: *A, B* NYPL) Design
 complete.
State II (one proof: *C 2nd State only
 proof*) Drawing added to cars, lines
 added to trousers of man in right
 corner.
State III (one proof: D) A poor ground
 which collapsed, alas. A film of foul
 biting all over, use scraper and
 burnisher (RM).
State IV (one proof: *E*) Scrape and
 burnish—charcoal—metal polish (RM).

State V (one proof: *F*) Drawing added
 to rear smoke. More scraping,
 burnishing, charcoal, and metal-
 polishing (RM).
State VI (one proof: *G*) Burnish, scrape,
 engrave (RM).
State VII (one proof: *H*) Engrave,
 scrape over (RM).
State VIII (four proofs) Engrave (RM).
Printing: Marsh, impressions 1 through 4;
 highest numbered impression located,
 18; *7* MMA, 8 WMAA, *12* NYPL,
 FOGG, Z.
Edition: Jones, fourteen impressions
 (1956); Whitney, one hundred
 impressions (1969).
Steel faced.

Note: Similar painting: *Locomotives
 Watering*, 1932, Collection Mrs.
 Reginald Marsh. Also, note relationship
 to etching S.87. Kraushaar Gallery
 inventory sheet may refer to this print,
 in which case the highest numbered
 impression would be 29. There is some
 doubt, however, because all other prints
 on list are from earlier years—closest
 is S.40, 1932. There is one related
 drawing in The Fogg Museum.

Photograph: Final state, 5.

156. *Striptease at New Gotham*
1935. Notebook No. 6, p. 5.
c. on bottom edge; RM 1935.
Etching; 305 mm. x 230 mm.
(12″ x 9″) plate.
State I (two proofs: *State I 1/2, I 2/2*)
Design complete.
State II (two proofs: *State II 1/2, C, D*)
Drew on nude, rails, and faces (RM).
State II (twelve proofs: *III 2/12*) Spit
bit fast Dutch about 1/2 hour (RM).
State IV Drawing added throughout,
notably on pillar and figures.
Background beneath curtain scraped
down. Marsh's notes are not clear
regarding the impressions made of this
state; he noted *V 1/1,* and *V 1/.*
State V (one proof: State *V 1/1*).
State VI Horizontal lines engraved on
floor and light box. Final state.
Printing: Marsh, impressions State VI
1/40 through 20/40; 9/40 LC, *14/40*
NYPL, 18/40 FOGG, Z.
Note: Painting, same design: *Striptease
at New Gotham,* 1935, Collection Mrs.
Reginald Marsh. There is one related
drawing in The Fogg Art Museum.

Photographs: Final state: State VI 1/;
painting, Collection Mrs. Reginald
Marsh.

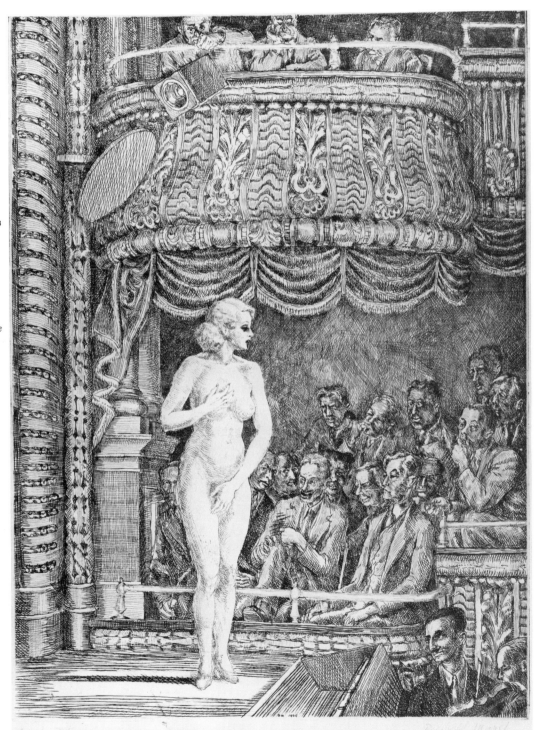

Final state

156. Striptease at New Gotham

Painting

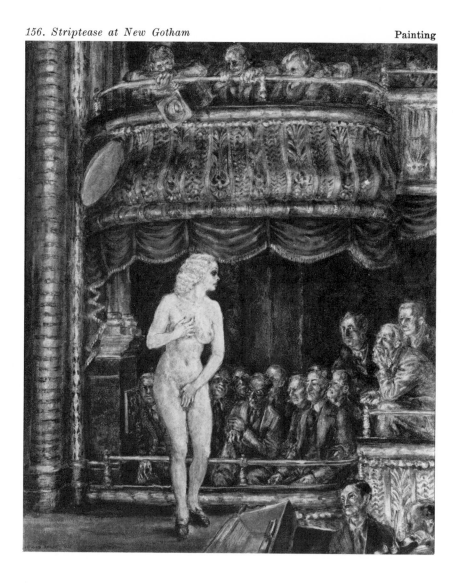

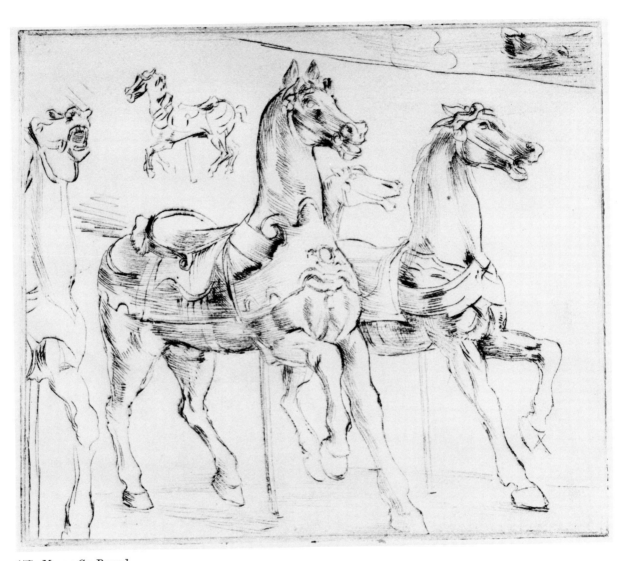

157. *Merry-Go-Round*
 1935. Notebook No. 8, p. 58.
 Drypoint; 127 mm. x 152 mm.
 (5″ x 6″) plate mark.
 Only state. (two proofs: *A* NYPL, *B*).
 Printing: Unknown.
 Plate destroyed. Notebook No. 7, p. 2;
 No. 8, p. 58.

 Photograph: Only state, B.

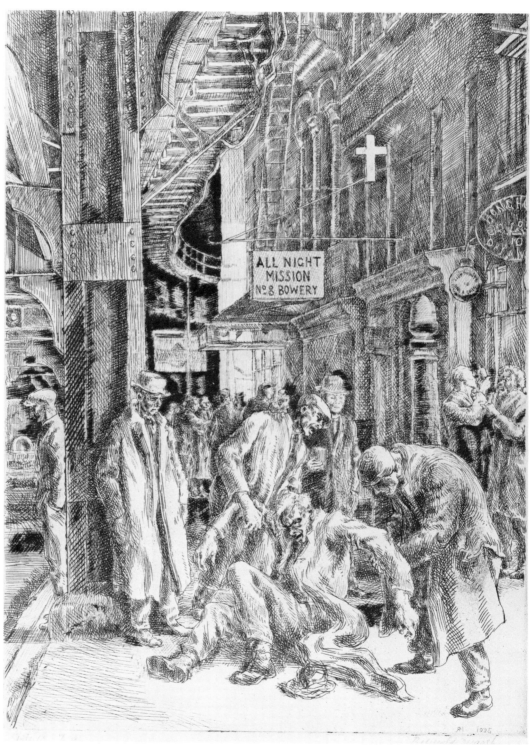

Final state

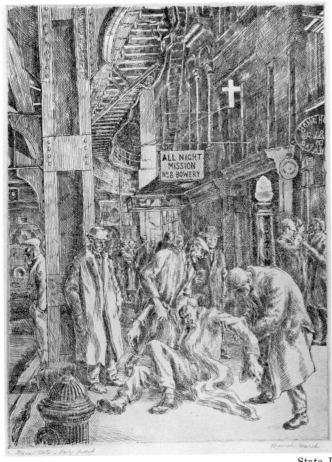

State I

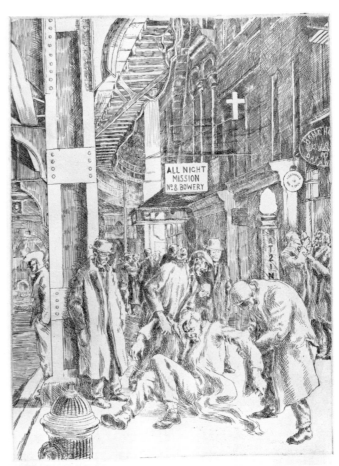

State II

158. *Smokehounds*

1934. (December 17, 1934)

l.r.; ЯМ 1935

Etching; 305 mm. x 229 mm.
 (12″ x 9″) plate.

State I (one proof: *Only trial proof first state*) Design complete.

State II (one proof: *Second state—only proof*; Marsh noted that this proof was unrecorded) Lines added to girder, around fire hydrant, to ground behind fallen figure, barber shop pole, and many other parts.

State III (one proof: *Third state—only proof*) Hydrant and dark side of barber pole tooled out (RM). Drawing added beneath central man's face and to some other parts. Initials and date added.

State IV (one proof: *Fourth state—only proof D*) Laid Sands (cold) rebiting ground. Spit bite in weak nitric without reopening lines. Slight foul biting. This is the first attempt at laying a rebiting ground. I rolled it three or four times (RM). Top of hydrant still in evidence.

State V (one proof: E V–1) Engraved. Plate damaged by rolling through the press while another plate (Zorach) lay underneath it (RM). Remainder of hydrant removed. Proof D, D2 of State V affected by this accident; only half of proof printed.

State VI (one proof: F V1–1/1) Very deep blacks on girder, back of figures, and distance created by engraving. It is not clear if this work was done in this state or in the two following states.

State VII (one proof: G VII–1/1) Information not available.

State VIII (one proof: *VIII–1/1*) Information not available.

State IX Diagonal lines added to lower left part of girder, and to the left of man's knee at far left. Final state.

Printing: Marsh, impressions 1 through 13 (August 27, 1935). [Marsh considered 7a, 11a defective]; State IX 1/13 ACH, *State IX 6/13* NYPL, Z.

Note: Painting, same design: *Smokehounds*, 1934, Corcoran Gallery of Art. There is one related drawing in The Fogg Art Museum.

Photographs: State I, State II, State III, State IV, State VIII, Final state, 7.

158. Smokehounds

State III

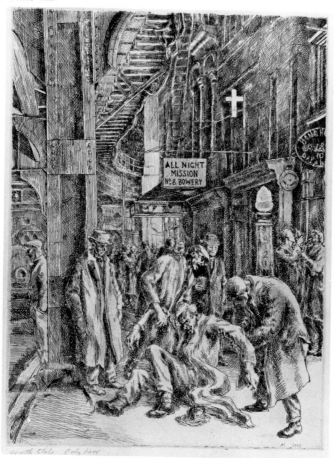

State IV

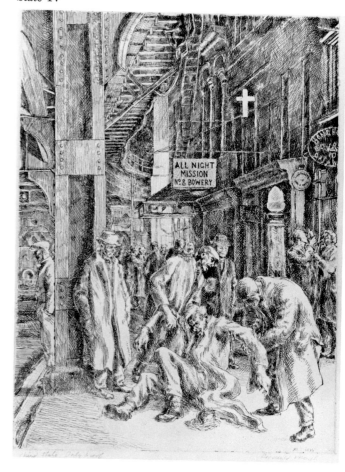

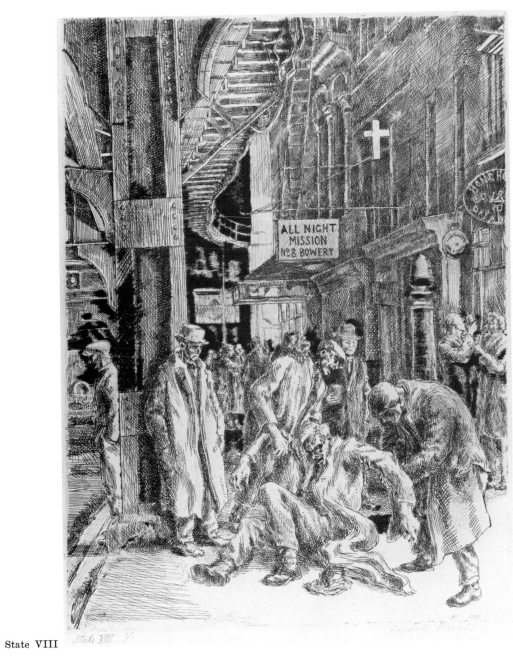

State VIII

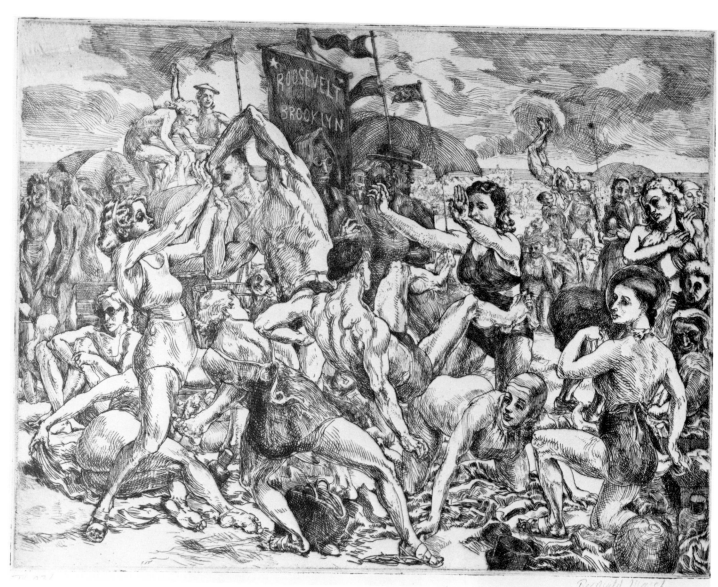

Final state

159. Coney Island Beach

1935. Notebook No. 6, p. 8.

Etching; 228 mm. x 305 mm.
(9″ x 12″) plate mark.

State I (one proof: *I 1/1*) Design
complete except for sky and ground at
lower left. Vise mark in upper right
corner.

State II (three proofs: *II 1/3, 2/3*
NYPL, *3/3* NYPL; Marsh noted that
these proofs were not good) Drawing
added to foreground and sky. Banner
scraped. Vise mark removed. There
seems to be a checkerboard of scrape
marks on plate.

State III (four proofs: *III 1/4, III 2/4,
III 3/4, III 4/4* Marsh noted that the
last three proofs were printed with Paul
Cadmus) Banner and head redrawn.
Dark lines added to upper left portion
of sky. Traces of scrape marks remain.

State IV (five proofs: *IV 1/5* Scraped
and engraved on man's cheek (RM).
Final state.

Printing: Marsh, twenty-four impressions
numbered IV 1/50 through 24/50; *4/50*
PMA, 6/50 MFA, 7/50 AD *12/50*
MMA, IV 15/50 UMO *IV 24/a* NYPL,
Z.

Edition: American Artists Group, about
two hundred impressions (October,
1936); ACH, PMA, MMA.

Plate not found.

Note: Painting, same design: *Coney
Island Beach*, 1935, The Benton
Collection. State IV 1/5 at Martin
Gordon's Gallery.

Photographs: Final state, IV 22/50;
painting, The Benton Collection.

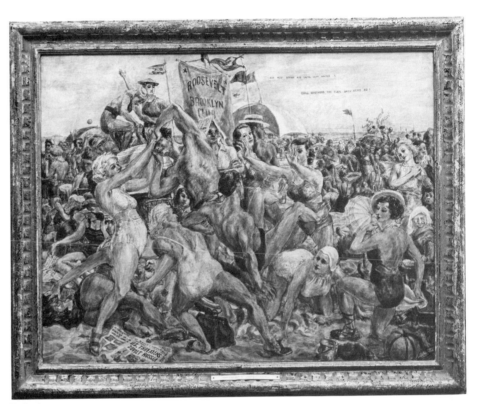

Painting

Painting

160. *Steeplechase Swings*
1935. Notebook No. 6.
l.r.; RM 1935
Etching; 230 mm x 330 mm.
 (9″ x 13″) plate.
State I (two proofs: *A, B*) Drew this
 plate in Florida (RM). Design
 complete except for windows in
 background.
State II (two proofs: *C, D* MMA
 touched) Some drawing added to majo[r]
 figures. Drawing added throughout,
 including background. Windows adde[d]
 Central area of print darkened.
State III (one proof: *E*) Drawing adde[d]
 to upper background. Upper area of
 print behind main figures darkened.
 Shadow added behind man in right
 corner. Lower left side darkened.
State IV (one proof: *F*) Lower center
 area darkened considerably.
State V (one proof: *G*) Drawing added
 to woman in upper right and man in
 lower right corner. Vertical element
 added immediately to the left of this
 man. Upper left corner darkened.
State VI (two proofs: *H, I* Marsh noted
 that he changed "I" to a number 1)
 Spit bite 2½ hours near ridge of base
 of column, shading behind man 4 min.
 (RM).
State VII Tooled down lower right
 portion (RM). Final state.
Printing: Marsh, highest numbered
 impression located 18a LC; 10/75 CA[I]
 11A MMA touched extensively, *15/75.*
 WMAA, *17/75* NYPL, Z.
Edition: Jones, ten impressions (1956);
 Whitney, one hundred impressions
 (1969).
Steel faced.
Note: Similar subject to painting but
 considerably different in design:
 Steeplechase Swings, 1931, Collection
 Mrs. Reginald Marsh.

Photographs: Final state, 4/75; paintin[g]
 Collection Mrs. Reginald Marsh.

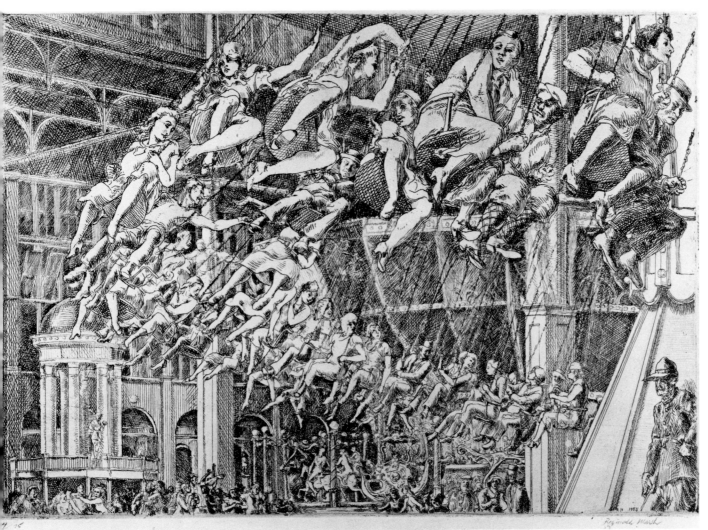

Final state

161. Fan Dance at Jimmy Kelly's
1936. (May 5, 1936) Notebook No. 6,
 p. 15
l.l.; RM 1936
Etching; 152 mm. x 127 mm.
 (6″ x 5″) plate mark.
State I (two proofs: *Trial state I-A, I-B*)
 Design complete.
State II (two proofs: *State II 1, II 2*)
 Background darkened and developed by
 adding additional cross-hatching.
State III Engraving added to areas near
 left edge, on arm and leg of woman
 drinking. A few lines added to right of
 main figure's knee. Final state.
Printing: Marsh, twenty impressions,
 Fifty proofs (May 21, 1936); FOGG,
 NYPL, Z.
Plate destroyed. Notebook No. 7, p. 2;
 No. 8, p. 60.
Note: Painting, same design, some
 change in details: *Down At Jimmy
 Kelly's*, 1936, ACA Galleries. Drawing,
 which is very close to the etching in
 design and details, was reproduced in
 Yale Record, date not known. There are
 seventeen related drawings in The Fogg
 Art Museum.

Photograph: Final state, Fifty Proofs.

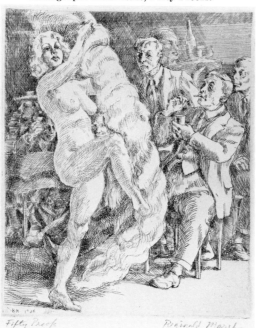

162. Opera Box
1936. Notebook No. 6, p. 10.
Engraving; 178 mm. x 127 mm.
 (7″ x 5″) plate mark.
State I (one proof: *State I 1/1*) Design
 complete.
State II (five proofs: *State II 1/5, 2/5,
 3/5, 3/5a* NYPL, *4/5, 5/5*) Shadows
 added behind men's heads, dark
 horizontal lines added near top,
 modeling added to figures and clothing.
State III (five proofs: *State III 1/5, 2/5,
 3/5, 4/5, 5/5*) Probably some minor
 additions or deletions. Final state.
Printing: Marsh noted an intended
 edition of forty in Notebook No. 7,
 p. 2; Z.
Plate destroyed. Notebook No. 7, p. 2;
 No. 8, p. 60.
Note: Painting, same design: *A Box at
 the Metropolitan*, 1934, Collection
 Margaretta Hinchman, Gladwyne, Pa.

Photograph: Final state, III 5/5.

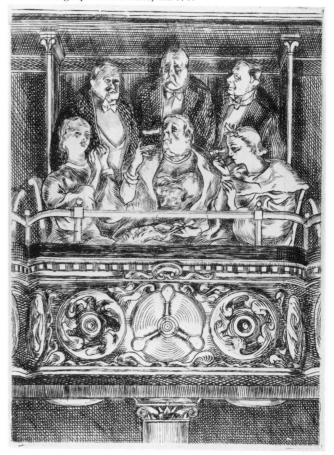

163. *Flying Concellos*

1936. (June 1, 1936) Notebook No. 6,
p. 17.

Etching (extensive engraving added in
States III & IV) ; 203 mm. x 255 mm.
(8″ x 10″) plate.

State I (three proofs: *I 1/3, 2/3* Rives,
3/3 Barcelona NYPL) Design
complete.

State II (three proofs: *II 1/3, 2/3*
NYPL, *3/3*) Lines added to back of
main figure and to two figures in lower
right. Cross-hatching added to
background.

State III (three proofs: *III 1/3, 2/3*
NYPL, *3/3* NYPL) Engraving added
(RM). Head darkened in lower left
corner ; upper left has strong diagonal
lines added. Middle background band
darkened.

State IV (two proofs: *IV* NYPL)
Extensive engraving added to
background. Final state.

Printing : Marsh, fifteen impressions
(July) ; BPL, POR, UMO, Z. White,
ten impressions (October 23, 1936).

Edition : Whitney, one hundred
impressions (1969).

Steel faced.

Note : Reproduced in : *Fine Prints of the
Year*, London, 1937.

Photograph : Final state, Forty Proofs.

164. *Two Girls (In Childs' Doorway)*

1936. (November 16, 1936) Notebook
No. 6, p. 23.

l.r. ; RM

Engraving ; 228 mm. x 152 mm.
(9″ x 6″) plate.

State I (two proofs: *1st Trial Proof A,
B*) Design complete.

State II (two proofs: *C, D*) Lines added
to left part of plate, behind right head ;
also to face of right figure, and cast
shadow to left arm. Final state.

Printing : Unknown ; NYPL, Z.

Note : Painting, same design, listed for
inclusion in exhibit (October 26, 1939) :
Two Girls in Childs' Doorway, 15 x 23,
present ownership and whereabouts
unknown.

Photograph : Final state, D.

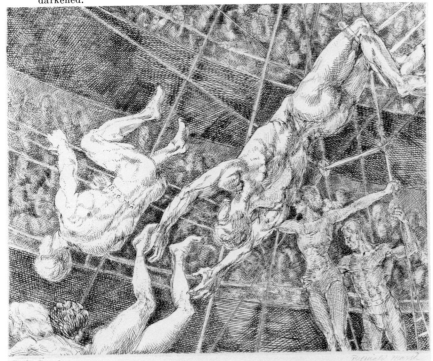

164A. *Kopper Koke Works*
> 1936. (October, 1936) Notebook No. 6,
> p. 22.
> Etching; 127 mm. x 178 mm. (5″ x 7″).
> Only state. Etching drawn on spot. 1 hour
> biting (RM).
> Printing: Marsh, one impression
> (October 23, 1936).
> Plate destroyed. Notebook No. 8, p. 60.
> Note: This etching was unknown to the
> author as there were no impressions left
> in Marsh's estate nor was the plate
> found. Apparently only one impression
> was made and the plate destroyed.
>
> Photograph: No photograph available.

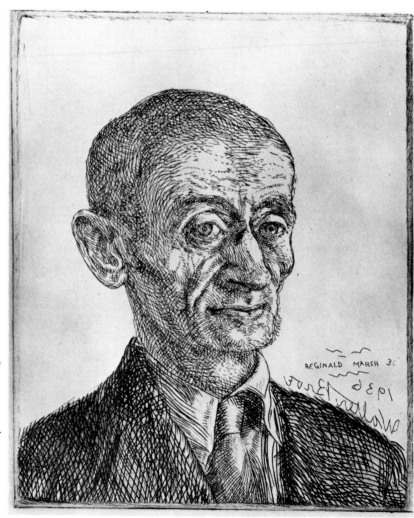

165. *Walter Broe*
> 1936. (October 3, 1936)
> l.r.; REGINALD MARSH 36 (also
> "Walter Broe" and "1936" in reverse)
> Etching; 127 mm. x 102 mm.
> (5″ x 4″) plate mark.
> State I (two proofs) Design complete.
> State II (two proofs) Scraped burr and
> added engraving to coat, tie, and shirt.
> Final state.
> Printing: Unknown; Z.
> Plate destroyed. Notebook No. 7, p. 2;
> No. 8, p. 60.
>
> Photograph: Final state.

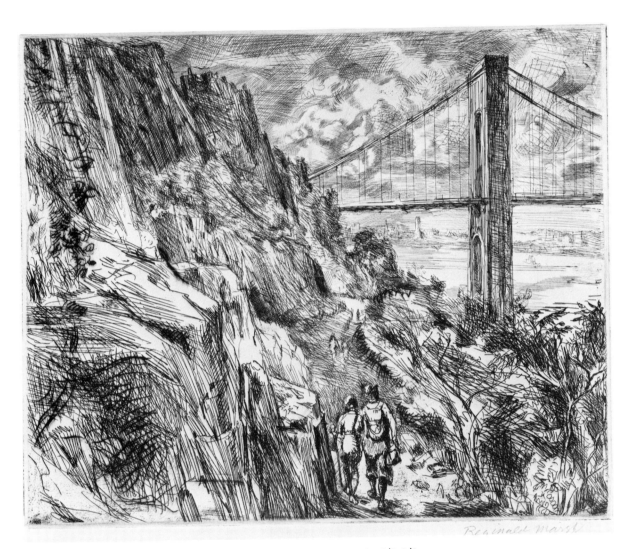

166. *George Washington Bridge (Palisades)*
1936. (September, 1935) ; however, the
first state was not etched until February
14, 1936. Notebook No. 6, p. 11.
Etching ; 203 mm. x 253 mm.
(8″ x 10″) plate mark.
State I (three proofs: *I 1/3, 2/3* NYPL,
3/3) Design complete.
State II (one proof: *II/1*) Redraw on
spot. Also drypoint and engraved
considerably (RM).

State III (two proofs: 1/2, 2/2
Whatman) Additional engraving added
to sky and water in section beneath
bridge. Final state.
Printing: White, five impressions
(October 23, 1936) ; NYPL, early
state Z.
Plate destroyed. Notebook No. 6, p. 11;
No. 7, p. 2; No. 8, p. 60.

Photograph: State II.

State I

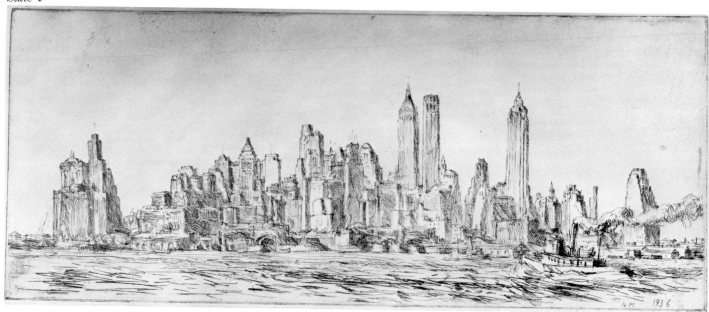

167. *N.Y. Skyline*
 1936. (June 7, 1936)
 l.r.; RM 1936
 Etching and engraving; 152 mm. x
 380 mm. (6″ x 15″) plate mark.
 State I (one proof: I) Entire design
 drawn from nature with a mirror
 directly on plate (RM). Design
 complete except for sky.
 State II (two proofs) Lines added to
 many buildings to darken them.
 State III (one proof: *III 1*) Some
 engraved lines added to water and tugs
 in foreground.
 State IV (one proof: IV, Marsh recorded
 this in his notebook as III 1/1 sole
 proof of this state. However, there are
 unmistakably three states prior to this
 state.) Additional engraving on water.

State V (one proof: *IV 1/*) Engraving
 added to rear of small tug and to some
 areas of the water.
State VI (one proof: *V 1*) Clouds added
 to sky by etching.
State VII (one proof: *A*) Many additions
 of what appears to be drypoint added
 to sky and buildings creating rich dark
 areas. May have been engraved but
 printed prior to removing burr.
State VIII (two proofs: *B, C*) Many
 additional horizontal lines engraved in
 sky area.
State IX (one proof: *D*) Engraving
 added to sky and other areas.
State X (six proofs) More engraving, and
 burr removed.
State XI (one proof) Rubbed down sky
 (RM). Final state.

Printing: Marsh, State VI, ten
 impressions Whatman (July 23, 1936);
 Forty Proofs.
Edition: American Artists Group, fewer
 than two hundred impressions (October
 1937); ACH, KIA, PMA.
Plate not found.
Note: Painting, similar design though
 much taller: *New York Skyline*, 1936,
 The Benton Collection.

Photographs: State I, State VIII, State
 IX.

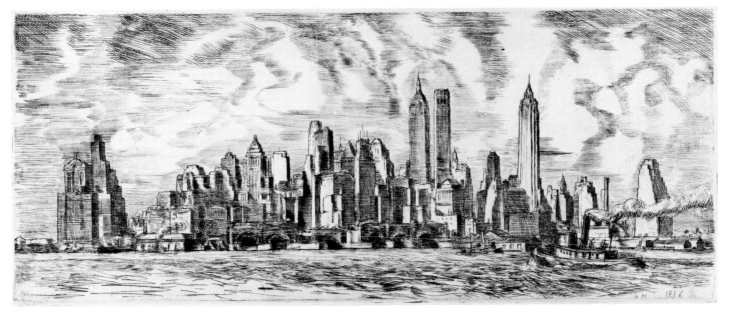

State VIII

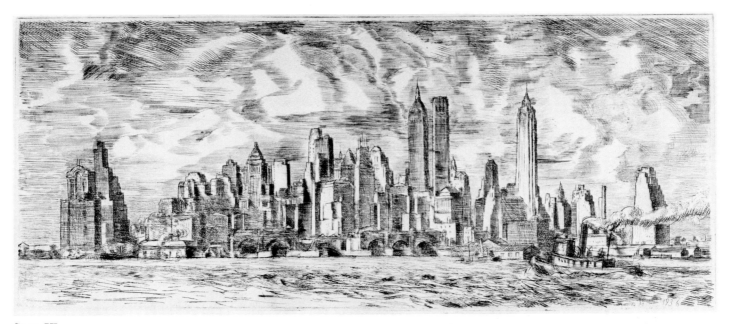

State IX

168. *Gas Works at E. 14th St.*
 1936. (May 22, 1936) Notebook No. 6,
 p. 16.
 Etching; 178 mm. x 253 mm.
 (7″ x 10″) plate mark.
 State I (two proofs: *I 1/2* NYPL, *2/2*)
 Design complete except for sky.
 State II (one proof: *II 1/*) Re-etched
 from nature (RM).
 State III (one proof: *III 1/1*) A few
 lines engraved to right of center in sky
 and in lower center part of plate. Final
 state.
 Printing: Unknown; Z.
 Plate destroyed. Notebook No. 7, p. 2;
 No. 8, p. 60.

 Photograph: Final state, III 1/1.

169. *A Morning in May*
 1936. (September 28, 1936) Notebook No.
 6, p. 20.
 l.r.; RM 1936
 Engraving; 217 mm. x 293 mm.
 (8½″ x 11½″) plate.
 Only state. (one proof: *Preparatory State*
 NYPL) Drew on spot. Plate etched for
 25 minutes. Worked the plate by burin
 only (RM).
 Printing: Marsh, two impressions
 (October 23, 1936); White, four
 impressions (October, 1936).
 Edition: Whitney, one hundred
 impressions (1969).
 Steel faced.
 Note: Painting, same design: *A Morning
 In May*, 1936, Collection Mr. & Mrs.
 Joseph Walker, Little Compton, Rhode
 Island.

 Photograph: Only state.

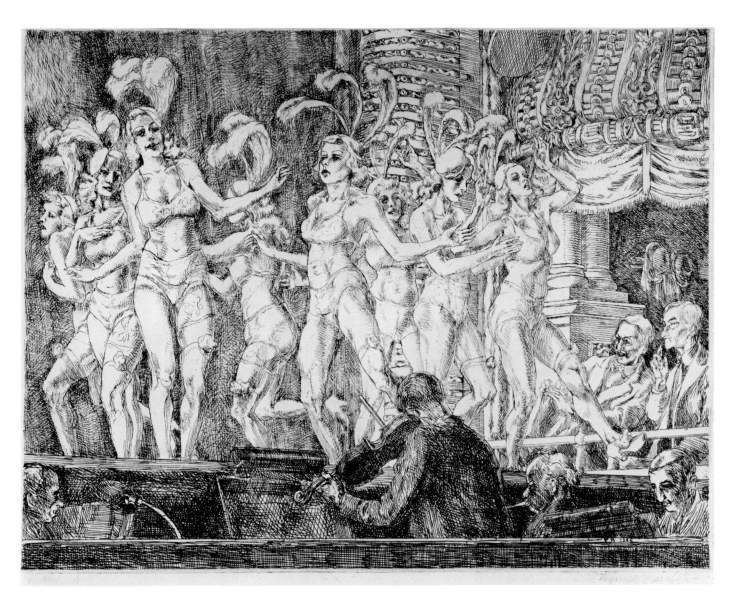

170. *Minsky's New Gotham Chorus*
 1936. (April 7, 1936)
 l.r.; RM 1936
 Etching; 231 mm. x 305 mm.
 (9″ x 12″) plate.
 State I (two proofs: *I/1* WB, *I/2* MMA
 touched) Design complete.
 State II (three proofs: *II/1* WB, *II 2*,
 II 3) Drawing added to curtain and
 figures.

State III (one proof: *III 1/1* WB)
 Scraped and burnished at length on
 curtains. Nitric on foreground (RM).
State IV (one proof: *IV 1/* WB)
 Drawing added to backdrop and flesh.
 Final state.
Printing: Marsh, six impressions (May,
 1936). I made twenty proofs about
 seventeen good—17—labeled Forty
 Proofs and signed (RM); ACH, DAL,
 NYPL, MMA, UMO, Z.

Edition: Jones, eleven impressions
 (1956); Whitney, one hundred
 impressions (1969).
Steel faced. Back of plate hammered up
 extensively.
Note: Painting, same design: *Minsky's
 Chorus*, 1935, Collection Mr. & Mrs.
 Albert Hackett.

Photograph: Final state, Forty Proofs.

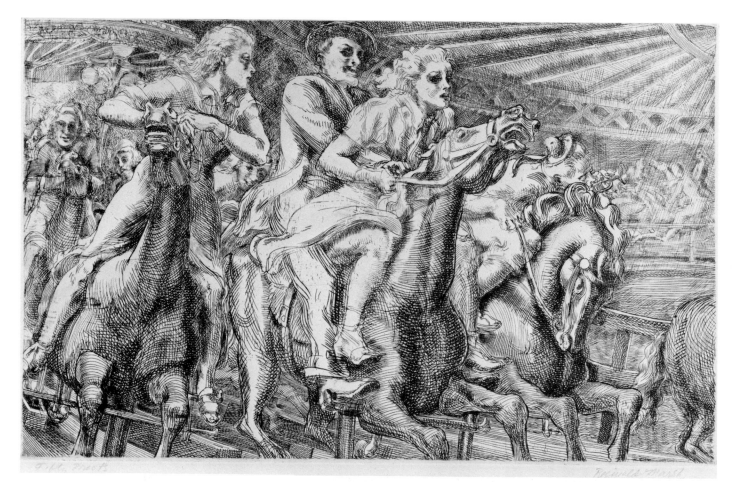

Final state

Painting

171. *Wooden Horses*

1936. (August 25, 1936)

Etching (extensive engraving added);
204 mm. x 340 mm. (8″ x 13¼″)
plate.

State I (two proofs: *A*, *B* MMA) Design
complete except for man's face which
is faintly indicated, and vise mark in
lower left corner.

State II (three proofs: C, D, *E* NYPL,
there is also a proof "A" which is
definitely State II) Extensive
engraving added throughout, including
lower left corner and man's face.

State III (one proof: *F*) Man's facial
features darkened, lines added to horse's
legs and right middle ground (ring).

State IV (one proof: G) Engraving
(RM).

State V (one proof: H) Engraving (RM).

State VI More engraving (RM). Final
state.

Printing: Marsh, eleven impressions.
White, ten impressions (October 23,
1936); BPL, NYPL, MMA, Z.

Edition: Jones, eleven impressions
(1956); Whitney, one hundred
impressions (1969).

Steel faced. Back of plate hammered up
in many places.

Note: Painting, same design, some
change in details: *Wooden Horses*,
1936, Collection Marjorie Kelly, Palm
Beach, Fla. Sketch illustrated in: *The
Sketchbooks of Reginald Marsh*, p. 77.

Photographs: State I, State II, Final
state, Fifty Proofs; painting,
Collection Marjorie Kelly.

State I

State II

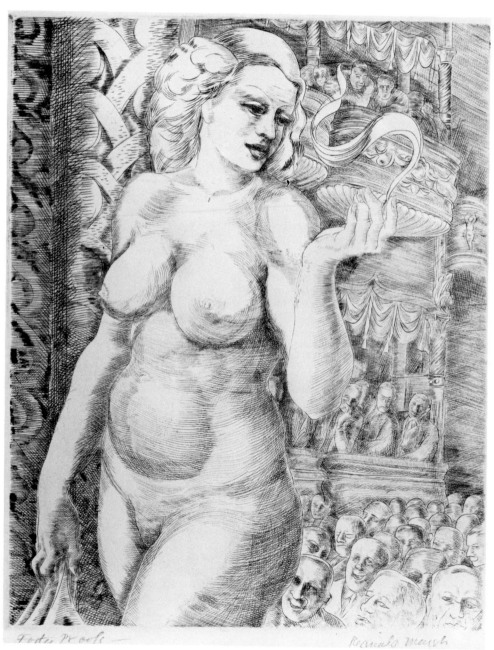

172. *G-String*
1936. (December 12, 1936)
l.r.; R
 M
Engraving; 252 mm. x 203 mm.
(9¾" x 8") plate.
State I (three proofs: A, *B* Rives, *C* on
vellum NYPL) Engraved entirely in
outline using grofé lozenge.
State II (one proof: *D* Rives)
Background area heavily engraved
using mostly parallel lines. Some
engraving added to woman's face, hand,
and breasts.
State III (two proofs: *E, F* Rives NYPL)
Extensive scraping of previous
engraving. Delicate lines added to
girl's figure.
State IV (three proofs: G, H, I)
Extensive engraving on all areas,
consisting mostly of cross-hatching.
Audience greatly developed.
State V (one proof: *J*) Engraved (RM).
Darks added to column at left. Many
additional lines, including
cross-hatching added to girl's figure.
Initials added.
State VI (two proofs: *K* NYPL, *L*)
Engrave and remove (RM). He
probably meant removing the burr.
Many lines added, especially on right
side of print.
Printing: Marsh, thirteen impressions
(February 21, 1937). Charles White,
ten impressions (March 3, 1937).
Note: Painting, same design, not
completed; Collection Mrs. Reginald
Marsh.

Photograph: Final state, Forty Proofs.

173. Felicia

> 1937. Notebook No. 6, p. 26.
>
> l.r.; ЯM appears on State VI and
> thereafter.
>
> Engraving; 229 mm. x 152 mm.
> (9″ x 6″) plate.
>
> State I (four proofs: *A* NYPL, *B*, *C*
> NYPL, *D* NYPL) Entire plate with
> one tool/Mullers (RM). Design
> complete.
>
> State II (one proof) Lines added to lower
> part of blouse, belt, left sleeve, and
> top of hat.
>
> State III (two proofs: E, F) Right side
> of blouse modeled further. "Felicia"
> added.
>
> State IV (one proof: *G*) Lines added to
> right shoulder.
>
> State V (one proof) Tool out on hair
> (RM).
>
> State VI (two proofs: *VIA* NYPL, Z)
> Changed "Felicia" to center—one
> print (RM). Dotted lines added to
> face and hat. Additional lines added to
> right shoulder.
>
> State VII (one proof: *VIB*) Final state.
>
> Printing: Marsh, twelve impressions of
> State V (April 10, 1937). Marsh, five
> impressions of State VII (October 4,
> 1938); BPL.
>
> Note: MMA proof, early state, touched
> extensively. According to The Art
> Institute of Chicago, a Chicago collecter
> owns what appears to be an early state,
> before "Felicia" was added; it has
> watercolor additions.
>
> Photograph: Final state, VIB.

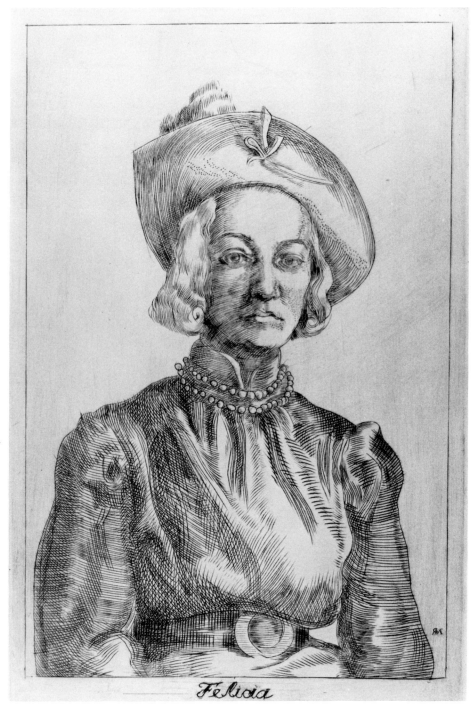

174. *Girl with Frilled-out Skirt Reading Newspaper*
1938. Notebook No. 6, p. 32.
l.l.; ЯM
Engraving; 127 mm. x 102 mm.
　(5″ x 4″) plate.
State I (two proofs: *A* FM, B) Engraved
　with one tool, Sellers large ◇ (RM).
　Design complete.
State II Initials added. Final state.
Printing: Marsh, thirteen impressions
　(October 18, 1938); NYPL.

Photograph: Final state, Forty Proofs.

175. *Girl with Umbrella*
1938. Notebook No. 6, p. 27.
l.r.; RM 38
Engraving (with a little drypoint);
　152 mm. x 102 mm. (6″ x 4″) plate.
State I (two proofs: *A, B*) Design
　complete.
State II (two proofs: C, D) Extensive
　engraving, vertical and diagonal lines
　on right edge of plate, shadow on
　ground and column. Umbrella and left
　side of figure darkened. Initials added.
State III Ground to the left of figure and
　whole figure darkened. Final state.
Printing: Marsh, fourteen impressions
　(March 12, 1938), *Forty Proofs*;
　NYPL, Z.
Edition: Jones, one impression (1956);
　Praeger, one hundred impressions
　(1956) for the limited edition of
　*Reginald Marsh, Etchings, Engravings
　and Lithographs*, Norman Sasowsky.
Note: Drawing on tracing paper for the
　engraving and two magazine clippings
　containing research material for
　engraving found among Marsh's papers.

Photograph: Final state.

176. *Two Girls in the Wind*
 1938. Notebook No. 6, p. 31.
 l.r.; **MR**
 Engraving; 128 mm. x 102 mm.
 (5″ x 4″) plate.
 State I (two proofs: *A*, *B* FM) All
 engraved with Sellers ◇ outlined by
 engraver's pen (RM). Design complete.
 State II (two proofs: *C*, D) Engraved
 with same tool (RM). Some scraping
 on right side of plate.
 State III Scraping marks removed.
 Additional work done on many parts of
 the figures. Final state.
 Printing: Marsh, ten impressions
 (October 7, 1938); NYPL, Z.
 Edition: Whitney, one hundred
 impressions (1971).
 Steel faced.

 Photograph: Final state.

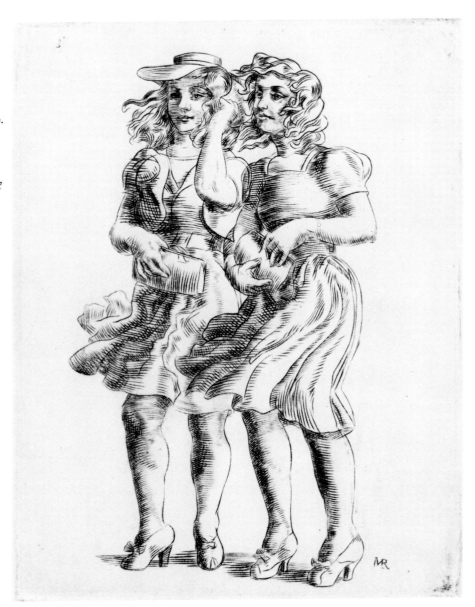

177. *Battery (Belles)*
1938. Notebook No. 6, p. 29.
l.r.; R.M. 1938
Etching and engraving;
 230 mm. x 305 mm. (9″ x 12″) plate.
State I (two proofs: *A* NYPL, *B*)
 Bordering wax was used—Nankwill
 Dutch—55 min. Continue to spit bite
 in nitric (RM). Design complete.
State II (one proof: *C State II—only
 proof*) Engraving added to background.
 Bird in center foreground darkened.
 Tugboat darkened.
State III (two proofs: *D Third State 2/2*
 NYPL) Engrave (RM). Foreground
 waves darkened. Ship in background,
 hull and smokestacks darkened.

State IV (two proofs: *E, Third State 2/2*
 NYPL) Engrave on arm (RM).
State V (one proof: F) Engrave (RM).
State VI Engrave on sky, etc. (RM).
 Final state.
Printing: Marsh, twenty impressions
 (June 30, 1938); MWPI, Z.
Edition: Jones, eleven impressions
 (1956); Whitney, one hundred
 impressions (1969).
Steel faced.
Note: Painting, similar design: *Battery
 Belles* or *Belles of the Battery*, 1938,
 Butler Institute of American Art,
 Youngstown, Ohio.

Photograph: Final state, Forty Proofs.

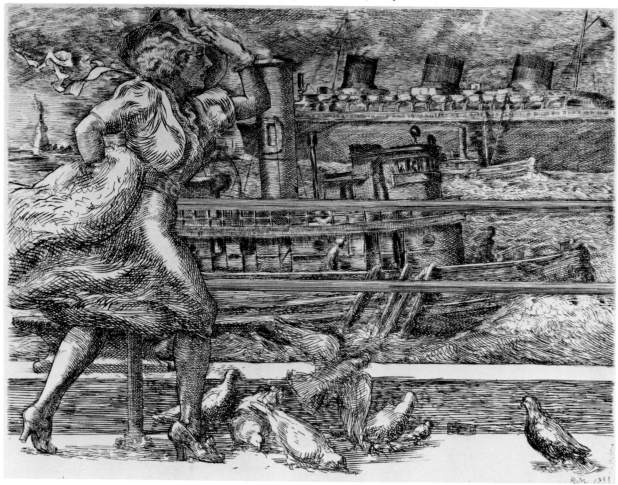

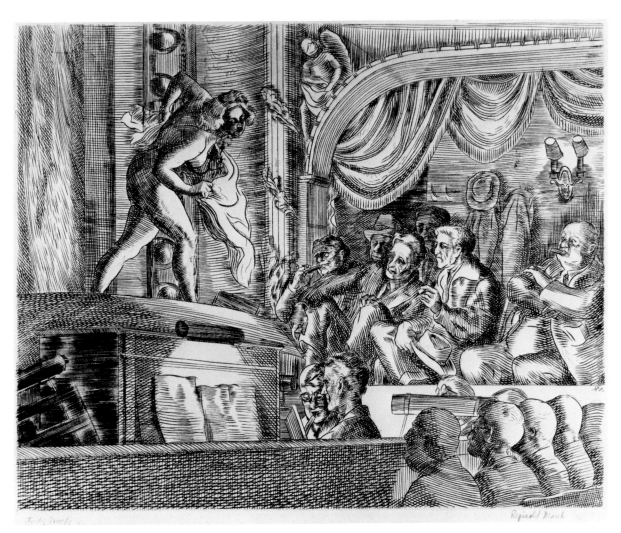

178. *Peoples Follies*
 1938. (February 12, 1938.) Notebook No.
 6, p. 28.
 r. edge; ℛM
 Engraving (zinc); 242 mm. x 305 mm.
 (9½″ x 12″) plate.
 State I (two proofs: A, B) Etch outlines
 only in Dutch about 20 minutes
 (engraved altogether) (RM). Design
 complete.
 State II (one proof: C) Changed outline
 of girl, additional engraving (RM).
 State III (one proof: D) Additional
 engraving (RM).
 State IV (one proof: E) Final state.

Printing: Marsh, eight impressions
 numbered "Forty Proofs" left in
 Marsh's estate; BPL, NYPL, Z.
Edition: Whitney, one hundred
 impressions (1971).
Steel faced.
Note: Painting, same design but changed
 in details: *The Peoples Follies*, 1938,
 The Benton Collection. *People's Follies
 #3*, reproduced in *Demcourier*, June
 1943, p. 14. Marsh's notes suggest that
 he completed the painting late in 1938.

Photograph: Final state, Forty Proofs.

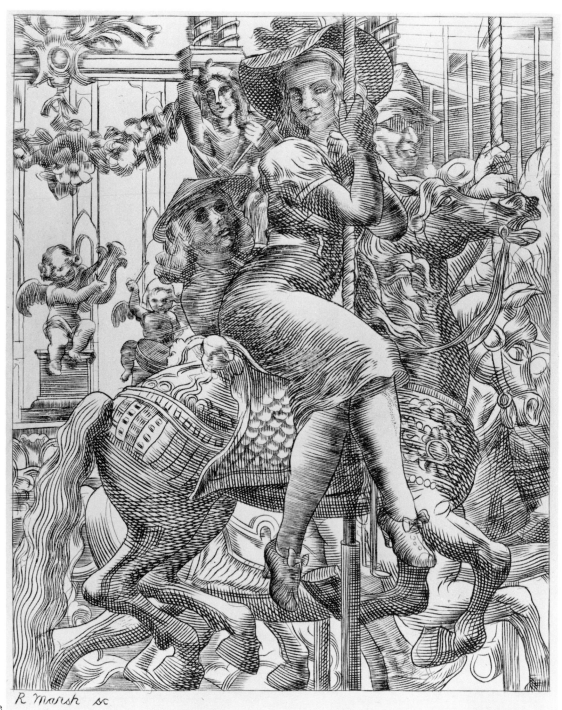

Final state R Marsh sc

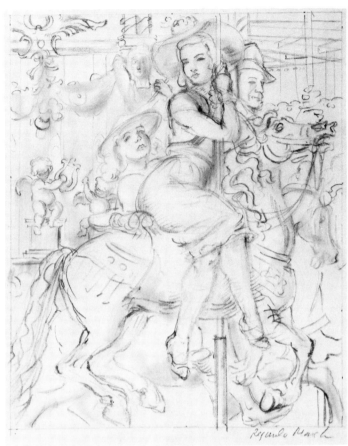

Drawing

179. *Merry-Go-Round*

 1938. (July 14, 1938)

 l.l.; R. Marsh SC

 Etching in first state; engraving
 afterward; 255 mm. x 205 mm.
 (10″ x 8″) plate.

 State I (one proof: *A etched—only print
 1st State*) Design etched in line.

 State II (two proofs: *B, C*) Made into
 engraving (RM). Mostly parallel lines
 added. Original outline engraved.

 State III (one proof: *D*) Crosshatched
 lines engraved in many areas.

 State IV (two proofs: E, F) Engraving
 added in many places. Name added.
 Girl's nose scraped. Final state.

 Printing: Marsh, ten impressions
 (August 22, 1938). Marsh noted that
 fifteen impressions were made but
 considered only ten valuable; CAR,
 NYPL, UMO, Z.

 Edition: Jones, eight impressions (1956);
 BPL, MMA, NYPL, UMO. Whitney,
 one hundred impressions (1969).

 Steel faced.

 Note: Painting, same design but many
 changes in details: *Merry-Go-Round*,
 1938, Collection Museum of Fine Arts,
 Springfield, Mass., The James Philip
 Gray Collection. Also reproduced in:
 *East Side West Side All Around the
 Town*, The University of Arizona
 Museum of Art, Tucson, Arizona, 1969,
 p. 44.

 Photographs: State I, State II, State III,
 final state; painting, Museum of Fine
 Arts, Springfield, Mass.; drawing, The
 Benton Collection.

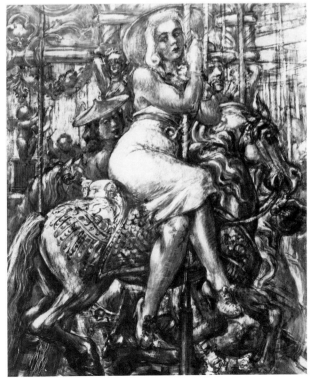

Painting

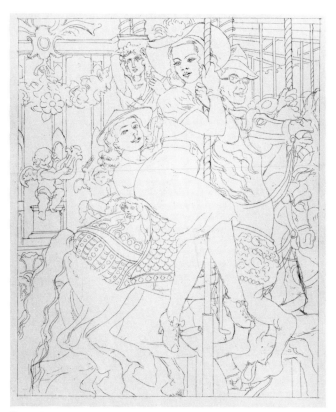

State I

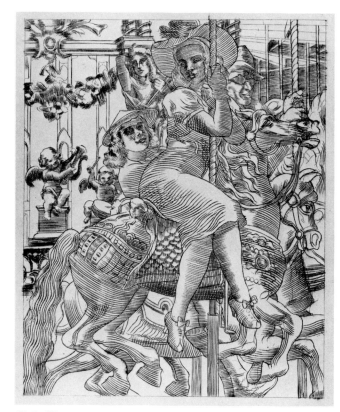

State II

179. Merry-Go-Round

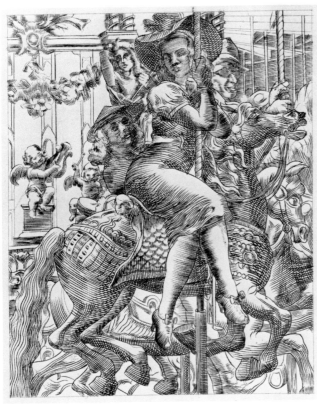

State III

180. *Pickaback*
 1939. Notebook No. 6, p. 34.
 l.r.; ЯM
 Engraving; 254 mm. x 127 mm.
 (10″ x 5″) plate.
 State I (one proof: A NYPL) Design
 complete.
 State II Shadow added on ground,
 corrections made on girl's foot; some
 additional engraving. Final state.
 Printing: Marsh, thirteen impressions;
 NYPL, Z.
 Edition: Whitney, one hundred
 impressions (1969).
 Steel faced.

 Photograph: Final state.

181. Felicia

1939. (February 24, 1939) Notebook No.
6, p. 36.

l.r.; RM

Engraving; 100 mm. x 76 mm.
(4″ x 3″) plate.

State I (one proof: NYPL, touched
Feb. 24, 1939 noted on proof)
Engraving entirely with one tool—
small ◇ (RM). Design complete.
Mostly in outline, some parallel lines on
face and hat.

State II Parallel lines added to face and
clothing.

State III Cross-hatching added to
clothing. Hair defined. Initials added.

State IV Lines added to light part of hat,
to left shoulder, to hair.

State V Dark triangular area added on
left shoulder near lapel. Final state.

Printing: Marsh, eighteen impressions—
sixteen on Whatman (March 2, 1939);
NYPL, MMA.

Edition: Jones, eight impressions (1956).

Photograph: Final state.

182. Beach Picnic

1939. (July 11, 1939)

l.r.; ЯM

Engraving; 128 mm. x 179 mm.
(5″ x 7″) plate.

State I (one proof: *First Trial
State—only proof* Rives) Design
complete except for umbrella, tube
and background figures.

State II (two proofs: *Second Trial S[tate]*
1/2, 2/2 Whatman white) Umbrell[a]
and tube added. Many parts darke[r].

State III Background figures added.
Short dashes added to various parts
including top of box in lower right.
Final state.

Printing: Marsh, twenty impression[s]
(August 12, 1939); NYPL, PMA,
Changing a few strokes as I go alon[g]
(RM). This statement of Marsh's
indicates minor additions to the pl[ate]
as he did the printing.

Note: Three drawings on tracing pap[er]
for the engraving found among Ma[rsh's]
papers.

Photograph: Final state.

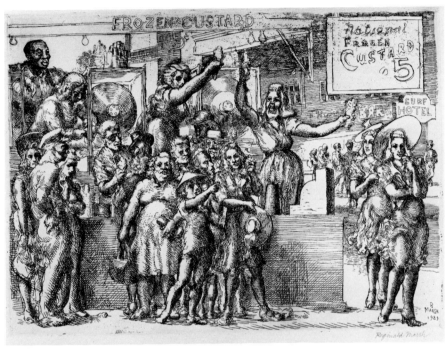

183. *Frozen Custard*

1939. Notebook No. 6, p. 41.

l.r.; R
MARSH
1939

Etching (extensive engraving added);
178 mm. x 254 mm. (7″ x 10″) plate.

State I (two proofs: *First Trial State I
1/2, 2/2*) Design complete.

State II (one proof: Rives white)
Engrave and re-etch (RM). Lines added
throughout. Bottles added to top of
custard machine. Final state.

Printing: Marsh, eighteen impressions
Whatman antique laid (August 28,
1939); ACH, NYPL, Z.

Note: Painting, same design with
considerably different details: *Frozen
Custard*, 1939. The Benton Collection.
Much foul biting on plate. Drawing in
red chalk on tracing paper for etching
found among Marsh's papers.

Photograph: Final state.

184. *Modern 1939 Venus*

1939. (September 11, 1939)

l.r.; R. MARSH 1939

Etching; 203 mm. x 305 mm.
(8″ x 12″) plate.

State I (one proof: *State I 1/1*
Fabriano) Design complete.

State II (one proof: *State II 1/1*)
Kneeling figure darkened, additional
lines added throughout.

State III (one proof) Engrave (RM).

State IV (one proof: *State IV—only
proof*) Engrave (RM). Outline of
figures engraved. Other touches of
engraving in various places.

State V Engrave (RM). Final state.

Printing: Marsh, ten impressions—five
Whatman, five Rives (September 28,
1939); BPL, NYPL.

Edition: Whitney, one hundred
impressions (1969).

Steel faced.

Note: Painting, same design: *Modern
1939 Venus*, 1939, Collection Macbeth.
Red chalk drawing on tracing paper for
the etching.

Photograph: State IV, State IV only
proof.

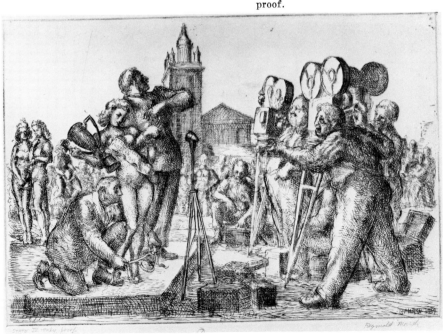

185. *Diana Dancing Academy*
 1939. Notebook No. 6, p. 44.
 l.r.; ЯM
 Engraving; 201 mm. x 256 mm.
 (8″ x 10″) plate.
 State I (two proofs: *Trial State I 1/1,
 First Trial State 1/2* Rives MMA,
 touched) Engrave with two tools, one
 large Muller, one medium Sellers (RM).
 Design complete except for couple in
 background.
 State II (one proof) Couple added in
 background, additional engraving on
 figures, area in back of figures
 darkened, on this or following state.
 State III (one proof: *Trial State III
 1/1*).

State IV (one proof: *Fourth Trial State
 1/1*) Dark area in back of figures
 scraped. Lines added to left corner.
State V Additional work on face of figure
 at far right. Edge darkened at far left.
 Parts of railing darkened as well as
 area behind railing support at left.
 Final state.
Printing: Marsh, twelve impressions
 Whatman white laid (November 16,
 1939); BPL, NYPL, Z.
Note: Painting, watercolor, same design:
 Diana Dancing Academy, 1939,
 Collection Mrs. Albert Hackett.

Photograph: State IV, Fourth Trial
 State 1/1.

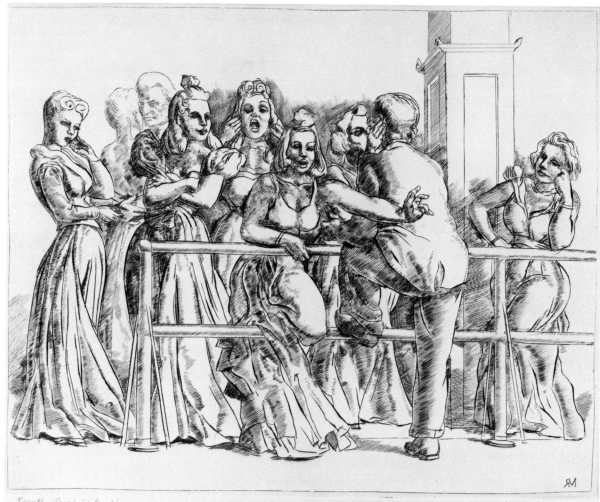

Fourth Trial State 1/1 Reginald Marsh

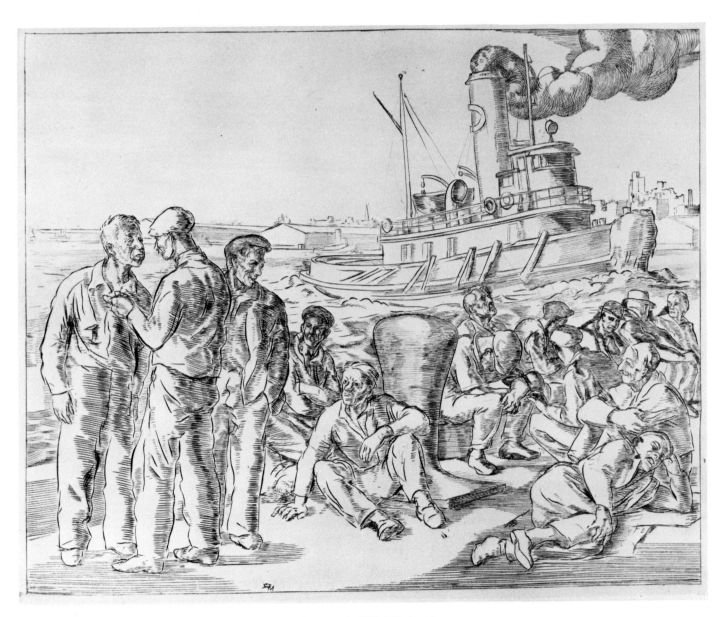

186. *Coenties Slip*
 1939. (November 28, 1939)
 l. edge near c.; ЯМ
 Engraving; irregular edge
 202 mm. x 153 mm. (7⅞″ x 6″) plate.
 State I (two proofs: A, B) Design
 complete except for smoke and
 buildings in background.

State II (one proof: *C IInd State only
 proof*) Added smoke, buildings, and
 initials. Shadow added in lower right.
 Saw plate in half (RM). (December
 23, 1939) Final state.
Printing: Unknown; first state, PMA.

Photograph: State II, IInd State only
 proof.

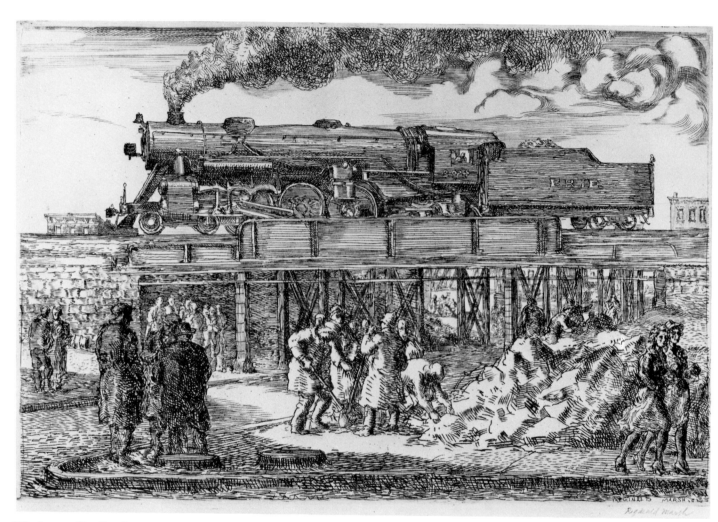

187. *Jersey City Landscape*
 1939. (March 26–30, 1939)
 l.r.; REGINALD MARSH 1939.
 Etching (extensive engraving added);
 203 mm. x 305 mm. (8″ x 12″) plate.
 State I (two proofs: Whatman) Bitten
 in three stages—1st stage heaviest—in
 reverse order (RM). Design complete
 except for clouds.
 State II (one proof: Rives) Engraving
 added.

State III (two proofs: Rives) Engraving
 added to area above buildings at left.
 Final state.
Printing: Marsh, twenty impressions
 Whatman; NYPL, PMA.
Note: Painting, watercolor, same design,
 some changes in detail: *Jersey City
 Landscape*, 1939, The Benton Collection.

Photograph: State II.

188. *Model on Love Seat*
 1939. RM envelope.
 l.r.; ЯM
 1939
 Engraving ; 102 mm. x 153 mm.
 (4″ x 6″) plate.
 State I Design complete in outline. A few
 parallel lines.
 State II (one proof : *2nd Trial State 1/1*)
 Most forms modeled with parallel and
 crosshatched lines. Initials and date
 added.
 State III Many lines added vigorously.
 Decoration added to top of sofa. Area
 under sofa darkened. Hair extended
 around head. Final state.
 Printing: Unknown ; NYPL, Z.
 Back of plate has extensive random
 engraving. Edges of plate not beveled.

 Photograph : Final state.

188A. *Girl Strolling**
 1939. Estimate.
 l.c.; RM
 Etching ; 97 mm. x 76 mm.
 (3⅞″ x 3″) plate mark.
 Only state.
 Printing : Unknown ; Z.
 Note : Located January, 1972.

 Photograph : Only state, Collection
 The Middendorf Gallery.

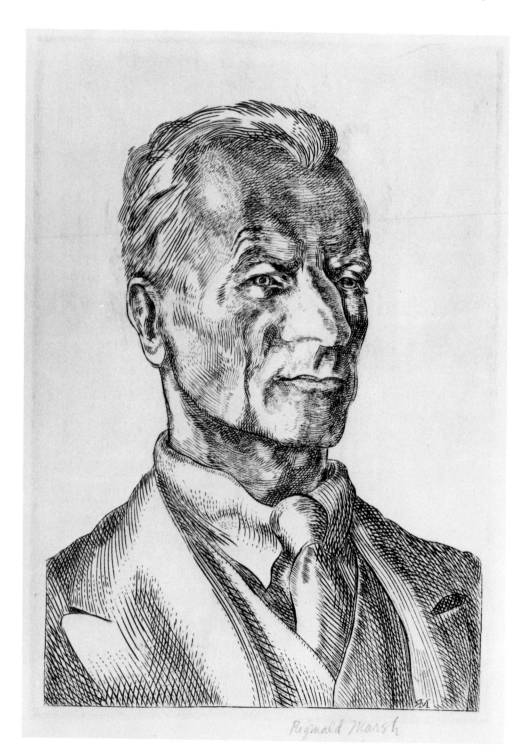

Reginald Marsh

189. *Kenneth Hayes Miller*
1939. (September 28, 1939)
l.r.; ЯM
Engraving; 165 mm. x 115 mm.
(6½″ x 4½″) plate.
State I (two proofs: *1st Trial State 1/2*
NYPL, B Whatman) Design complete.
State II (one proof: C Rives **MMA**
touched) Existing lines carried further
in many instances by added dots and
dashes. Initials added.
State III (one proof: D Rives) Routed
out nose (RM). Lines on nose removed.
State IV (one proof: *E* Rives) Lines
added to head, two dark lines above left
eye, chin darkened; diagonal line on
jaw added.
State V (one proof: *F* Duc de Parma)
Lines added to vest and right lapel.
Burrs removed.
State VI (one proof: *G only print—6th
Trial Proof*) Various parts of face
darkened.
State VII (one proof: *H*) Information
not available. Final state.
Printing: Marsh, nineteen impressions
Whatman and Barcelona (February
27, 1940); MMA, NYPL, PMA.
Back of plate hammered up extensively.

Photograph: Final state.

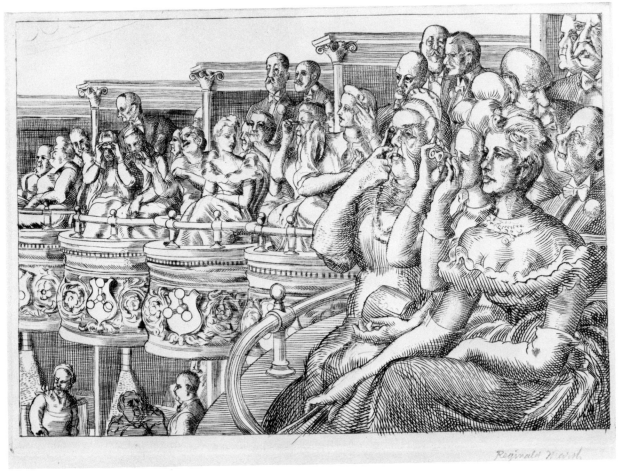

Final state

State I

190. *Grand Tier at the Met.*
1939. Notebook No. 6, p. 39.
Engraving; 178 mm. x 254 mm.
(7″ x 10″) plate.
State I (one proof: *First trial state—only proof*) Design complete except for box decorations.
State II (one proof: 1) Head of woman in lower right removed and replaced with another head. Box decorations added in this or final state. June 1, 1939 (RM).
State III (one proof: 2) June 1, 1939 (RM). Final state.
Printing: Marsh, fifteen impressions Whatman white laid (November 30, 1939); MMA, NYPL.
Edition: Jones, twelve impressions (1956); Whitney, one hundred impressions (1969).
Steel faced.

Photogaphs: State I, final state.

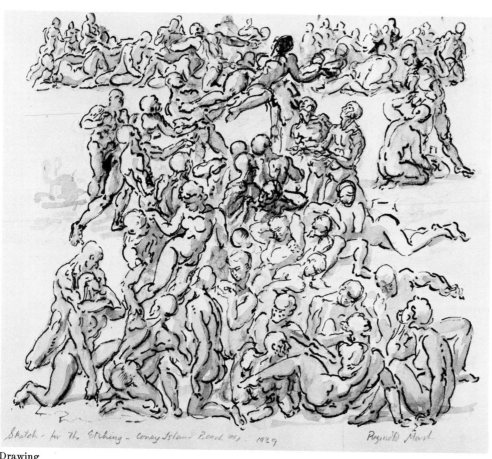

Drawing

191. *Coney Island Beach #1*
 1939. (February 8, 1939) Notebook No.
 6, p. 35.
 l.r.; ЯМ 1939
 Etching; 204 mm. x 305 mm.
 (10″ x 12″) plate.
 State I Design complete.
 State II Feb. 15 (RM). Probably just a
 few engraving touches in upper central
 portion of plate. Final state.
 Printing: Marsh, seventeen impressions
 Whatman white laid toned Anvil
 (February 15, 1939); DAL, NYPL,
 PMA, Z.
 Edition: Jones, seven impressions
 (1956); Whitney, one hundred
 impressions (1969).
 Steel faced.

 Photographs: Final state; drawing, The
 Benton Collection.

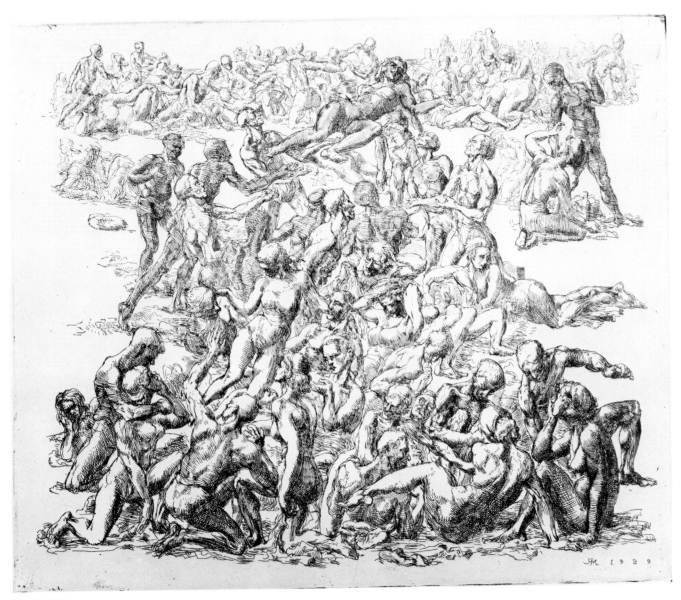

Final state

192. *Seated Female Nude**
 1940. Estimate. Probably one of the six
 demonstration plates listed in Notebook
 No. 8, p. 64.
 Engraving; 152 mm. x 102 mm.
 (6″ x 4″) plate.
 State I Design complete mostly in outline.
 State II Parallel lines added to right side
 of torso and underneath figure. Final
 state.
 Printing: Unknown.
 Note: Verso of plate S.209.

 Photograph: Final state.

193. *Zayda in Subway (Demonstration
 Plate)*
 1940. RM envelope.
 Engraving; 152 mm. x 102 mm.
 (6″ x 4″) plate.
 State I Design complete in outline.
 State II Entire figure engraved. Seat
 made explicit. Final state.
 Printing: Unknown; (2) Z.
 Plate damaged in lower center.
 Note: Verso of plate S.200.

 Photograph: Final state.

194. *Girl In Subway**
 1940. Estimate. Probably one of the six
 demonstration plates listed in
 Notebook No. 8, p. 64.
 Engraving; 153 mm. x 101 mm.
 (6″ x 4″) plate.
 State I Design complete in outline.
 State II Parallel lines added in some
 areas. Final state.
 Printing: Unknown; (4) NYPL.
 Edges of plate not beveled.
 Note: Additional engraving
 (demonstration or experimentation) on
 plate face not related to design. Back
 of plate has extensive random
 engraving.

 Photograph: Final state.

195. *Girl Standing**
 1940. Estimate. Probably one of the six
 demonstration plates listed in Notebook
 No. 8, p. 64.
 Engraving; 153 mm. x 102 mm.
 (6″ x 4″) plate mark.
 Only state.
 Printing: Unknown.
 Edition: Jones, one impression (1956).

 Photograph: No photograph available.

196. *Demonstration Plate*
 1940. RM envelope, 101E.
 Engraving; 153 mm. x 102 mm.
 (6″ x 4″) plate.
 State I Design complete in outline.
 State II Parallel lines added to left side
 of figure.
 State III Diagonal lines added to lower
 left corner. Final state.
 Printing: Unknown; NYPL.
 Note: Verso of plate S.197. Probably
 executed as a demonstration for the
 Society of American Engravers.

 Photograph: Final state.

197. *Girl Reading Newspaper**
 1940. Estimate.
 Engraving; 153 mm. x 102 mm.
 (6″ x 4″) plate.
 Only state.
 Printing: Unknown; NYPL, Z.
 Edition: Jones, one impression (1956).
 Note: Verso of plate S.196.

 Photograph: Only state.

198. *Girl Standing in Fur Coat*
 (Demonstration Plate)
 1940. RM envelope, 101B.
 Engraving; 152 mm. x 102 mm.
 (6″ x 4″) plate.
 Only state.
 Printing: Unknown; NYPL, Z.
 Note: Demonstration plate for the Society
 of American Engravers. Back of plate
 has extensive engraving and etching,
 mostly experimenting with tools and
 techniques. Hammered up in places.
 Marsh's name engraved. Face of plate
 has additional engraving which does
 not appear in the illustration of this
 print added to background. Additional
 engraving seems unrelated to design.

 Photograph: Only state.

199. *Demonstration SAE Plate*
 1940. RM envelope, 101C.
 Engraving; 152 mm. x 102 mm.
 (6″ x 4″) plate.
 State I (two proofs: NYPL, Z) Design
 complete except for figure in upper left
 and sun symbol.
 State II Figure and sun symbol added.
 Final state.
 Printing: Unknown.
 Note: Verso of plate S.221.

 Photograph: Final state.

*200. Two Girls Chatting**
1940. Estimate.
Engraving ; 152 mm. x 102 mm.
 (6″ x 4″) plate.
Only state.
Printing : Unknown.
Note : Verso of plate S.193.

Photograph : Only state.

201. Two Girls
1941. Estimate.
Engraving ; 152 mm. x 105 mm.
 (6″ x 4⅛″) plate.
Only state.
Printing : Unknown ; NYPL.
Edition : Jones, one impression (1956).

Photograph : Only state.

202. *Demonstration Plate*
 (Rochester, N.Y.)
 1940. RM envelope, 102B
 Engraving; 254 mm. x 204 mm.
 (10″ x 8″) plate.
 Only state. Unfinished (RM).
 Printing: Unknown; NYPL.
 Surface of plate badly scratched.
 Note: Verso of plate S.226.

 Photograph: Only state.

203. *Girl-Hat Window*
 1940. RM envelope.
 Engraving; 255 mm. x 204 mm.
 (10″ x 8″) plate.
 State I (one proof: NYPL) Standing
 female figure in outline.
 State II (one proof: NYPL) Storefront
 window and hat display added. Lines
 added to main figure.
 State III (one proof: NYPL) Man added
 in upper right. Additional lines added
 to main figure.
 State IV Buildings and street added in
 background. Extensive cross-hatching
 and dashes added to woman. Purse
 darkened. Final state.
 Printing: Unknown.
 Note: Back of plate has some random
 engraving.

 Photograph: Final state.

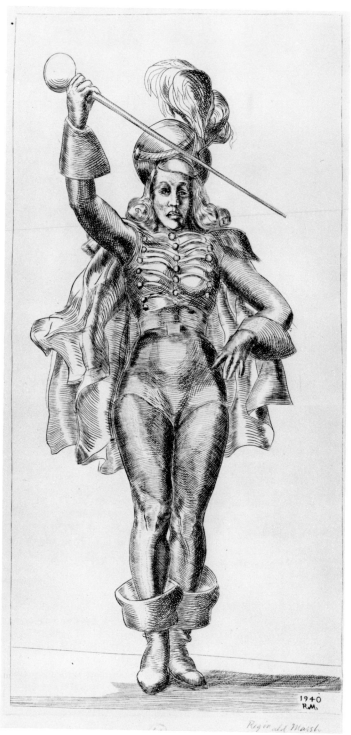

204. *Drum Majorette*
 1940. Notebook No. 6, p. 46.
 l.r.; 1940
 RM
 Engraving; 298 mm. x 152 mm.
 (11¾″ x 6″) plate mark.
 State I (one proof: *IA*) Cut with giant
 Sellers' graver (RM). Design complete
 except for shadow on ground.
 State II (one proof: *Trial Proof Only
 print 2nd State* Whatman) Shadow on
 ground added. Entire figure darkened.
 State III (one proof: *C Third Trial State
 1/1*) Highlight on left leg filled in.
 Part of cape added where arm joins
 cape at left. Base line added.
 State IV (one proof: D) Back part of
 ground shadow darkened. Final state.
 Printing: Marsh, twelve impressions
 Whatman white wove (April 22, 1940).
 Edition: Laurel Gallery, three hundred
 impressions printed by Atelier 17,
 published in the quarterly magazine
 Laurel, May 1947; *1* NYPL, 65 PMA,
 ACH, BPL, Z.
 Plate not found.

 Photograph: Final state.

205. *Girl in Fur Jacket Reading Tabloid*
1940. Notebook No. 6, p. 47.
l.r.; M
Engraving; 305 mm. x 153 mm.
 (12″ x 6″) plate.
State I (one proof: *A*) Design complete
 except for entire ground shadow.
State II (one proof: *II 1/1 Z*) Shadow
 extended and initial added in this or
 third state.
State III (one proof: *III 1/1* Whatman)
 Information not available.
State IV (one proof: *4th Trial State 1/1*
 Whatman) Base line added. Top part of
 paper darkened. Highlight on right leg
 filled in. Cheek darkened.
State V (one proof: E Whatman) Given
 to Cornelia (RM). Information not
 available.
State VI Information not available. Final
 state.
Printing: Marsh, twelve impressions
 Whatman white wove (April 22, 1940);
 CAR, NYPL.
Edition: Jones, sixteen impressions
 (1956); Whitney, one hundred
 impressions (1969).
Steel faced.
Note: On Synder's copper refaced—
 written on RM envelope.

Photograph: Final state.

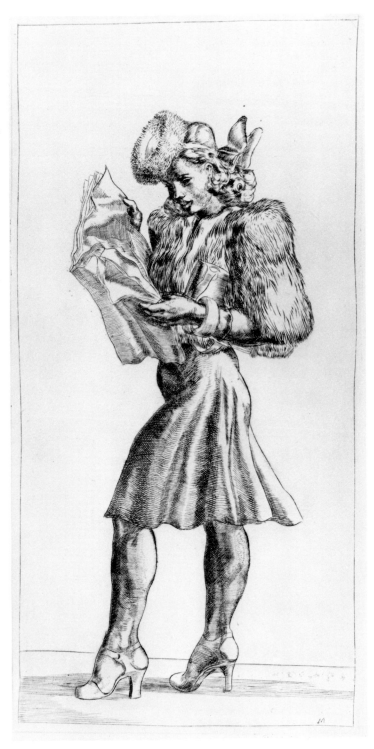

206. *Studies of Nudes in Drypoint*
　　1940.
　　l.r.; 1940
　　Drypoint; 203 mm. x 255 mm.
　　　(8″ x 10″) plate.
　　Only state.
　　Printing: Unknown; NYPL.

　　Photograph: Only state.

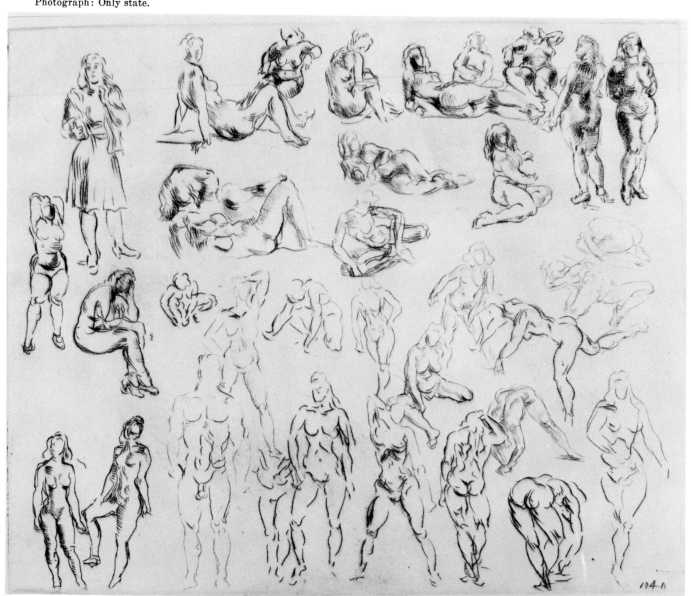

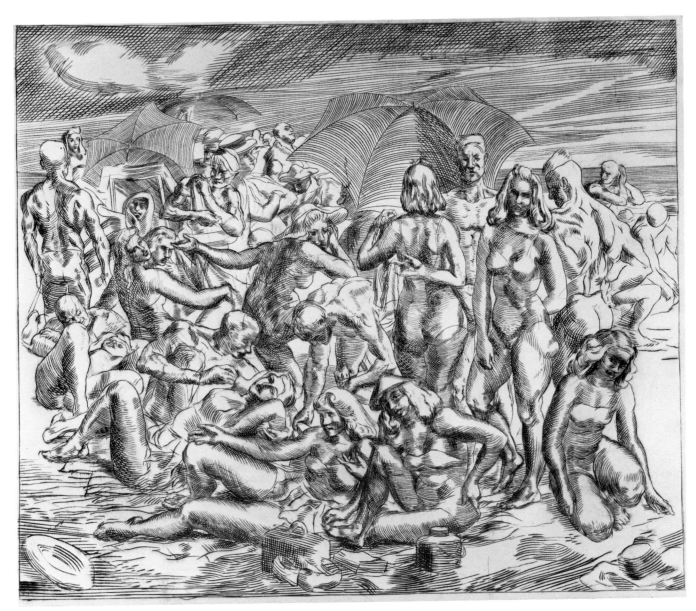

207. *Coney Island Beach*

1940. (October 10, 1940) Notebook No. 6, p. 50.

Engraving; 254 mm. x 305 mm. (10″ x 12″) plate.

Only state (two proofs: A, B Rives) Cut almost entirely with #5 Muller's square. Study with Hayter October 7th (RM).

Printing: Marsh, four impressions Whatman (December 23, 1940); NYPL, PMA.

Note: After cutting much with Seller's square #8 I used Muller's square #5 (RM). It is not clear if Marsh worked on this plate after making the four impressions. Painting, watercolor, similar design: *Coney Island Beach*, 1940, present location or ownership unknown. Drawing for the engraving, collection of the author.

Photograph: Only state.

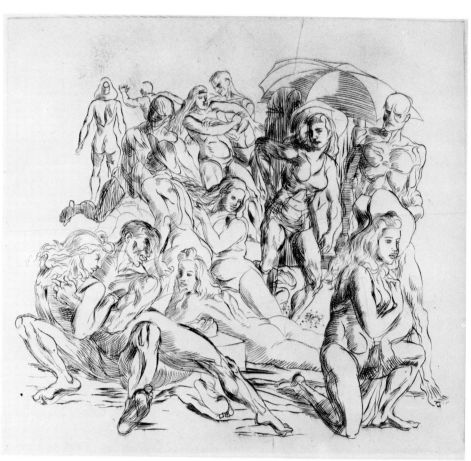

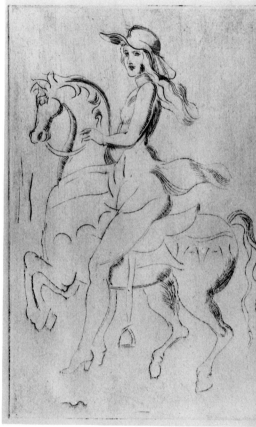

208. Beach No. 2—Unfinished
 1940. RM envelope, 101.
 Engraving; 224 mm. x 252 mm.
 (9″ x 10″) plate.
 State I Design complete except for a
 figure in upper left.
 State II Unfinished (RM). Figure added
 in upper left, very light. Couple in
 lower left darkened. Final state.
 Printing: Unknown.
 Note: Random engraving on back of
 plate.

 Photograph: State I.

209. Girl on Merry-Go-Round
 1940. Estimate.
 Engraving; 152 mm. x 102 mm.
 (6″ x 4″) plate.
 Only state.
 Printing: Unknown; NYPL.
 Note: Verso of plate S.192.

 Photograph: Only state.

210. Merry-Go-Round
 1940. RM envelope.
 Engraving; 203 mm. x 305 mm.
 (8″ x 12″) plate.
 State I Design complete except for lower
 background.
 State II Forms added to lower
 background. Dashes added to right
 horse's neck.
 State III Skirtline over left knee made
 stronger; line of dashes added to left
 leg; lines added to main figure's dress
 and to upper right background. Final
 state.

Printing: Unknown; NYPL.
Edition: Whitney, one hundred
 impressions (1969).
Steel faced.

Photograph: Final state.

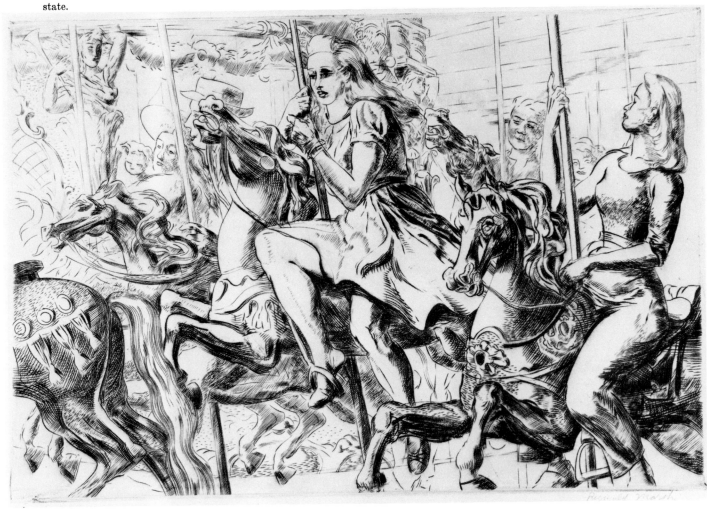

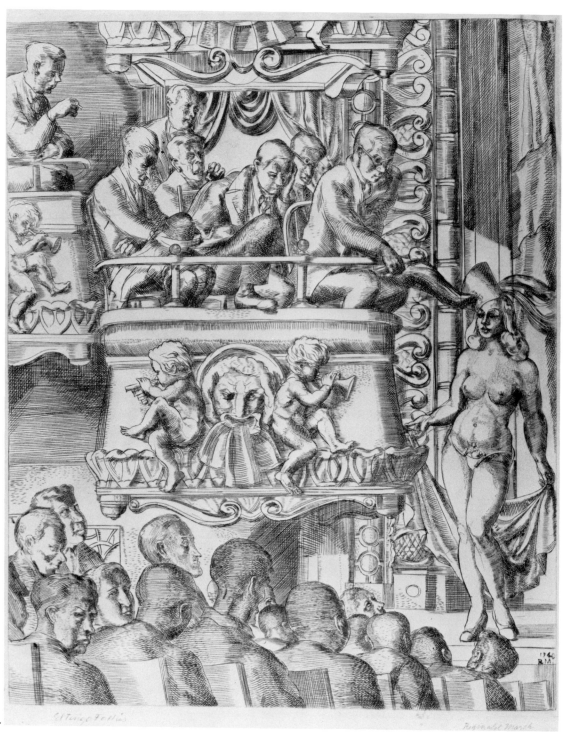

Final state.

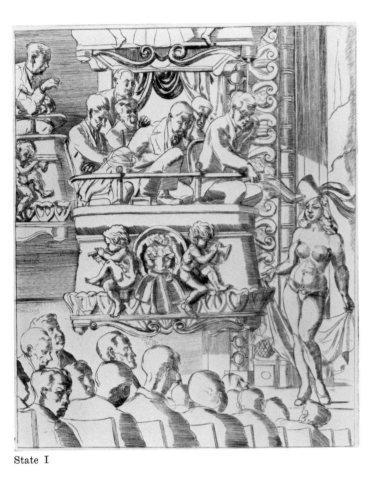

State I

State IV

211. *Eltinge Follies*
1940. (May 24, 1940) Notebook No. 6,
p. 98.
l.r.; 1940
RM
Engraving; 305 mm. x 254 mm.
(12″ x 10″) plate.
State I (two proofs: *Trial State I 1/2*
WB, *2/2* Umbria white) Cut entirely
with small Seller's lozenge (RM).
Design complete.
State II (one proof: *State II* Rives
white) Information not available.
State III (one proof: *State III 1/1* WB
Rives white) Many lines added
throughout in the form of
cross-hatching.

State IV (one proof: *Fourth trial state
1/1* Rives white) Shadow in upper
right darkened. Several heads and
shoulders of foreground figures
darkened. Initials and date added. Arm
of front figure in box darkened.
State V (one proof: *V 1/1* Whatman
antique) Information not available.
State VI (one proof: *VI 1/1* PMA
Whatman antique) Information not
available.
State VII According to Marsh's records
this is the final state.
Printing: Marsh, fifteen impressions
Whatman antique toned laid (August
12, 1940); BPL, NYPL, (2) MMA, one
MMA impression has color added; (2)
Z one is an early state.

Edition: Jones, thirteen impressions
(1956); Whitney, one hundred
impressions (1969).
Steel faced.
Note: Painting, watercolor, same subject
in a horizontal format: *Eltinge Follies*,
1940, Collection Henry Luce III.

Photographs: State I, State IV, final
state.

212. *Raphael Soyer**
1941. Date given by Raphael Soyer.
Etching; 116 mm. x 45 mm.
 (4½″ x 1¾″) plate.
Only state.
Printing: Marsh; PMA, Z. Sasowsky;
 two posthumous impressions (1956);
 DIA.
Note: Back of plate has the name "H.
 Bryson Burroughs" engraved.

Photograph: Only state.

213. *Bathers-in-the Hudson*
 1941. RM envelope.
 Engraving; 204 mm. x 305 mm.
 (8″ x 12″) plate.
 State I (two proofs: NYPL, PMA
 touched extensively) Design complete.
 State II Central area behind figures
 darkened considerably. Final state.
 Printing: Unknown; (2) NYPL, MWPI,
 Z.
 Edition: Whitney, one hundred
 impressions (1969).
 Steel faced.
 Note: Drawing for the engraving,
 collection of the author.

 Photographs: State I; drawing.

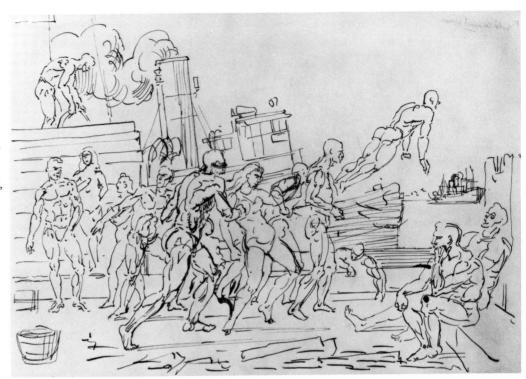

Drawing

State I

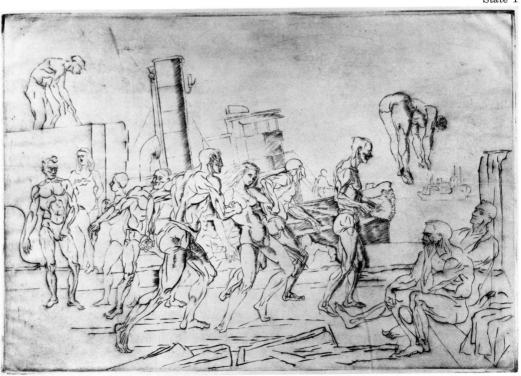

214. *Three Girls on a Chicken*
 1941. RM envelope.
 Engraving; 203 mm. x 254 mm.
 (8″ x 10″) plate.
 State I (two proofs: *First trial state*)
 Design complete except for two figures
 in background.
 State II (two proofs: *2nd State*) Two
 figures added in background. Diagonal
 parallel lines added to background
 figures. Some additional lines added to
 main figures. Final state.

Printing: Marsh, twenty impressions left
 in Marsh's estate; BPL, NYPL, Z.
Edition: Jones, two impressions (1956).

Photograph: Final state.

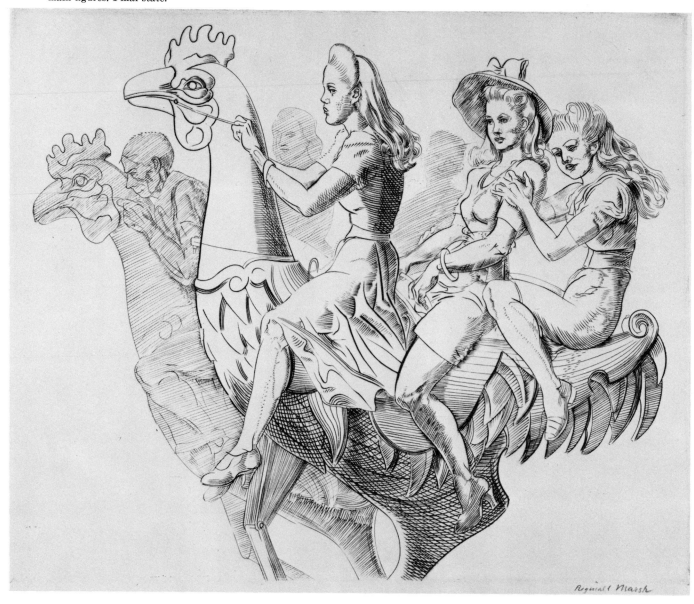

Reginald Marsh

215. *Study with Hayter*
1941. Notebook No. 8, p. 64.
Engraving; 254 mm. x 203 mm.
 (10″ x 8″) plate.
State I (one proof: NYPL) Design
 complete except for head and shoulders
 of figure.
State II (one proof: NYPL) Head,
 shoulders, and arm added.
State III Parallel lines added to back of
 figure, and to left side of figure. Final
 state.
Printing: Unknown.
Note: Back of plate engraved extensively.
 Horse, letters, etc., engraved, using
 different-faced gravers.

Photograph: Final state.

216. *Girl Walking**
1941. Estimate. Notebook No. 8, p. 66.
Engraving; 254 mm. x 203 mm.
 (10″ x 8″) plate.
Only state. Unfinished (RM).
Printing: Unknown.
Edition: Jones, one impression (1956).

Photograph: Only state.

217. Two Girls (One Smoking)
1941. RM envelope, 102c.
Engraving; 255 mm. x 203 mm.
 (10″ x 8″) plate.
Only state.
Printing: Unknown; NYPL.
Verso of plate S.222. Plate surface
 scratched.
Note: Additional engraving on plate (on
 hair of left figure) seems to have been
 done in anger.

Photograph: Only state.

218. *Globe Theater (Eltinge Follies)*
 1941.
 l.r.; R. MARSH
 1941
 Etching; 203 mm. x 254 mm.
 (8″ x 10″) plate.
 Only state.
 Printing: Unknown.
 Note: Impression in Z collection may be
 an early state.

 Photograph: Only state.

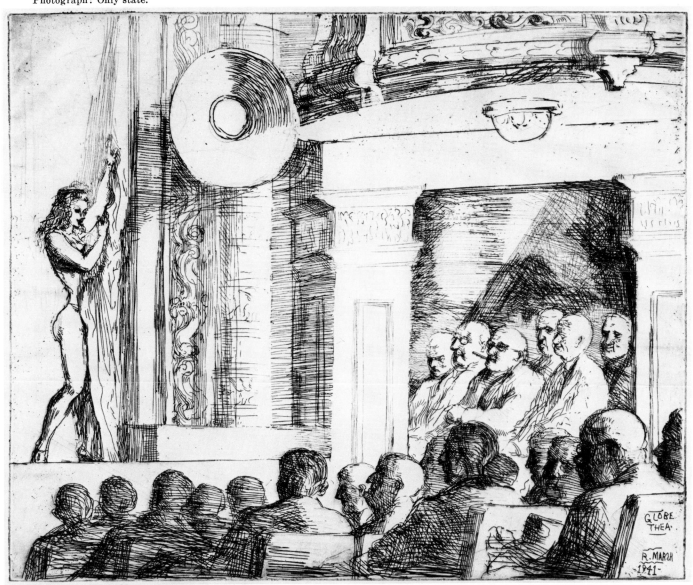

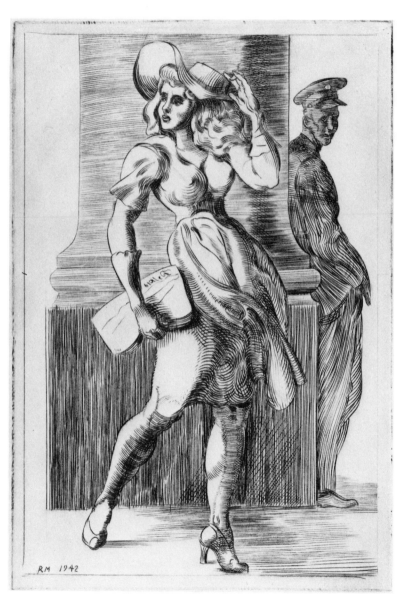

219. *Girl Walking—Pillar—Soldier*
　　1942. Notebook No. 8, p. 66.
　　l.l.; RM 1942
　　Engraving; 153 mm. x 105 mm.
　　　(6″ x 4″) plate.
　　State I Bank note style of engraving
　　　(RM). Design complete.
　　State II (two proofs: *State II 1/1, 1/2*)
　　　Unfinished (RM). Extensive engraving
　　　in dark areas. Final state.
　　Printing: Unknown; NYPL, MMA.
　　Edition: Jones, eleven impressions
　　　(1956).

　　Photograph: Final state.

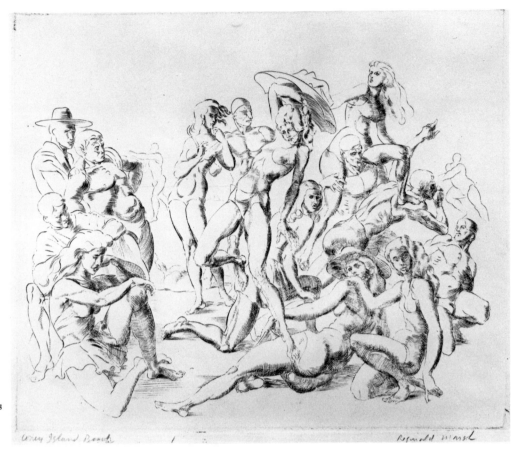

220. *Coney Island Beach*
 1942. RM envelope.
 Engraving; 203 mm. x 254 mm.
 (8″ x 10″) plate.
 Only state.
 Printing: Unknown.
 Edition: Jones, twelve impressions
 (1956); MMA.

 Photograph: Only state.

221. *Discussion on Beach?*
 1942. Estimate.
 Engraving; 102 mm. x 152 mm.
 (4″ x 6″) plate.
 Only state.
 Printing: Unknown; NYPL.

 Photograph: Only state.

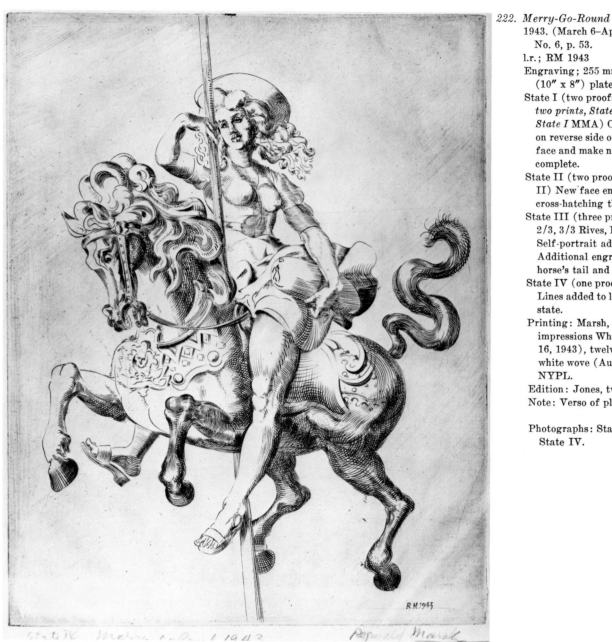

State IV Merry-go-round 1943 Reginald Marsh

Final state

222. *Merry-Go-Round*
1943. (March 6–April 4, 1943) Notebook
 No. 6, p. 53.
l.r.; RM 1943
Engraving; 255 mm. x 203 mm.
 (10″ x 8″) plate.
State I (two proofs: *No. 1 state one of
 two prints, State I* Duc du Parma,
 State I MMA) Cut with fish belly #9
 on reverse side of old plate. Tool out
 face and make new face (RM). Design
 complete.
State II (two proofs: State II 1/2, State
 II) New face engraved. Extensive
 cross-hatching throughout.
State III (three proofs: State III 1/3,
 2/3, 3/3 Rives, Duc du Parma)
 Self-portrait added on horse's chest.
 Additional engraving on shirt near
 horse's tail and on horse.
State IV (one proof: *State IV* MMA)
 Lines added to leg and right arm. Final
 state.
Printing: Marsh, State IV, twelve
 impressions Whatman tone laid (July
 16, 1943), twelve impressions Whatman
 white wove (August 2, 1943); BPL,
 NYPL.
Edition: Jones, two impressions (1956).
Note: Verso of plate S.217.

Photographs: State I, State II, State III,
 State IV.

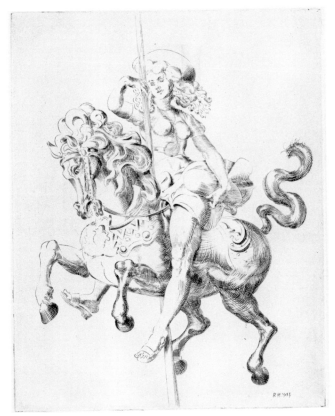

State I

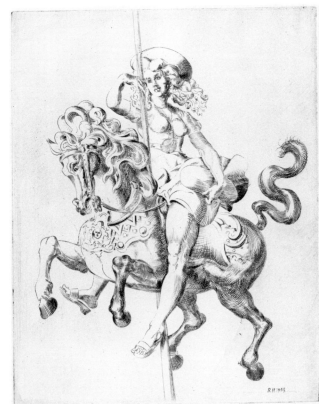

State III

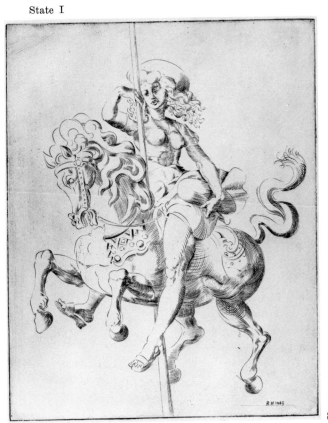

State II

223. *Demonstration Plate*

 1943. Impression marked: *demonstration plate 1943* WB.

 l.r.; ʜsɿɒM blɒnigɘЯ

 Engraving; 152 mm. x 102 mm. (6″ x 4″) plate. Not beveled.

 State I Design not complete. Only top half of figure engraved.

 State II (*demonstration plate 1943*) Remainder of figure added. Also, name added. Final state.

 Printing: Unknown.

 Note: Notice similarity to figure in plate S.219.

 Photograph: Final state.

224. *Girl Standing—Repeated*

 1943. Estimate.

 Engraving; 165 mm. x 109 mm. (6½″ x 4¼″) plate.

 Only state.

 Printing: Unknown.

 Edges of plate not beveled.

 Photograph: Only state.

225. *Two Girls on Swings*
1943.
l.r.; RM '43
Engraving; 203 mm. x 160 mm.
 (8″ x 6¼″) plate.
Only state.
Printing: Unknown; NYPL.
Note: Verso of plate S.227.

Photograph: Only state.

226. *Two Girls Walking to Right*
1943. Estimate.
Engraving; 254 mm. x 204 mm.
 (10″ x 8″) plate.
State I (two proofs: *State I 1/2* NYPL,
 2/2) Design complete except for two
 figures.
State II Two figures added. Final state.
Printing: Unknown. Marsh probably did
 not print State II, thus explaining why
 his title refers to "two girls."
Edition: Whitney, one hundred
 impressions (1969).
Steel faced.
Note: Verso of plate S.202.

Photograph: Final state, Collection
 Whitney Museum of American Art.

227. *Girls Walking down Street**
 1941. Estimate.
 Engraving; 203 mm. x 160 mm.
 (8″ x 6¼″) plate.
 State I Design complete except for two
 faces.
 State II Two faces added in left section.
 Final state.
 Printing: Unknown.
 Edges of plate not beveled.
 Note: Verso of plate S.225.

 Photograph: State I.

228. *Seated Girl**
 1944. Estimate.
 l.r.; RM
 Engraving; 115 mm. x 79 mm.
 (4½″ x 3″) plate.
 Only state.
 Printing: Unknown; NYPL.
 Note: Verso of this plate has an etching;
 a scene with figures standing in a
 street, possibly Paris. Title etched in
 lower left: St. Anne; lower center
 MARSH '95. If date is correct it might
 indicate work done by Marsh's father.

 Photograph: Only state.

228A. *Two Girls**
 1944. Estimate.
 l.r.; RM
 Engraving; 51 mm. x 39 mm.
 (2″ x 1½″) plate.
 Only state.
 Printing: Unknown; MMA, Z.

 Photograph: Only state.

229. *Girl Seated in Subway Car**
 1944. Estimate.
 Engraving; 76 mm. x 51 mm.
 (3″ x 2″) plate mark.
 Only state.
 Printing: Unknown.
 Plate not found.

 Photograph: Only state.

230. *Schoolgirls**
1944.
l.r.; MARSH
 1944 RM
Engraving; approximately
 190 mm. x 253 mm. (7½″ x 10″) exact
 size of plate uncertain as only known
 proofs are trimmed short.
Only state.
Printing: Unknown; NYPL.
Plate not found.

Photograph: Only state.

231. *Cocktail**
1946. Dated on State II proof.
Engraving; 205 mm. x 151 mm.
 (8″ x 6″) plate.
State I Design complete.
State II (proof: *demonstration plate ASE
 December 1, 1946, 2nd state*) Printed
 by Charles White on Whatman (RM).
 Lines added to figures. Final state.
Printing: Unknown.

Photograph: Final state.

232. *Switch Engines*
 1948. Estimate.
 Engraving; 204 mm. x 254 mm.
 (8″ x 10″) plate.
 State I (two proofs: *State I-1/2 line engraved* CL). Design complete.
 State II (two proofs: *State II 2/2* CL) Many lines added throughout. Final state.
 Printing: Unknown.
 Note: Probably done as part of the commission for Print Club of Cleveland. Same design as S.30. Drawing, collection of the author.

 Photographs: Final state, courtesy of The Print Club of Cleveland; drawing.

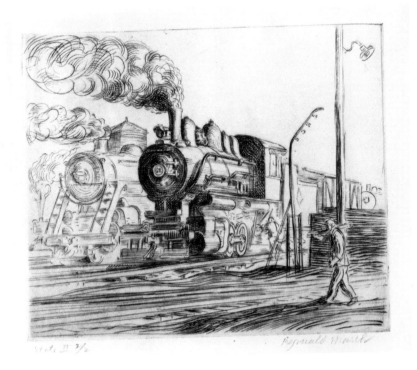

Drawing

Final state

233. *Bathers—Two Girls One Man*
 1948. Estimate.
 Engraving; 255 mm. x 203 mm.
 (10″ x 8″) plate.
 Only state.
 Printing: Unknown; NYPL.

 Photograph: Only state.

234. *League Print*
 1949.
 Engraving; 253 mm. x 203 mm.
 (10″ x 8″) plate mark.
 Only state.
 Printing: Unknown.
 Edition: Art Students League of New
 York, two hundred impressions (1949).
 Plate owned by Art Students League.

 Photograph: Only state.

5. *Girl Walking Near Stairs**
 1950.
 l.r.; R MARSH
 1950
 Drypoint (zinc); 254 mm. x 202 mm.
 (10″ x 8″) plate.
 Only state.
 Printing: Unknown.
 Surface of plate corroded.

 Photograph: Only state.

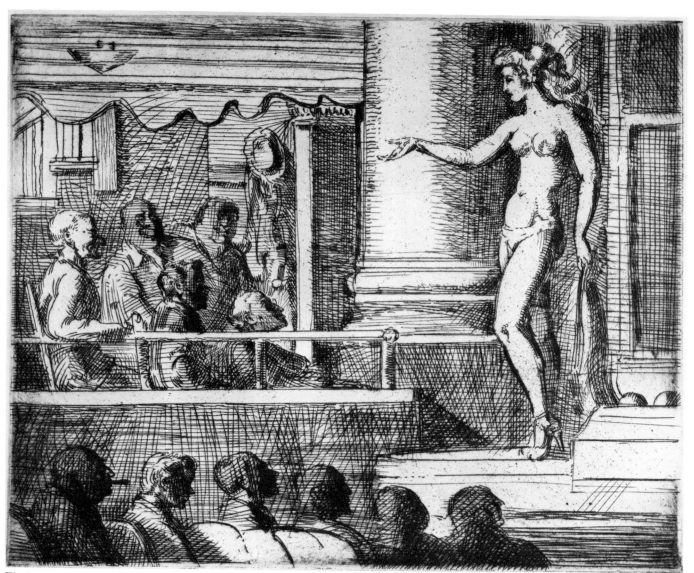

Final state

236. *Striptease in New Jersey*
 1951. 1951 Diary, Wednesday, March 7,
 1951.
 Etching; 203 mm. x 253 mm.
 (8″ x 10″) plate mark.
 State I Design complete.
 State II (proof: *Strip tease in N. Jersey
 2nd State*) Various areas darkened,
 mostly with horizontal lines.
 State III Figures and background in box
 darkened. Two heads in audience also
 darkened. Area to left of girl darkened.
 State IV Many lines added to left part of
 plate—lines in many directions.
 Horizontal lines added to right of girl.

State V All dark parts of plate darkened
 considerably with vertical lines. Final
 state.
Printing: Unknown. According to Marsh's
 diary Ernest Roth, a professional
 printer, did the printing.
Edition: Associated American Artists,
 two hundred fifty impressions (1951).
Plate owned by Associated American
 Artists.

Note: Marsh entered the following in his
 diary: "bite etching 2:30 at E. Roth."
 March 16, 1951: "to Ernest Roth—2:30,
 etching, 2nd state." March 17th: "Etch
 eve." May 26: "sign etchings
 AAA." Painting, similar design,
 Collection Mrs. Reginald Marsh.

Photographs: Final state. Painting,
 Collection Mrs. Reginald Marsh

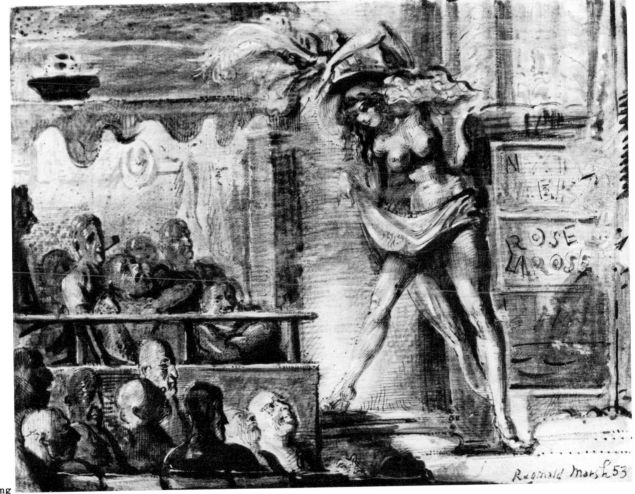

Painting

Photographic credits

Numbers in brackets [] indicate a painting or drawing of the same design as this print number.

All the photographs were taken by Geoffrey Clements, New York City, with the following exceptions: Peter A. Juley & Son, New York City: [101], [156]; Eric Pollitzer, New York City: 188A; H. Edward Short, Newark, Delaware: [49], [102], [213], [232], three pages of Marsh's notebooks; Joseph Szaszfai, New Haven: [153], [156]; A. J. Wyatt, Philadelphia: [140], Edward Hopper etching *Train and Bathers*.

Appendixes

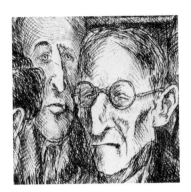

Awards

Institute of Graphic Arts—''Fifty Prints of the Year,''
 1932—*Gaiety Burlesque*

Library of Congress—J. and E. R. Pennell Purchase Prize,
 April, 1946—*Girl Walking*

Society of American Etchers—25th Annual Exhibition,
 1941—*Eltinge Follies*

American Academy and the National Institute of Arts and Letters,
 May, 1954—Gold Medal for Graphic Arts

Print exhibition

1928 Whitney Studio Galleries, New York:
Reginald Marsh. Lithographs.
November–December.

1931 Frank K. M. Rehn Galleries, New York:
Etchings by Reginald Marsh.
March.

1937 Yale University Art Gallery, New Haven:
February 11–March 4.

1939 M. A. McDonald Gallery, New York:
February–March.

1941 Memorial Art Gallery, Rochester:
March.

1944 Berkshire Museum, Pittsfield, Massachusetts:
Works by Reginald Marsh.
August 3–31.

1948 The Print Club of Cleveland:
Exhibition of Work by Reginald Marsh and Stevan Dohanos.
The Cleveland Museum of Art, October 1–31.

1955 Kennedy Galleries, Inc., New York:
Reginald Marsh. Etchings, Engravings, Lithographs.
September 21–October 15.

1955 Art Alliance, Philadelphia:
Marsh Memorial Show of Etchings and Engravings.
November 3–December 4.

1956 Childs Gallery, Boston:
Memorial Exhibition. Etchings, Engravings, Lithographs.
January 2–14.

1957– The American Federation of Arts, New York:
1959 *The Prints of Reginald Marsh*.
April 1957–April 1959.

1964 Kennedy Galleries, Inc., New York:
The Sidewalks of New York,
Four Decades of Graphics by John Sloan and Reginald Marsh.
March 2–31.

1972 Martin Gorden Gallery, New York:
Reginald Marsh.
February.

1974 The William Benton Museum of Art,
The University of Connecticut, Storrs:
The Evolution of an Etching: Reginald Marsh.
March 11–April 7.

Alphabetical listing

TITLE	CATALOG NUMBER
Girl Seated in Subway Car	229
Girl Standing	195
Girl Standing in Fur Coat (Demonstration Plate)	198
Girl Standing—Repeated	224
Girl Strolling	188A
Girl Walking—Elevated	28
Girl Walking	216
Girl Walking in Front of Brownstone	31
Girl Walking Near Stairs	235
Girl Walking—Pillar—Soldier	219
Girl with Frilled-out Skirt Reading Newspaper	174
Girl with Umbrella	175
Girls Walking Down Street	227
Globe Theater (Eltinge Follies)	218
Gossips	L
Grand Tier at the Met.	190
Greetings from Justin & Raymond	C
Greetings—Reginald Marsh	A
G-String	172
Guy Pène du Bois School of Art	150
Hamlet	V
Harlem Dancer	77
Huber's Museum	14
Iron Steamboat Co.	131
Irving Place Burlesk, 1929	75
Irving Place Burlesk, 1930	101
Irving Place Burlesque, 1928	15
Irving Place Burlesque (#2)	49
Jersey City Landscape	187
Joan of Arc	FF
Joan (The Tabloid)	109
Kenneth Hayes Miller, 1931	108
Kenneth Hayes Miller, 1939	189
Kopper Koke Works	164A

TITLE	CATALOG NUMBER
Three Heads	44
Three Women	J
Tombs Prison	65
Tug at Battery	145
Tugboats	124
Tug—Chas. D. McAllister	146
20th Cent. Ltd.	125
Two Couples	I
Two Flappers Walking	64
Two Girls, 1941	201
Two Girls, 1944	228A
Two Girls Chatting	200
Two Girls (in Childs' Doorway)	164
Two Girls in Subway	58
Two Girls in the Wind	176
Two Girls (One Smoking)	217
Two Girls on Swings	225
Two Girls Walking to Right	226
Two Men—One on Horse	U
Two Models on Bed	9
Two Tramps by Seine	32
Union Square	27
U. S. Marine	144
Wall Street (Skyline from Laurents)	118
Walter Broe	165
West Island	123
Wild Party	47
Woman Reading Book	H
Woman with Sword	W
Wooden Horses	171
Woodstock	119
Woolworth Tower #1	AA
Woolworth Tower #2	BB
The Wooly West	S

Selected bibliography

Baigell, Matthew. "The Beginnings of 'The American Wave' and the Depression."
 Art Journal XXVII (Summer 1968). 387–98.

Beall, Karen F. (compiler). *American Prints in the Library of Congress.*
 Baltimore: Johns Hopkins Press, 1970.

Bellows, Emma S., ed. *George Bellows, His Lithographs.*
 New York: Alfred A. Knopf, Inc., 1928.

Benton, William. "Reg Marsh—American Daumier."
 The Saturday Review 38: 8–9.

Boswell, Peyton. *George Bellows.*
 New York: Crown Publishers, Inc., 1942.

————. *Modern American Painting.*
 New York: Dodd, Mead & Co., 1940.

Brown, Bolton. *Lithography for Artists.*
 Chicago: University of Chicago Press, 1929.

Brown, Milton W. *American Painting from the Armory Show to the Depression.*
 Princeton: Princeton University Press, 1955.

Burroughs, Alan. *Kenneth Hayes Miller.*
 New York: Whitney Museum of American Art, 1931.

Cortissoz, Royal, ed. *Contemporary American Prints, Etchings, Woodcuts,
 Lithographs 1931.*
 Vol. 2. New York: American Art Dealers Association, 1931.

Craven, Thomas. *Modern Art.*
 New York: Simon and Schuster, Inc., 1934.

————, ed. *A Treasury of American Prints.*
 New York: Simon and Schuster, 1939.

Garver, Thomas H. *Reginald Marsh, A Retrospective Exhibition.*
 Newport Beach, California: Newport Harbor Art Museum, 1972.

Goodrich, Lloyd. "A Half-Day in the Studio of Reginald Marsh."
 American Artist 5 (June 1941): 6.

———. *Kenneth Hayes Miller.*
New York: The Arts Publishing Corp., 1930.

———. *Reginald Marsh.*
New York: Whitney Museum of American Art, 1955.

———. "Reginald Marsh."
American Artist 19 (September 1955): 18–23.

———. *Reginald Marsh.*
New York: Harry N. Abrams, Inc., 1972.

Hayter, Stanley W. *About Prints.*
London: Oxford University Press, 1962.

———. "Hogarthian Marsh."
Art Digest 13 (February 1939): 25.

———. *New Ways of Gravure.*
New York: Pantheon Books, Inc., 1949.

Karshan, Donald H. "American Printmaking 1670–1968."
Art in America (July–August 1968): 22–46.

Laning, Edward. *East Side, West Side, All Around the Town.*
Tucson, Arizona: The University of Arizona Museum of Art, 1969.

———. "Reginald Marsh."
Demcourier 13 (June 1943): 3–8.

———. *The Sketchbooks of Reginald Marsh.*
Greenwich, Connecticut: New York Graphic Society Ltd., 1973.

———. "Through The Eyes of Marsh."
Art News 54 (September 1955): 22–24.

Morgan, Charles H. *George Bellows, Painter of America.*
New York: Reynal & Co., 1965.

Pousette-Dart, Nathaniel. "Reginald Marsh—A Powerful Painter and Etcher of Life."
Studio News 5 (June–July 1934): 4–5.

Reese, Albert. *American Prints of the Twentieth Century.*
New York: American Artists Group, 1949.

Rose, Barbara. *American Art since 1900.*
New York: Frederick A. Praeger, Publishers, 1967.

Sasowsky, Norman. *Reginald Marsh, Etchings, Engravings, Lithographs.*
New York: Frederick A. Praeger, Publishers, 1956.

Watson, Forbes. ''Reginald Marsh.''
American Magazine of Art 28 (January 1935) : 62.

Zigrosser, Carl. *Artist in America. Twenty-Four Closeups of Contemporary Printmakers*
New York: Alfred A. Knopf, Inc., 1942.

———. *Six Centuries of Fine Prints.*
Garden City: Doubleday & Co., Inc. 1939.

Index